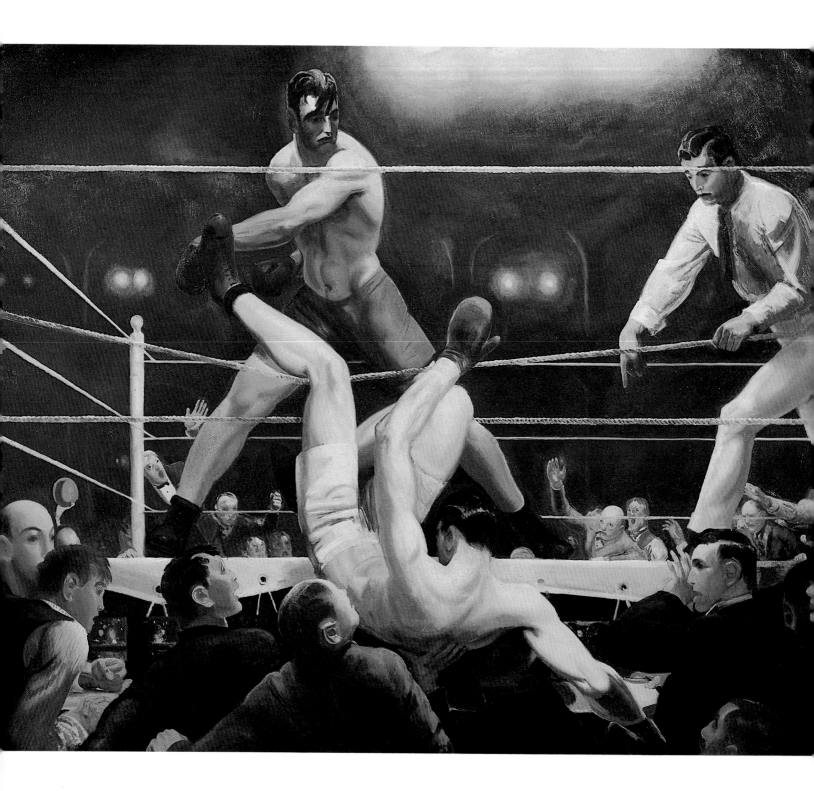

BELLOWS
The Boxing Pictures

E.A. Carmean, Jr.
John Wilmerding
Linda Ayres
Deborah Chotner

National Gallery of Art, Washington

This catalogue was produced by the Editors Office, National Gallery of Art, Washington.
Printed by Schneidereith & Sons, Baltimore, Maryland.
Set in Novarese by Composition Systems Inc., Arlington, Virginia.
Cover and text papers are eighty-pound Warren Lustro Dull Coated.
Edited by Cathy Gebhard.
Designed by Melanie B. Ness.
Boxing glove drawn by Mark Leithauser.

Exhibition dates at the National Gallery of Art: September 5, 1982-January 2, 1983.

cover: Detail of pl. 5
frontispiece: Plate 1. Bellows, *Dempsey and Firpo*, Whitney Museum of American Art, New York (cat. no. 6)

Library of Congress Cataloging in Publication Data:

Main entry under title:
Bellows, the boxing pictures.

 Bibliography: p. 101
 1. Bellows, George, 1882-1925— Exhibitions. 2. Boxing in Art—Exhibitions. I. Bellows, George, 1882-1925.
II. Carmean, E. A. III. National Gallery of Art (U.S.)
N6537.B45A4 1982 760'.092'4
82-8161
ISBN 0-89468-028-5

Contents

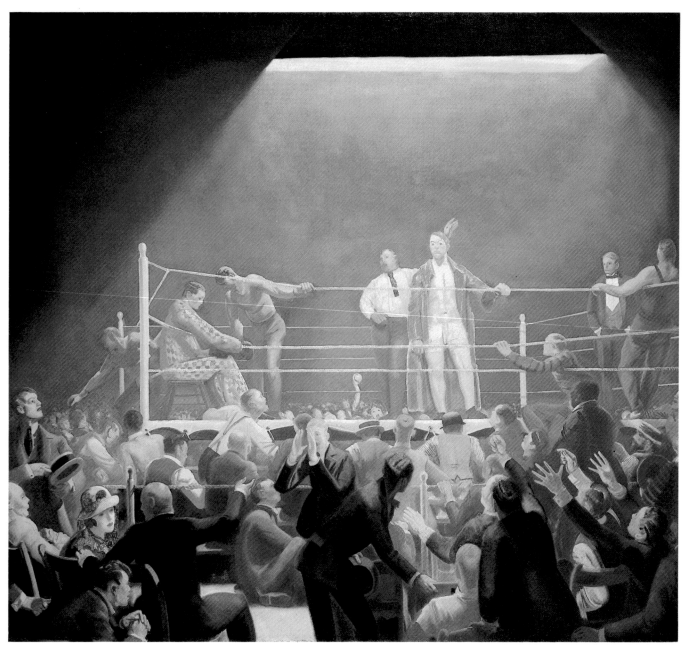

Plate 2. Bellows, *Ringside Seats*, Estate of Joseph H. Hirshhorn, Courtesy the Hirshhorn Museum and Sculpture Garden, Smithsonian Institution, Washington, D.C. (cat. no. 5)

Foreword

George Bellows: The Boxing Pictures is the result of a collaboration between the departments of American and twentieth-century art at the National Gallery. As such, it falls within the series of exhibitions presented in recent years in both of those areas.

On the one hand, this show and accompanying publication reflect the attention the Gallery has been devoting to different important aspects of the American art tradition, including luminism, naive painting, George Catlin's Indian images, and the collection of Jo Ann and Julian Ganz, Jr. On the other hand, our focus on Bellows succeeds previous monographic studies of major modern artists such as Mondrian, Picasso, and Kandinsky, who are represented by outstanding singular works in the Gallery's collections. As in those earlier cases, this Bellows exhibition highlights a key work owned by the National Gallery, the impressive canvas Both Members of This Club. The one hundredth anniversary of the artist's birth seemed an especially appropriate moment to reappraise this summary image in the context of related works in his career.

To that end we have brought together here all of Bellows' other boxing paintings and most of the known graphic versions. Moreover, we have undertaken this effort against the background of our own strong collection of his work. The National Gallery is fortunate to own a superb concentration of paintings by Bellows from all periods of his career, thanks primarily to the generosity of Chester Dale. This sampling includes portraits of Dale himself and his first wife Maud; two other figure paintings, Nude with Red Hair and Florence Davey; and two urban landscapes, Blue Morning and The Lone Tenement.

Both Members of This Club received a great deal of attention when it was donated by the Dales in 1945, especially in light of the Gallery's policy at that time of not accepting artists' work until twenty years after their deaths. Indeed, the New York Times reported on 7 January 1945 that "today the painting will be hung in the National Gallery . . . Bellows died on 8 January 1925. |He| is therefore being honored by inclusion in our national museum at the earliest possible second." The chronology included here makes readily clear the consistent popularity of Bellows' work since his lifetime; indeed his paintings, drawings, and prints have occasioned numerous periodic exhibitions. For its part, the Gallery continued its attention to the artist, devoting a one-man exhibition, its first, to Bellows in 1957.

In anticipation of the present show, Both Members of This Club has been off exhibition recently for cleaning in our conservation laboratory. To viewers who know this work from prior visits to the Gallery or from old color reproductions, its presentation will be a revelation.

On the scholarly side, this project has been organized by E. A. Carmean, Jr., curator of twentieth-century art, and John Wilmerding, curator of American art and senior curator. Their assistants, Linda Ayres, Deborah Chotner,

and Trinkett Clark made important contributions to the catalogue and have carried out many of the technical and administrative details. Additionally, we have been fortunate to have the indispensable help of a number of people. Gordon K. Allison of H. V. Allison and Company, for many years Bellows' dealer, cheerfully answered a myriad of questions about the boxing pictures, the artist's collectors, location of works, and exhibitions. Charles H. Morgan, author of the most complete biography of Bellows, graciously shared his broad knowledge of the painter and his work and helped locate several drawings and lithographs. Edward Henning, chief curator of modern art at the Cleveland Museum of Art, provided full access to the files on their boxing picture and facilitated our study of the canvas itself. Finally, Bellows' daughter Jean, Mrs. Earl M. Booth, painstakingly checked through the artist's Record Books for us and generously shared many family reminiscences.

Above all, the National Gallery is grateful to the several private and public lenders of works, for in a show of such a clearly defined nature having every loan was truly essential for success. Our only regret is that the two private owners of Bellows boxing oils, John Hay Whitney, a former trustee of the Gallery, and Joseph Hirshhorn did not live to see this project come to fruition. To all who have given their time, thought, or objects we are much indebted.

J. Carter Brown
Director

Acknowledgments

In addition to those individuals mentioned in the
director's foreword, the National Gallery of Art would like to
acknowledge with gratitude the following,
who kindly assisted us by facilitating loans and providing
valuable information for the catalogue:

Ann B. Abid, *The St. Louis Art Museum*
Clinton Adams, *Tamarind Institute, Albuquerque*
Archives of American Art Staff, *Smithsonian Institution*
Judith A. Barter, *Mead Art Museum, Amherst College*
Marianne Blair, *the artist's granddaughter*
Harry A. Brooks, *Wildenstein & Company*
Mrs. Samuel F. Carstens, *The Junior League
of the City of New York*
Mary Carver, *J. B. Speed Art Museum*
Margaret Christman, *National Portrait Gallery*
Marjorie Cohn, *Fogg Art Museum, Harvard University*
Harry Cloudman, *Macmillan Publishing Company*
Elizabeth Dailey, *Graham Gallery*
Anita Duquette, *Whitney Museum of American Art*
Mrs. Julian Eisenstein
Charlene Engel, *Moravian College*
John S. Evans, *Grand Central Art Galleries*
Stuart Feld, *Hirschl & Adler Galleries*
Catherine Glasgow, *Columbus Museum of Art*
Germaine G. Glidden, *National Art Museum of Sport*
Susan Gurney, *National Portrait Gallery and
National Museum of American Art Library*
Delbert Gutridge, *Cleveland Museum of Art*
Ben Ali Haggin
Elizabeth Hawkes, *Delaware Art Museum*
Mrs. Joseph Hirshhorn
John Holverson, *Portland (Maine) Museum of Art*
Francine B. Horowitz
Mr. and Mrs. Raymond Horowitz
Mrs. Arvin Karterud, *Lyman Allyn Museum*
Lynne Kortenhaus, *Phillips New England*
Cecily Langdale, *Davis & Langdale*

Barbara LaSalle, *The Brooklyn Museum*
William Lieberman, *The Metropolitan Museum of Art*
Robert M. Light
Nancy C. Little, *M. Knoedler & Company*
Patricia Loiko, *Museum of Art, Rhode Island School of Design*
Suzanne Folds McCullagh, *The Art Institute of Chicago*
Robert A. Mann
Annette Masling, *Albright-Knox Art Gallery*
Grete Meilman, *Sotheby's, New York*
Joan Michelman
Agnes Mongan, *Fogg Art Museum, Harvard University*
Jane Nelson, *The Fine Arts Museums of San Francisco*
Richard Nelson, *Muskegon Museum of Art*
Valerie Loupe Olsen, *New Orleans Museum of Art*
Glenn Peck, *Hirschl & Adler Galleries*
Martin E. Petersen, *San Diego Museum of Art*
Joyce Rambo, *Hirschl & Adler Galleries*
Kathryn Ritchie, *Whitney Communications Corporation*
Sam Roshon, *Columbus (Ohio) Public Library*
Arline Segal, *Rosenbach Museum and Library*
Patterson Sims, *Whitney Museum of American Art*
Mary Solt, *The Art Institute of Chicago*
Miriam Stewart, *Fogg Art Museum, Harvard University*
Catherine Stover, *Pennsylvania Academy of the Fine Arts*
Elisabeth Sussman, *Institute of Contemporary Art, Boston*
Peter Tatistcheff
Nicki Thiras, *Addison Gallery of American Art, Phillips Academy*
Brian Wallis, *The Museum of Modern Art*
Don Winer, *William Penn Memorial Museum*
Bruce Young, *Virginia Museum of Fine Arts*
Andrew Zaremba, *The Century Association*
R. Eugene Zepp, *Boston Public Library*

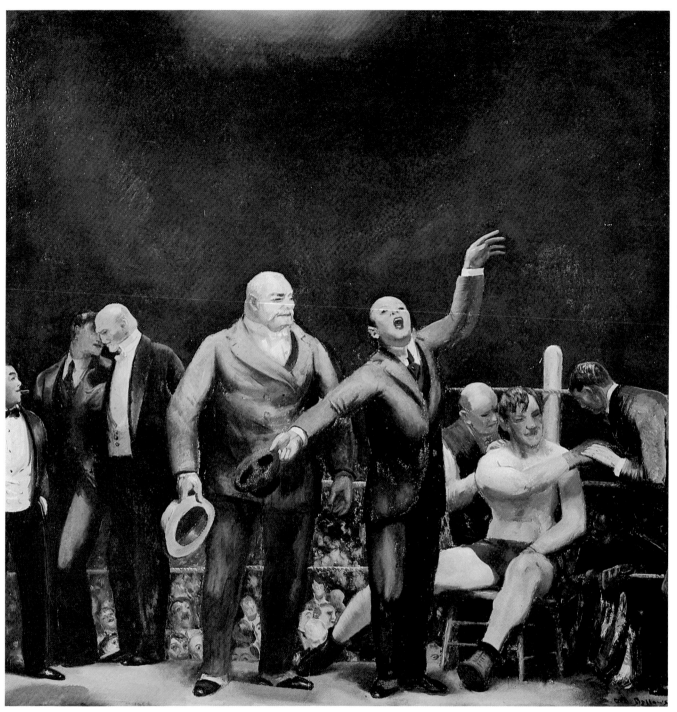

Plate 3. Bellows, *Introducing John L. Sullivan*, Mrs. John Hay Whitney (cat. no. 4)

Lenders to the Exhibition

Anonymous Lenders

Mr. and Mrs. Peter R. Blum

Boston Public Library, Print Department

Cleveland Museum of Art

Delaware Art Museum, Wilmington, John Sloan Archives

Estate of Joseph H. Hirshhorn, Courtesy the Hirshhorn Museum
and Sculpture Garden, Smithsonian Institution,
Washington, D.C.

Mead Art Museum, Amherst College, Massachusetts

The Metropolitan Museum of Art, New York

Mrs. John Hay Whitney

Whitney Museum of American Art, New York

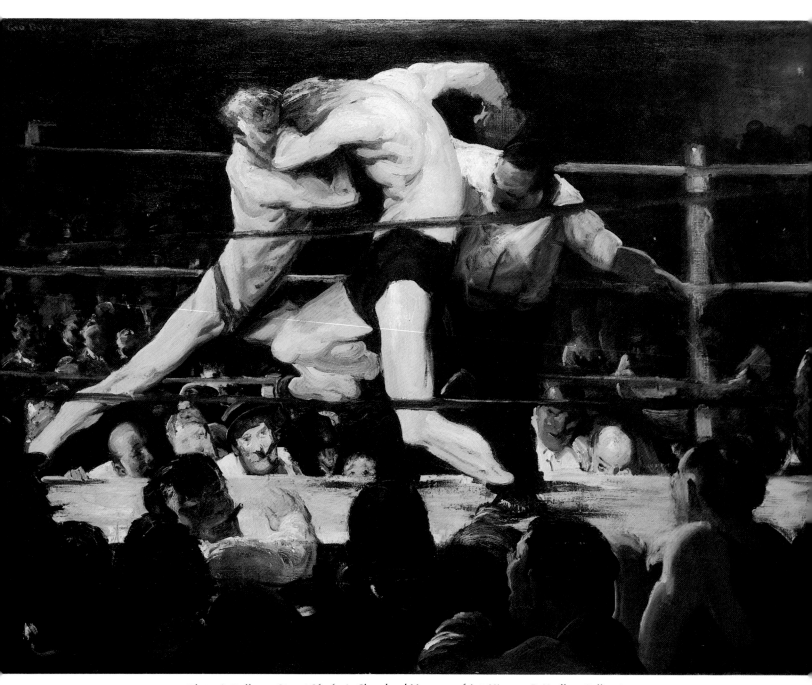

Plate 4. Bellows, *Stag at Sharkey's*, Cleveland Museum of Art, Hinman B. Hurlbut Collection
(cat. no. 2)

Bellows' Boxing Pictures and the American Tradition

John Wilmerding

The assertive boxing images of George Bellows have long had an interest in their own right as one of the central and recurring themes in his career. They were among his most popular pictures in his lifetime and have remained compelling for audiences to this day. His reputation as an artist perhaps resides most familiarly in this series. Of all his subjects this best embodies his respective talents as a passionate observer of sports and as a bold recorder of individual human figures. But these works, so much a part of his career and his period, may also be viewed against the broader background of sporting themes treated periodically throughout the earlier history of American art. Bellows at once updates and transforms this tradition with his own forceful personality.

Subjects of sport and games belong within the larger context of the American out-of-doors as a natural setting for vigorous exercise or sociable relaxation. Americans from the beginning thought of their landscape as a benign new world and a predestined place of strength and beauty. Whether engaged in exploration, settlement, self-preservation, or spiritual renewal, Americans felt at home in their geography to the extent that, for much of the nineteenth century at least, nature came largely to define the national identity. Genre themes depicting the commonplace activities of everyday life and the shared experiences of the ordinary citizen did not become popular until the first quarter of the nineteenth century, when leisure time was increasingly available. Before then, the necessities of survival in the colonial world, the all-consuming drama of the revolutionary war, and the struggles to make a new nation work in the federal period focused artists' talents on the practicalities of executing portraits for posterity and recording the features and historic actions of the Republic's founding figures.

A few early genre paintings of importance are known, among the most engaging being *Sea Captains Carousing in Surinam*, painted by John Greenwood around 1758 (The St. Louis Art Museum). While related to the colonial wish for recording individual likenesses, this is less a group portrait than a lighthearted caricature of figures indulging themselves in an exotic adventure. Such themes of collective pleasure were rare in the colonial period, and only at the end of the eighteenth century do artists begin to paint them, as well as more specific gaming images, more frequently. Typical are Jeremiah Paul's *Four Children Playing in a Courtyard*, 1795 (private collection), and the spirited winter panoramas in New York City painted by Francis Guy. His *Tontine Coffee House* of 1797 (The New-York Historical Society) and *Winter Scene in Brooklyn*, c. 1817-1820 (fig. 1), depict lively vistas of the busy urban streets and architectural facades of that day. These follow in the tradition of early Flemish painting, particularly the sweeping village views packed with children and peasants done by Pieter Bruegel the Elder in the 1560s. Although Bruegel's themes were primarily religious and allegorical, he did set them in familiar contemporary and local surroundings. Guy's canvases are more typically American in their straightforward delight in recording, without any philosophical underpinnings, the daily pursuits of pleasure and industry among the citizenry. These are topographical in delineating not just the growing townscape of the young Republic but also the comfortable and self-possessed presence of people in their environment.

This easygoing accommodation of man and environment finds one of its fullest expressions in the pastoral vignettes which preoccupied many American artists during the middle third of the nineteenth century, as they began to chronicle more aspects of both their natural surroundings and their everyday affairs. Games were but one activity which took place in this benevolent world of rich harvests, agreeable climate, and pleasing geographical features. Henry Inman, a characteristic painter in this period, captures

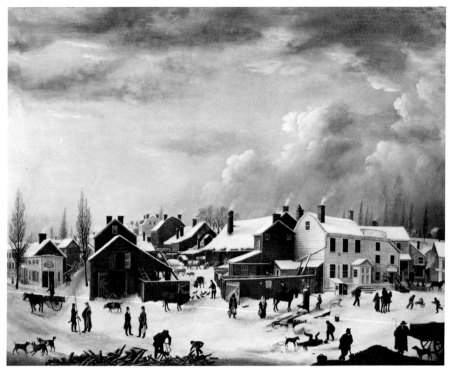

1. Francis Guy (American, 1760-1820), *Winter Scene in Brooklyn*, c. 1817-1820, The Brooklyn Museum, Gift of the Brooklyn Institute of Arts and Sciences

its essential spirit in *Mumble the Peg*, 1842 (fig. 2). The game depicted is more a pleasant pastime than a vigorous sport and is appropriately rendered in bright colors and gentle curves. The concentration on two youths is but a part of the larger American sense of the nation's presence in the morning of life. Not surprisingly, at this same time Thomas Cole's series *The Voyage of Life* was enjoying enormous popularity, with the second picture *Youth* especially inspiring untold numbers of copies by other artists. Thus, the game in this golden age of national promise mirrored an air of optimism and calm reflection.

Competition of another sort, along the coastal waterways and on the open oceans, also provides an index of the period's high spirits. During the 1840s the design and manufacture of the great clipper

2. Henry Inman (American, 1801-1846), *Mumble the Peg*, 1842, Pennsylvania Academy of the Fine Arts, Philadelphia, Bequest of Henry C. Carey

ships led to races for the Pacific trade, testing American ingenuity and marrying practicality with remarkable beauty of form. In 1851 the establishment of the America's Cup signified the new challenge of international yacht racing. Thomas Buttersworth, an emigré from England, devoted much of his later career to documenting the dramatic scenes of these graceful vessels maneuvering at sea. Also known as an accomplished marine painter, his contemporary Fitz Hugh Lane painted a particularly colorful canvas of the first challenge, *The Yacht "America" Winning the International Race*, 1851 (fig. 3). Appropriately, the artist sees the triumph taking place on moderate seas under sunny skies and fair-weather clouds. Lane's delineation is crisp and solid; his composition is orderly and spacious, filled with a literal and implied radiance which would come to dominate the so-called luminist paintings of his mature career. Though an image of more formalized sports than is Inman's playing children, this, too, belongs to a moment of exuberant prosperity, when the nation held command of the seas and individuals had the wealth to build and sail pleasure yachts.

Gaming in the imagery of this period was ordinarily a gentlemanly activity, hardly one of combat or violence. Even such sports as fishing and shooting were typically depicted by A. F. Tait and others as merely hearty pursuits of men at ease in their surroundings. One of the games most often treated by American artists at mid-century and perhaps most representative of these sociable avocations was card playing. It was an occasion for both individual contest, as two figures faced each other with a deck of cards, and shared experience, as others gathered around with differ-

ent degrees of interest. Between about 1840 and 1870 the subject engaged artists as varied as Richard Caton Woodville, William Sidney Mount, Albertus D. O. Browere, Eastman Johnson, John Rogers, Thomas Anshutz, and George Caleb Bingham. The last used a simple pyramidal composition for several related pictures, *The Checker Players* (1850) and *Raftsmen Playing Cards* (fig. 4), also known in a smaller version. The simple design, basic primary colors, and solid geometries of his figures contribute to a stable, earthy image of rugged frontiersmen at one with the wilderness setting made placid by the limpid light. Bingham conveys the sense of an orderly world through his balanced forms and equilibrium of men and landscape. The facing cardplayers seem less a confrontation than union of opposites. The combination of two combatants, surrounding onlookers, and a circumscribed arena sets an appropriate precedent for Bellows' indoor scenes of a half century later.

During the second half of the nineteenth century boxing subjects begin to interest painters and illustrators. Often these were the work of nonacademic folk artists taking delight in depicting a popular community activity, as is the case with *Bare Knuckles* by George A. Hayes (fig. 5). The carefully patterned rhythms of forms and the even placement of figures attest to the naive painter's heightened instincts for expressive two-dimensional design. In its conscious posing of the boxers, the tiered arrangement of the observers, and the outdoor setting above all, this painting belongs more to the classic, timeless spirit of Bingham's pictures than to the intense, dynamic immediacy of Bellows' vision. Yet, the anecdotal character of *Bare Knuckles* and the theme's interest for the un-

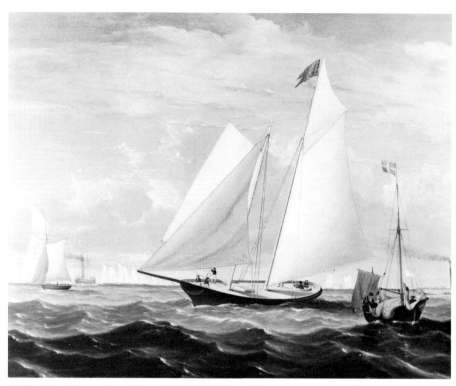

3. Fitz Hugh Lane (American, 1804-1865), *The Yacht "America" Winning the International Race*, 1851, Peabody Museum, Salem, Mass. (photo by Mark Sexton)

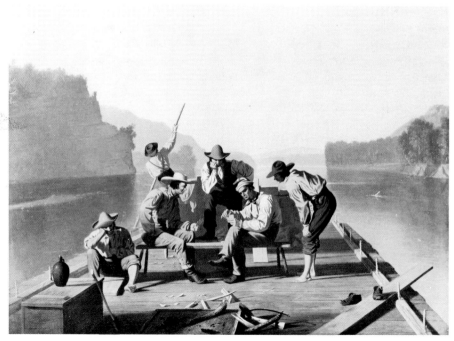

4. George Caleb Bingham (American, 1811-1879), *Raftsmen Playing Cards*, 1847, The St. Louis Art Museum, Ezra H. Linley Fund

15

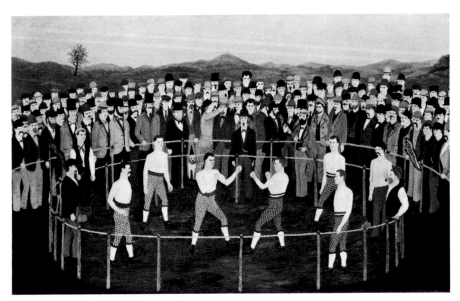

5. George A. Hayes (American, 1854-1934), *Bare Knuckles*, c. 1870-1885, National Gallery of Art, Washington, D.C., Gift of Edgar William and Bernice Chrysler Garbisch, 1980

trained artist suggest the broadening popularity of the subject. In this regard the boxing match as an ordinary genre subject would very much be an element adopted by the ash can school and by Bellows in the early twentieth century.

This kind of generalized narrative image was one which gained broader familiarity through popular illustrations, especially chromolithographs. Undoubtedly one of the most accomplished and widely known firms producing such sporting prints through the later nineteenth century was that of Currier and Ives. They issued prints in a full range of categories, including fishing and trapping, hunting, cock fighting, billiard and card playing, rowing, and baseball. Some of these simply illustrated the adventurous spirit of camping and hunting, others the particular details of different competitive sports. Even in other subjects depicted by the firm's artists one finds a related interest in themes of challenge and adventure, whether the races of sidewheelers

on the Mississippi or of locomotives crossing the plains.

Among the other miscellaneous sports which Currier and Ives illustrated less frequently in lithographs was boxing. Paired combatants in a boxing ring appeared in both humorous political caricatures and documentary prints of championship fights. Among the former were a number published in the years after the Civil War, depicting the battle between the States as a contest between the respective forces of good and evil, personified by Lincoln and Jefferson Davis. At the same time the firm began to issue prints portraying the major boxers of the day in England and America. In two lithographs published side by side on a page *Tom Sayers Champion of England* and *John Morressey* assume contrasting poses in outdoor boxing rings, a juxtaposition meant to suggest their pairing rather than the actual meeting. Sayers faces off in another fight of 1860, as seen in an image probably lithographed shortly thereafter, *The Great Fight for the*

Championship between John C. Heenan and Tom Sayers of England (fig. 6). Here the two meet in the ring on 17 April 1860, when (in the words of the caption details) "the Battle lasted 2 hours 20 minutes, 42 rounds, when the mob rushed in and ended the fight."

This type of commemorative print experienced relatively wide circulation and ultimately entered the popular consciousness as a commonplace replicated image. The successor to the multiple prints sold by Currier and Ives was the magazine or newspaper illustration, as may be seen in *James J. Corbett and Robert Fitzsimmons* reproduced in the *Police Gazette* of 15 December 1894 (fig. 7). While the setting is no longer explicitly out-of-doors as in previous depictions, it remains vague and generalized, with the figures assuming classic fixed poses. While Bellows would draw on this graphic tradition, especially through his association with ash can colleagues who were trained as newspaper illustrators, he would bring to the iconography a new vitality of interpretation, composition, and style.

Instead of the commemorative and ceremonial elements of the subject, Bellows sought to record the dynamics of the moment, the immediacy of action, and the contending physical forces in a densely packed arena. Moreover, Bellows would alter the spectator's view from one of aesthetic observer to that of embroiled participant. These new psychological and physical sensations were in part the result of artistic considerations which came to preoccupy many painters at the turn of the century. To appreciate fully this transformation in American art over the later decades of the nineteenth century, we need to follow the stylistic changes which took place in the major currents of real-

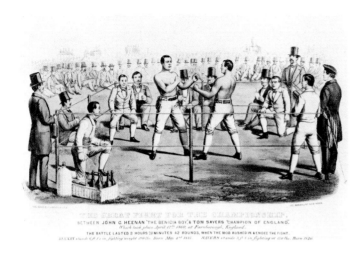

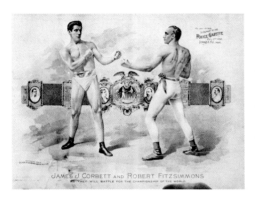

on a sunny day is a benevolent activity in a gentle outdoor setting, all befitting the country's sense of identity. But Homer's career carried through the end of the century, and his outlook became graver and more philosophical in later decades, as the nation experienced the new pressures of expansion, regionalism, technological and industrial development, and international relations. Homer's love of the out-of-doors, the experiences of nature in different seasons and weather, and the enjoyment of hunting and fishing trips are directly reflected in all periods of his career.

But there is a marked transition in his attitude about these subjects, especially during the 1880s. From the lighthearted tone and reportorial manner of *Snap the Whip* and such companion works of the seventies as *Breezing Up* (National Gallery of Art) Homer moved toward an increasing starkness of design and content in his subsequent paintings.

Top left: 6. Currier & Ives (American, firm active 1835-1907), *The Great Fight for the Championship between John C. Heenan and Tom Sayers of England*, after 1860, Museum of the City of New York, The Harry T. Peters Collection

Bottom left: 7. Unknown American School, *James J. Corbett and Robert Fitzsimmons*, 1894, Ring Magazine

ism. In particular, a summary glance at the work of Winslow Homer and Thomas Eakins will sharpen our perspective on Bellows' place in this tradition.

Possibly more than any other American painter, Homer exemplifies the national fervor for the out-of-doors, youthful leisure, and physical exercise. *Snap the Whip*, 1872 (fig. 8), is one of the most familiar and appealing works of his early career, rooted in the mood of optimism and well-being we have already noted in Bingham's painting (see fig. 4). Homer's own apprenticeship as a graphic artist and emerging career as an observer of domestic life in post-Civil War America grounded his work in the lively genre precedents flourishing at mid-century.

An improvised game among boys

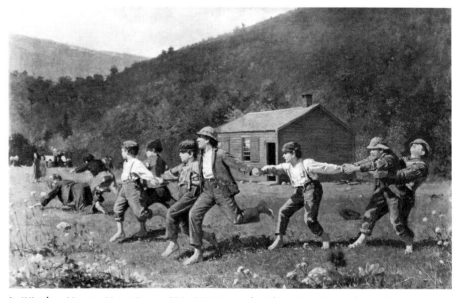

8. Winslow Homer (American, 1836-1910), *Snap the Whip*, 1872, The Butler Institute of American Art, Youngstown, Ohio

Right and Left, 1909 (fig. 9), represents the culmination of his career and of the change in his late style. Still regularly taking fishing and hunting trips in these years, to Canada and the Adirondacks during the autumn and Florida or the Caribbean in the winter, Homer continued to bring first-hand knowledge and observation to his subjects. Shooting ducks and geese were familiar activities to him and his friends along the coast of Prouts Neck, Maine, where this striking canvas was conceived. But this is an image quite distant from the carefree innocence and the celebration of youth in his earlier paintings of boys at play. Now Homer's composition is more abstract, his palette more severe, in keeping with the mortal drama forced directly on the viewer. This sporting scene bears a disturbing seriousness of meaning and feeling. As a painting actually of the twentieth century, it gives a hint of the modern world's questions about survival and life in the balance.

Homer's contemporary Thomas Eakins also brought his later art to a comparable level of heroic realism. In contrast to Homer's Yankee restraint and self-imposed seclusion on the Maine coast, Eakins lived most of his life in genteel Philadelphia, trained in its academy and familiar with the beaux-arts traditions of cosmopolitan Europe. But he, too, loved sports and outdoor exercise, and the rigors of athletics provided Eakins with a consciousness of discipline which infused both his early and late sporting scenes. In another parallel to Homer, Eakins moved from indoor and outdoor genre scenes of direct factual observation to increasingly contemplative and psychologically charged depictions of the human presence.

Eakins took great pleasure in sailing with friends on the Delaware

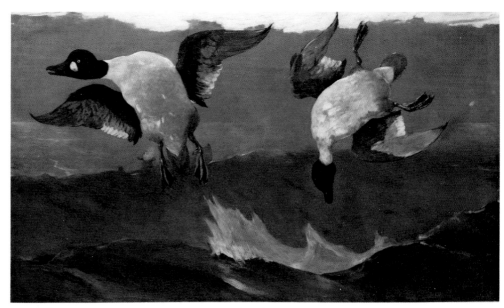

9. Winslow Homer (American, 1836-1910), *Right and Left*, 1909, National Gallery of Art, Washington, D.C., Gift of the Avalon Foundation, 1951

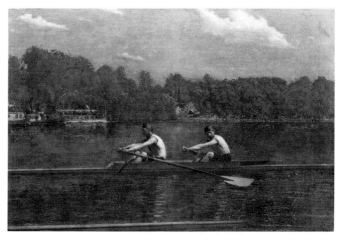

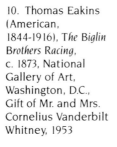

10. Thomas Eakins (American, 1844-1916), *The Biglin Brothers Racing*, c. 1873, National Gallery of Art, Washington, D.C., Gift of Mr. and Mrs. Cornelius Vanderbilt Whitney, 1953

River, sculling alone on the Schuylkill, and hunting railbirds with his father in the nearby marshes. He commemorated all of these activities under sharp sunlight in several canvases of the 1870s. Typical is *The Biglin Brothers Racing* (fig. 10) in which we see Eakins' training in mathematics, perspective, and anatomy fused to achieve a spatial design of total clarity, order, and integration. Usually Eakins' figures compete less against each other than against the

abstractions of time and change. It is a vision unmistakably tempered by ideas of contemporary science, whether the insights of modern medicine or recent developments in still photography. Beyond describing a familiar sporting pleasure, Eakins also addresses relationships in his pictures, that is, the connections of individuals to each other and the place of people in their environment. In a perfect way, then, the clear mathematics of his linear

constructions complement the coordination, rhythm, and equilibrium his oarsmen must bring to their pursuit. He shows the organic machinery of the body functioning efficiently both within itself and in relation to the surrounding physics of nature.

Although Eakins' rowing paintings suggest a more scientific realism than we have seen in Homer, *The Biglin Brothers Racing* stands firmly in the existing American traditions of lively genre and plein-air landscape subjects. When Eakins took up athletic themes again at the end of his career, he had shifted his attention indoors. Around the turn of the century he completed a series of major boxing pictures, which are the precedents most frequently cited for Bellows' examples a decade later. Though there are smaller related oil studies, three large canvases form a trilogy devoted to the prowess, exertion, and vitality necessary for the sport. *Salutat* (fig. 11) is the most classical and traditional in its allusions, with the victorious boxer acknowledging his triumph as he leaves the ring. His poised stance in the arena recalls that of a Roman gladiator, while his fine physique is indebted to life studies of anatomy from the drawing classes taught by Eakins' French master Jean Léon Gérôme. The cheering spectators are more involved observers than those rendered in previous boxing scenes (figs. 5 and 6) and look forward to Bellows' animated audiences. Yet Eakins always remains the scrutinizing portraitist, and along with the subtle differences in physiognomy, he seeks to record the range in human responses, just as he had in his great medical arena paintings. Bellows might occasionally give a clue to identify a specific figure at ringside, but usually he preferred to generalize his audience as a

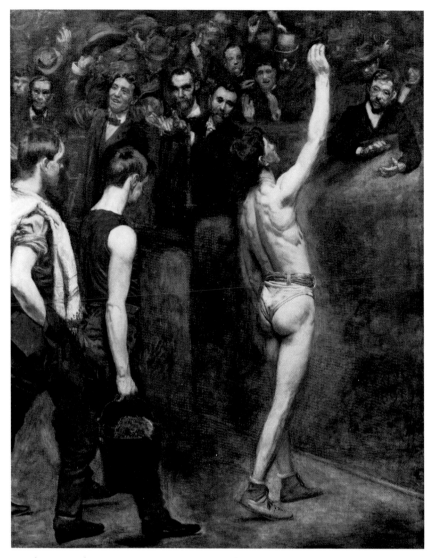

11. Thomas Eakins (American, 1844-1916), *Salutat*, 1898, Addison Gallery of American Art, Phillips Academy, Andover, Mass.

turbulent enveloping mass.

The most important fact about Eakins' series is that it shows almost no action. For him the boxing arena is a place for complex human interactions, as much psychological as physical. To this end in both *Taking the Count* and *Between Rounds* (figs. 12 and 13) large colorful banners of circus stars hang from the balconies in the background; they are artificial images of performers contrasting with the boxers actually before us.

The referee, attendants, and crowds behind bring other degrees of engagement to the match, each with his own imperatives of concern and response. As both titles confirm, the moments shown are those between the bursts of action, not the apex of action itself. In one a boxer knocked down awaits a mandatory count, while in the other a fighter rests in his corner. We sense that each is thinking about going back into combat, but for now we join the pictorial

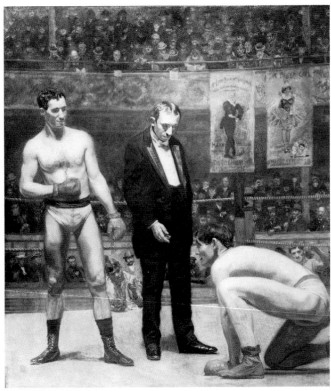

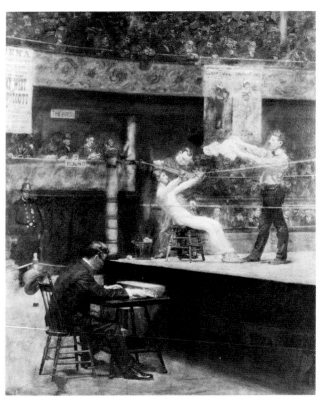

12. Thomas Eakins (American, 1844-1916), *Taking the Count*, 1899, Yale University Art Gallery, New Haven, Conn., Whitney Collection of Sporting Art, given in memory of Harry Payne Whitney by Francis P. Garvan

13. Thomas Eakins (American, 1844-1916), *Between Rounds*, 1899, Philadelphia Museum of Art, given by Mrs. Thomas Eakins and Miss Mary A. Williams

viewers across the ring in marking time's passage. Below both platforms are men keeping track of the two different intervals, each a rest period of fixed duration. In part Eakins is examining sequential aspects in the ceremony of this sport, the marshalling of one's energy and thoughts as one contemplates victory or defeat. His sense of drama and his vigorous realism in the powerful rendering of human form set the stage for Bellows' efforts. But the younger artist will crucially replace this cerebral tension with a physical energy he and his colleagues enthusiastically believed was at the heart of the new century.

As we have seen in his rowing paintings, Eakins did have some interest in depicting figures in motion, and this concern reappeared in occasional later works such as The

Swimming Hole, 1883 (Fort Worth Art Museum). During this period he had begun to correspond with Eadweard Muybridge about the latter's experiments with motion photography. Eakins himself actively made use of the camera in his later career, photographing the human figure, as did Muybridge, in sequential stages of certain motions or activities. When in his paintings he adapted the poses he had caught with the camera, the figure seemed isolated in a stilled and clarified moment. Eakins' attention to psychological presence led him to pursue photography largely as a means for portraiture. By contrast, Muybridge undertook a massive compilation of serial action photographs of humans and animals, which he published beginning in 1887 in several folio volumes under the title *Animal Locomotion*. Plate

336 shows *Men Boxing, Open Hand* (fig. 14), and here we come much closer to Bellows and modern ideas of spontaneous dramatic action. In this regard the camera's ability to freeze an unexpected moment, an awkward or unposed gesture, reveals a strain and excitement which Bellows would similarly seek to capture in paint.

Bellows' work, then, comes at the confluence of several elements in earlier American art: the inherent love of narrative in the genre tradition, the Eakins style of direct recording and strong realism, the broad impact of popular illustration, and the sense of immediacy made possible by photography. But Bellows' subjects and manner of handling paint also reflect the collective aspirations of his own generation. His thick impastos, ex-

pressive contrasts of light and dark, close-in viewpoints, and involvement of the spectator are all aspects of his friends' work and occasioned the collective title of ash can school. Flourishing in New York in the first decade of the twentieth century, this group consciously chose as their modern landscape not the countryside but the back streets and lowerclass gathering places of the city. The bright delicate scenes of the impressionists and The Ten were too nostalgic and pretty for these younger painters; only in the city of growing skyscrapers, throngs of immigrants, and densely packed streets were to be found the new energies of the day.

Some of the older painters whom Bellows joined under the ash can rubric were already members of The Eight, a loose association of friends who practiced very different styles of art but who were commonly devoted to asserting new subjects and styles for their generation. Under

the leadership of Arthur B. Davies, they organized the notorious Armory Show of 1913, a turning point in breaching entrenched aesthetic conservatism in America. During this period several artists turned to confront the implications of avantgarde abstraction; others were given the ash can label for promoting their commonplace urban subjects and manner of bold realism. Bellows did not formally participate in the causes of The Eight, being almost a generation younger than its leaders (he was born in 1882; Robert Henri, the foremost teacher of his time, was born in 1865). Henri was a charismatic personality and instructor. When Bellows arrived in New York from Columbus, Ohio, in 1904, the older man befriended him and drew Bellows into this artistic circle.

Henri himself had been enrolled at the Pennsylvania Academy and had studied with Thomas Anshutz, Eakins' most able student and assistant. After a period of experimen-

tation with impressionism, at the end of the 1890s Henri returned to a style of dark tonalities and broad handling. Inspiration for this manner came from the seventeenth-century masters Diego Velázquez and Frans Hals and the mid-nineteenth-century precedents of Edouard Manet. Also, at the turn of the century, Henri met and received support from William Merritt Chase, who had himself studied in Munich during the early 1870s. There Chase had had his own exposure to Hals and Velázquez as their work was revived in the modern styles of Courbet and the German Wilhelm Leibl. Although Chase later went on to evolve a more impressionistic mode of painting, he did reinforce Henri's turn to a tonal bravura. After 1900 Henri taught in Chase's New York School of Art and thus became an important artistic link in the tradition of dark realism inherited from the seventeenth century, reinterpreted by the nineteenth, and transmitted to the work of the young painters of the early twentieth.

The other colleagues who joined Henri in New York — George Luks, John Sloan, William Glackens, and Everett Shinn — had begun their careers as newspaper artists in Philadelphia, dashing off on-the-spot drawings of people and activities seen first-hand in the streets around town. Thus, the joined lineage of realism and reportage descended directly into Bellows' immediate circle of associates. Some became known for portraits of humble workers, immigrants, and orphans; others for depictions of life in the city parks, cafés, and waterfront docks. In just a sampling of their subjects we can see those themes which became a shared language for the group, including Bellows. George Luks' *The Wrestlers*, 1905 (fig. 15), presents the imagery of a vigorous masculine

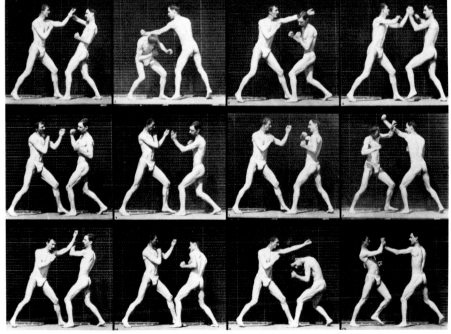

14. Eadweard Muybridge (American, 1830-1904), *Men Boxing, Open Hand*, 1887, The Library of Congress, Washington, D.C.

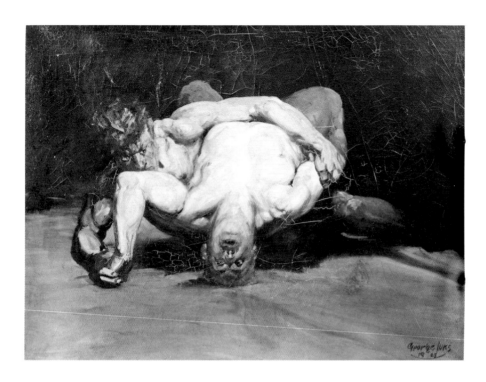

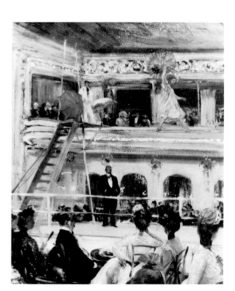

world and a sport of strenuous physical combat. It is a precedent particularly striking in relation to Bellows' boxing pictures which follow a couple of years later. Our view is almost at ground level and close to the two men locked together in maximum tension. Luks' paint strokes are broad and energetic; his figures are spotlighted in a rugged silhouette within the surrounding dense black.

When these men were not visiting athletic clubs for subjects, they sought similar entertainment in cafés, nightclubs, and circus arenas. From the same period date Shinn's *Theater Box* and Glackens' *Hammerstein's Roof Garden* (figs. 16 and 17), while simultaneously Stanford White was designing perhaps the city's most famous palace of pleasure, the original Madison Square Garden. The packed crowds, front-row view, artificial lighting, and excitement of performance were basic ingredients of such ash can pictures, whether the audience was upper crust or

working class. The cropped or odd angle of vision, blurring of forms, and vigorous execution only enhanced a sense of immediacy and of the physical interaction between spectators and performers.

Studying with Henri and aligning himself with the social concerns of Luks and Sloan, Bellows naturally adopted themes of the masses at work and play. He, too, loved the filled arena and press of bodies. Coming from the midwest and later spending vacations on Monhegan Island, Maine, and in upstate Woodstock, New York, Bellows always derived pleasure from the rugged natural landscape. To the end of his career he concurrently painted indoor and outdoor scenes, often with strikingly similar modes of composition. However, alone among his colleagues, he had been a professional athlete and had loved sports from early youth. He played basketball and baseball first in high school and then at Ohio State. During his upperclass years he played on a

semiprofessional baseball team, earning the nickname "Phenomenon of Ohio State" and leading to an invitation to join the Cincinnati Reds. His love of sketching began equally early, and by the time he decided to

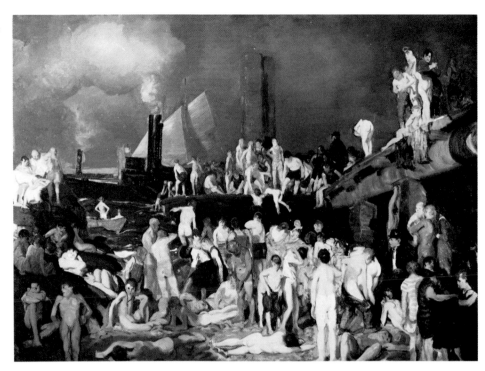

19. Bellows, *Riverfront No. 1*, 1915, Columbus Museum of Art, Ohio, Howald Fund

foresake the confines of home for New York, he was able, in recording events, to enjoy the roles of both observer and participant.

His two sets of boxing pictures serve as brackets around his mature career, and in examining briefly other scenes preoccupying him during the teens and twenties, we come to note how consistently he approached a diversity of subjects. Indeed, despite the singular force and unity of the boxing suite, seeing it in context makes us realize how much Bellows enjoyed the spatial expanse of the arena, using this device as well for many of his landscapes, whether set under natural or artificial light. The spirit of entertainment, the physical exuberance, and the emotional fusing of a crowd found in the boxing pictures are also apparent in Bellows' paintings of political and recreational gatherings like *The Sawdust Trail* and *Riverfront No. 1* (figs. 18 and 19). In the first we stand at eye level with the platform, while in the second strong diagonals

and tonal contrasts animate the riverside enclave.

Of course, not all his works are composed in this way, though Bellows did employ the device of contesting figures within a defined enclosure with striking consistency. As might be expected, he undertook paintings of several sporting subjects, including fishing, polo, and tennis (and excluding baseball). Both polo and tennis were more genteel than the gritty activities he witnessed in the boxing clubs of New York, but he brought to them all a similar focused energy, spotlit drama, and broad brushwork. Consider *Polo at Lakewood*, 1910, or *Tennis Tournament, Woodstock, New York, June 1920* painted ten years later (figs. 20 and 21): though given relatively spacious settings under turbulent skies, they show the different sportsmen at straining intensity, confined within the marked edges, respectively, of the polo field and tennis court. These rectangles of landscape, circumscribed by patterns of

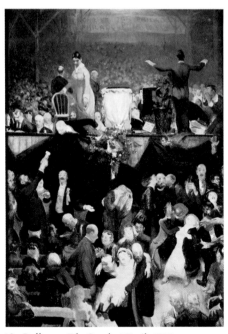

18. Bellows, *The Sawdust Trail*, 1916, Milwaukee Art Museum, Layton Collection

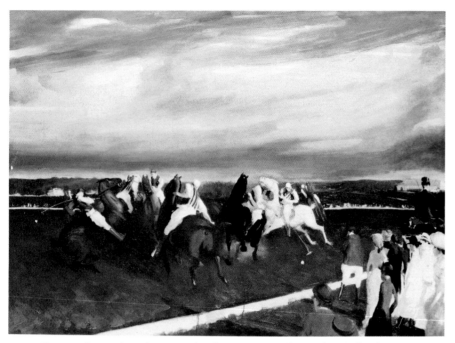

20. Bellows, *Polo at Lakewood*, 1910, Columbus Museum of Art, Ohio, Columbus Art Association Purchase

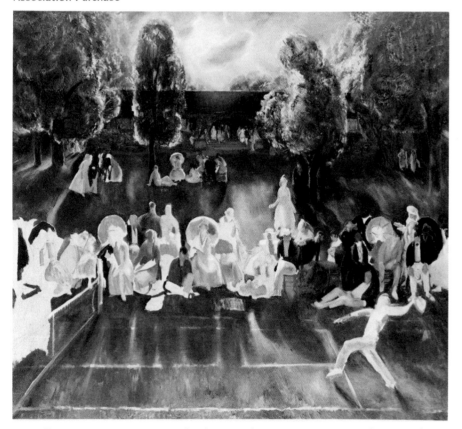

21. Bellows, *Tennis Tournament, Woodstock, New York, June 1920*, 1920, Mr. and Mrs. Paul Mellon, Upperville, Virginia

lines and the forms of spectators, readily translate into the platform and ropes of Bellows' boxing rings, which acquire additional visual force through the dark compression of their indoor nighttime settings.

Thus, it appears that Bellows' boxing paintings combine to maximum effect his pictorial methods, at once drawing on an approach to composition he often used elsewhere and contributing something of their stylistic force to many of his other subjects. Even in pictures with little or no human presence and no relation to sports we can see how concerned Bellows remains with composing and handling paint for powerful expressive purposes. Significantly, in 1909, the same year he completed one of his first great boxing canvases, *Both Members of This Club* (fig. 29), he painted *Blue Morning* (fig. 22). Contrasts of light and shadow, foreground lines and background masses again set off a pyramid of straining figures at the center. In its bold gestures of paint, suggestion of observers and laborers, and above all lines of fence and iron structure, we observe another urban arena of dynamic activity.

A few years later, after his first summers on Monhegan Island, Maine, Bellows began to produce a number of small oil studies of surf crashing on the rocky cliffs. Not since the monumental late seascapes of Winslow Homer in the previous two decades (see fig. 9) had an American artist attained such expressive capacity with the manipulation and texture of paint. Small panels like *Churn and Break* (fig. 23) have all the freshness and immediacy of on-the-spot observation, yet they are by no means records of confused spontaneity. These generalized forms struggle toward an effective composition, as we recognize Bellows' penchant for contrasting

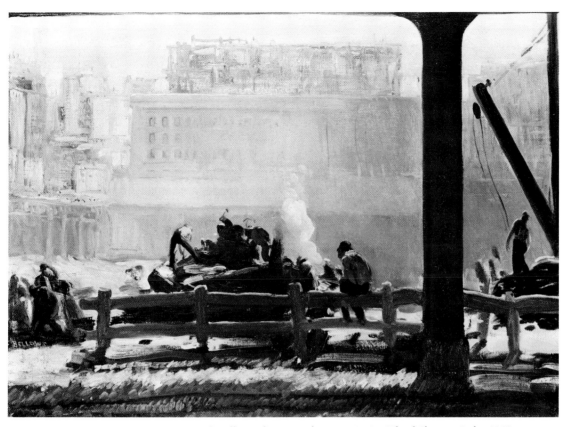

22. Bellows, *Blue Morning*, 1909, National Gallery of Art, Washington, D.C., Gift of Chester Dale, 1962

verticals, horizontals, and diagonals. As in his boxing rings, contesting forces strike one another, here water against rock, light and liquid against dark and solid. Even the turbulent foreground serves as a palpable platform for the viewer as implied witness of the ferocious battle at center stage. Most of all, corporeal paint conveys a spirit of the here and now which is Bellows' special accomplishment. For as we turn back to concentrate on the boxing paintings themselves, we are soon aware of his ability to use paint to record both what he saw and what he felt. With all his best works — and the boxing group may be posed as a summary achievement — the literal paint describes fact, in a conventional sense, at the same time that it carries subjective energies, in a much more modern sense.

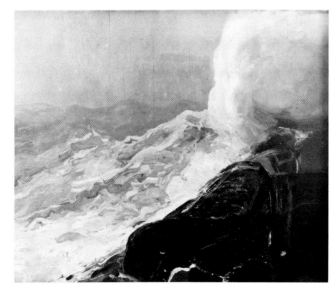

23. Bellows, *Churn and Break*, 1913, Columbus Museum of Art, Ohio, Gift of Mrs. Edward Powell

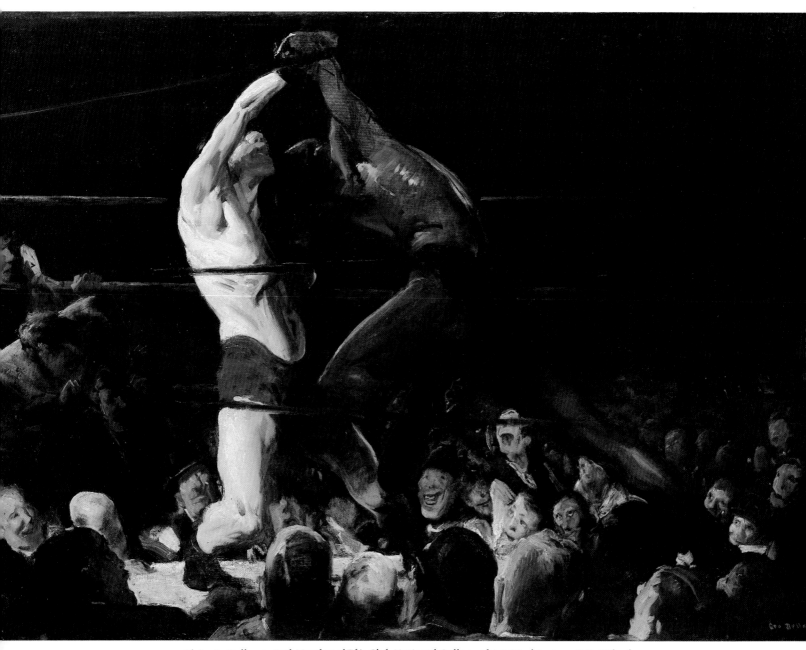

Plate 5. Bellows, *Both Members of This Club*, National Gallery of Art, Washington, D.C., Gift of
Chester Dale, 1944 (cat. no. 3)

Bellows: The Boxing Paintings

E. A. Carmean, Jr.

If you're a fight fan it's worth visiting the National Gallery of Art just to see George Bellows' painting 'Both Members of This Club.' Never been anything like it done in oils and you'll get a kick out of its brutal contrast to the long-hair arty stuff hung near it.

Bob McLean's sports column
Times-Herald, New York, 31 March 1947

George Bellows' best-known works are his boxing paintings. Their subject is a rare one in the history of art, and Bellows' modern presentation of it makes them virtually unique in twentieth-century painting. Interestingly, they have long been held in high regard. When the initial boxing painting, now in the John Hay Whitney Collection (fig. 25), was exhibited in 1908, it prompted Bellows' first important critical notice in the press. Two years later he included the second canvas, now at Cleveland (fig. 28), in the Independent Artists Exhibition, the show of American realist art which caused a near riot at its opening. The *New York American* featured the painting as the principal illustration in its coverage of the "panic." The third boxing oil, *Both Members of This Club* (fig. 29) received even wider attention in 1913, when it was reproduced as a double-page spread in *Harper's Weekly*.[1] Bellows was only thirty years old at the time.

In the early 1910s the artist was also gaining notice for his graphic work on boxing subjects, through drawings made for reproduction in magazines and through his boxing lithographs, which he began in 1916. By the two years before his death in 1925, the appearance of a Bellows painting of a prize fight had become a "highly awaited" event.[2] This appreciation increased in the two decades following Bellows' death,

leading to his description as "the greatest painter of this phase of our life."[3] Another thirty-five years has not altered this view, and the boxing paintings remain among the most highly prized works of his generation. Interestingly, they are also appreciated as almost pure images of early modern boxing, acceptable apart from the conventions of fine art (see the introductory quotation above).[4]

Given this extraordinary recognition, one is surprised to discover the existence of only six boxing paintings by Bellows. Furthermore, only two of these works can actually be called "famous," *Stag at Sharkey's* and *Both Members of This Club*, which have been on public view in Cleveland and Washington for many years and which have often been reproduced. The other early oil, *Club Night*, has long been in a private collection and appears less frequently as an illustration. These three early paintings form a trio of works which are related chronologically and stylistically. This grouping is paralleled by that of the three later paintings, which are also formally or thematically akin, *Introducing John L. Sullivan, Ringside Seats*, and *Dempsey and Firpo* (figs. 34, 36, and 44). Of these 1923-1924 paintings, only the Whitney Museum's *Dempsey and Firpo* has been on regular public exhibition.

The boxing scenes are the domi-

nant sports images in Bellows' work although other sports subjects appear, including football, baseball, tennis, polo, and golf. Bellows' interest in these themes is not surprising, as he was also an athlete. Born one hundred years ago in Columbus, Ohio, he grew up in this midwestern environment. He played baseball and basketball as a schoolboy and became a basketball star when he reached his height of six feet, two inches. He continued both sports at Ohio State University, playing successfully enough to be sought after by the Cincinnati Reds professional baseball team during his senior year. But Bellows rejected their offer in order to pursue a career as an artist.[5]

To further this ambition, Bellows moved to New York in 1904 and enrolled in the New York School of Art. There he had the good fortune to be assigned to Robert Henri, which not only gave him the benefit of excellent teaching but also brought him into direct contact with the emerging realist movement, then developing under Henri's guidance. Realism in America would eventually center in 1908 around a group of artists called The Eight, including Henri and four of his friends and students from his earlier days in Philadelphia: John Sloan, William Glackens, Everett Shinn, and George Luks. Although Bellows' work germinated — and rapidly — within the realist

movement, neither he nor his student colleagues, such as Edward Hopper and Rockwell Kent, was made a part of The Eight. However, unlike his student friends, Bellows had extraordinary success with *Club Night* in 1908, which was sufficient to make him the youngest of the realist artists then beginning to gain public attention.

Henri maintained that painting must depict the life of the city with an unedited directness. In taking this stance he placed realism against the dominant, academic style, which favored either the allegorical or the saccharine view of American life. In emphasizing their contrasting aesthetic, Henri and his colleagues painted all aspects of urban existence and treated each subject with the same dispassionate method.

Sharkey's

To some degree, the realists were like the French impressionists in basing their work on subjects observed in everyday life. But where

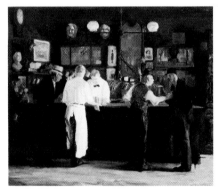

24. John Sloan (American, 1871-1951), *Mc-Sorley's Bar*, 1912, The Detroit Institute of Arts

the impressionists painted the gay Parisian café or a boating party on the Seine, in American canvases the subject became the alley, the neighborhood bar, or the Manhattan ferry

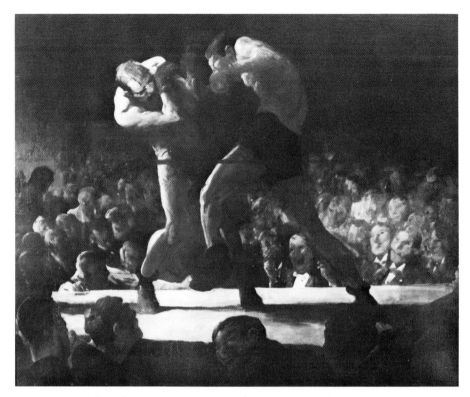

25. Bellows, *Club Night*, 1907, Mrs. John Hay Whitney (cat. no. 1)

boat (fig. 24). Bellows worked in this manner and painted many similar realist subjects, but his most important thematic choice was the boxing ring. In July of 1907 he made his first boxing work, the rather highly finished drawing entitled *The Knock Out* (fig. 52). In keeping with realist procedures, this sheet was based on Bellows' experiences at Sharkey's, a boxing bar located almost directly across the street from his studio.[6]

The Knock Out is largely anecdotal in character and correspondingly illustrational in style. The moment shown is the climactic one of the match, with the loser sprawled across the canvas and the referee restraining the victor. This focus on the story, rather than the scene, also is evident in the crowd where Bellows exaggerated certain spectators and their emphatic reactions. Because of these qualities, the strong-

est visual context for *The Knock Out* is not traditional American art but the contemporary world of newspaper sports illustration. Many of the realists had begun their careers as newspaper illustrators, and Luks was still engaged in newspaper work at this time.[7] Bellows had also worked in this genre during his student days in Ohio, so in *The Knock Out* he used these conventions with a personal knowledge.[8]

Chronology

As interesting as this early *Knock Out* drawing is, Bellows' major development of the theme emerges in the initial boxing paintings. For several years there has been some debate over which painting actually was Bellows' first oil on the subject, the John Hay Whitney *Club Night* (fig. 25, pl. 7) or the Cleveland Museum's

Stag at Sharkey's (fig. 28). Bellows kept a rather accurate journal of his works in which he recorded painting *Stag at Sharkey's* in August-September of 1907 and *Club Night* in August 1909. This dating also corresponds to the records of the 1908 exhibition, which lists *Stag at Sharkey's* as the work shown. On the basis of this information, the Cleveland picture has often been dated two years earlier than the John Hay Whitney canvas.

However, for reasons which are still unclear, sometime before or in 1921 Bellows switched the titles of these two paintings. Thus the Whitney oil was originally known as A *Stag at Sharkey's* and is the initial work from 1907; Cleveland's painting follows it by two years.[9] There are several factors which support this reassignment. The primary evidence is Bellows' journal, in which he not only listed titles but sometimes included a small sketch of each work. Intended as records rather than independent drawings, these images have never been published. The drawing for the 1907 *Stag at Sharkey's*, Bellows' catalogue number 47, makes it clear that the Whitney painting is that work, while the Cleveland oil corresponds to the sketch accompanying catalogue number 87, *Club Night*, which is dated 1909.

Bellows sought to copyright *Stag at Sharkey's* on 4 December 1908 and *Club Night* on 1 December 1909. Here the description of *Stag at Sharkey's* — "two prize fighters, one on the right lunges blow at crouching opponent on left" — again matches the imagery of the Whitney oil.[10] Furthermore, we know that the Cleveland painting continued to be called *Club Night* up to 1910, as its captioned reproduction in the *New York American* makes clear. However, given the longer tradition of using their present titles, we here refer to the Whit-

ney oil as *Club Night*, 1907, and to the Cleveland painting as *Stag at Sharkey's*, dating it "1909(?)" at Cleveland's request.[11]

Club Night

The Whitney painting's date of August-September 1907 places it only one month after Bellows' initial use of the subject in *The Knock Out*. Given such a short time, the differences between the two pictures are remarkable. Where *The Knock Out* is largely illustrational in style, *Club Night* is characterized by a heightened sense of realism, especially in its more direct presentation of the scene. This is a quality which it shares with the other early boxing paintings and which gives all three their particular expressive power.

In *The Knock Out* we look down on the foreground audience and onto the boxing ring's canvas floor, a perspective which provides considerable information about the activities in the ring. By contrast, in *Club Night* the point of view has been greatly lowered so it becomes that of the foreground audience, looking upward toward the fighters. This more realistic attitude extends to the inclusion of the ropes which enclose the ring on the near side.

Bellows also reduced the size of the foreground group in *Club Night* and made the members more anonymous, save for the figure looking outward from the picture. But even this character, who is drawn from *The Knock Out*, loses his caricatured smile and gesturing hand. A similar decrease in detail is also noticeable in the background audience. In the drawing we focus on several dramatically posed individuals, but in *Club Night* Bellows employed only a few expressive heads to register reaction to the fight; these are presented in a manner permitting them

more readily to merge into the larger audience.

This diminished attention to the narrative is evident too in his treatment of the boxing subject. Where the drawing presents the climactic moment at the finish of the fight, *Club Night* shows the boxers boxing, engaged in the kind of action which might occur at any moment in the contest. Correspondingly Bellows changed the fighters' poses from conventional, static positions to ones reflecting observed action.

On the formal level, the pictorial power of *Club Night* derives largely from the dramatic lighting of the scene, an effect which Bellows increased in the following two works. Not only are the boxers seen high above the floor of the ring and thus against the near black of the crowd and the room, but a large portion of their bodies is also in shadow, so the highlights of white and flesh colors take on even greater visual authority. Like the impact of the boxers' active, natural stance, the pictorial effect of this dramatic contrast suggests an image quickly seen rather than an activity described.

At Sharkey's

Central to understanding Bellows' achievements in the boxing paintings is the realization that while this lighting in *Club Night* is dramatic, it is also realistic; it is true to what Bellows would have seen at Sharkey's, surely the location of this fight given the painting's original title. Sharkey's was probably the scene of the two 1909 works as well.[12] Boxing was illegal in New York in 1907, but this did not prevent its occurrence. An understandable loophole in the law permitted athletic clubs to hold contests: to stage a fight, a bar needed only to conform to this restriction, which it could do by hav-

ing its dark back room become a "club" for the evening of the boxing event. The fight would take place on a juryrigged ring, surrounded by the flushed faces of drinking fans, just as we see in *Club Night*. Sharkey's, the scene of Bellows' works, was in fact a bar run by an ex-boxer named Tom Sharkey, who had given it the name Sharkey's Athletic Club. The law also stipulated that the boxing could only take place between those who were part of the athletic association, a regulation which could also be easily circumvented by making the professional fighters "members" of the club for the evening. This loophole explains the title of the Washington painting.

The situation placed Bellows' boxing paintings in a paradoxical position, one which may explain their early warm acceptance, particularly when compared to the scorn given the work of other realists.[13] Whereas the latter could be charged with having depicted the city as ugly, Bellows painted something which was undeniably "ugly" to begin with. Furthermore, as boxing was illegal, Bellows' pictures provided an image of a largely unknown but fascinating subject. In this instance realism would be approved and even valued for its documentary character. Indeed, since Bellows' approach surpassed that of contemporary illustrators, his paintings were even more convincing as "eyewitness" accounts of the forbidden events taking place in New York's athletic clubs.

Close Up

Beyond these thematic, sociological, and formal aspects, there is another formal factor which explains the sense of heightened realism in all three early boxing paintings. By making this his major sports subject,

Bellows selected the visual image most adaptable to two-dimensional representation by traditional means. As in reality, in Bellows' images of tennis and polo (figs. 20, 21), the figures are seen in the clarity of daylight and are located a considerable distance from each other and from us. When we see an actual tennis match, we look from figure to figure to follow the game, and as we do so we are aware of motion in the periphery of our vision. But as our eye shifts from one painted player to another, both remain motionless, a perceptual factor which ultimately makes them seem statues frozen in position. By contrast, the elements of the boxing pictures — the dramatic lighting, the confrontation of the fighters, and their closeness to us — make the boxers seem not so much posed in the ring as glimpsed in an instant of ongoing action.

An interesting parallel to these pictorial conventions can be found in the depiction of sports on television. Television in its early days had limited technical abilities, and images were shown on small screens in a black and white matrix. Of all of the sports programming possible, it was boxing which became dominant; its live action even challenged filmed entertainment productions. The reasons for this are akin to those that underpin the success of Bellows' prize-fight paintings, namely boxing took place in a restricted area, allowed a close-up viewpoint, and was quite legible in black and white. Indeed, football did not begin to move toward its present dominance of sports programming until the invention of the slow motion replay, numerous isolated cameras, the larger screen, and color broadcasting.[14]

Tangential to this indirect relationship to early television imagery is Bellows' first boxing paintings'

graphic depiction of the instantaneous action of the fight. This raises the question of their relationship to contemporary photography. Boxing matches in Bellows' day were represented in the newspaper by drawn illustrations; the use of the stop-action sports photograph so familiar to us today did not become current until the 1920s.[15] Indeed, Bellows' later drawing *Dempsey through the Ropes* (fig. 78) was commissioned for just such an illustrative purpose, although photography had advanced sufficiently to capture a similar image. In its earlier state, photography would not have been capable of recording the faintly illuminated scene at Sharkey's.

Nevertheless, Bellows may have looked at some yet unknown boxing photographs for other purposes. In doing so, he would have followed the precedent set by Eakins, who had used a photograph in making his celebrated *Wrestlers*, a painting which may have influenced both Luks' and Bellows' sporting pictures. Eakins used his camera image as an aid in depicting his wrestlers with an almost scientific clarity. But this kind of photographic certainty does not play a role in *Club Night* or the other early boxing works, nor was it a part of Bellows' aesthetic ambitions. This we know, because when an observer noted that the hands and feet of his boxers were portrayed in positions fighters would not use, Bellows replied: "I don't know anything about boxing. I am just painting two men trying to kill each other." He also remarked, "who cares what a prize fighter looks like? It's his muscles that count."[16] However, what photography could have revealed to Bellows is the existence of a time gap between an act in the ring and the audience's response to it, a temporal period so large that a photograph showing a dramatic

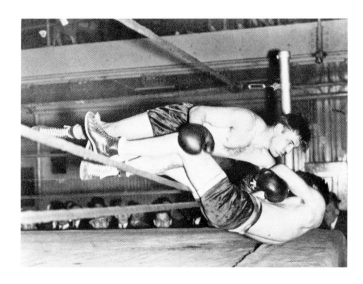

26. Henry Olen, *Powerful K.O. Punch Sends Victor and Vanquished Flying out of Ring*, 1936, *Daily News*, New York

Stag at Sharkey's

The extended horizontal format in *Club Night* works in opposition to the verticality of the fighters who are in close combat at the center of the ring: the figure on the right moves inward with his left foot raised, while his opponent blocks this thrust with his arms and the tilt of his upper torso. Bellows continued the motif of infighting in the next paintings, *Stag at Sharkey's* and *Both Members of This Club*, but at the same time made it more active by extending the bodies of the boxers away from their point of contact.

In the Cleveland *Stag at Sharkey's* (fig. 28, pl. 4) the fighters are literally locked in head-to-head combat but no other parts of their bodies touch. The figure on the left, in green trunks, drives to the right, his motion propelled from his outstretched right leg, which establishes a dominant diagonal line. This movement is intensified by the position of his

punch also reveals a yet unmoved audience (fig. 26). Such contemporary images may well have influenced the lessening of audience response in the boxing paintings, although it is also possible that Bellows observed this phenomenon in actual study of both the fighters and the scene at Sharkey's.

What Bellows was far more likely to have gained primarily from the study of photographs — and not necessarily sports photographs — is an appreciation of the way in which the camera cuts its image from a much larger visual field. It is precisely this kind of cropping that contributes to the three oils' heightened sense of realism. Extensive cropping is especially apparent in *Stag at Sharkey's* and *Both Members of This Club*, as their more horizontal compositions emphasize the partial nature of the scene, with the crowd and the ring seeming to extend beyond the vertical edges of the picture. The ropes underscore this view by their implied meeting at a corner post beyond the edge of the visual field. However, it should be noted that the angle of the ropes does not correspond to the angle which would be present in a photograph.

Bellows might have also experienced the impact of the camera's perspective indirectly, through certain paintings by Degas. Here there are similarly truncated images of an arena, albeit the sphere of ballet and theater rather than a boxing ring (fig. 27).[17]

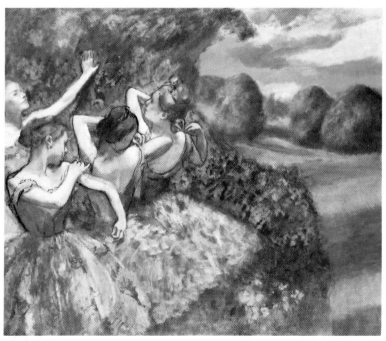

27. Edgar Degas (French, 1834-1917), *Four Dancers*, 1899, National Gallery of Art, Washington, D.C., Chester Dale Collection, 1962

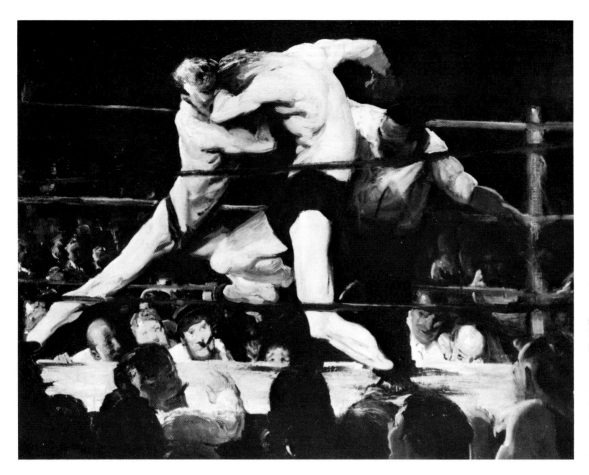

Left: 28. Bellows, *Stag at Sharkey's*, 1908, Cleveland Museum of Art, Hinman B. Hurlbut Collection (cat. no. 2)

Right: 29. Bellows, *Both Members of This Club*, 1909, National Gallery of Art, Washington, D.C., Gift of Chester Dale, 1944 (cat. no. 3)

left leg, which has lifted off the ground, creating a vertical thrust culminating in the upper-cut punch delivered by his right arm.

True to Bellows' sense of realism the green-trunked boxer's blow is not climactic. On the right, the figure in black trunks resists this punch, his back arched and his right leg raised, driving him inward to match forces with his opponent; while his left leg, with its long vertical accent, cushions the blow. More importantly, the punch is countered by his right arm, which swings back and outward in preparation for the next blow, implying the uninterrupted action of the bout. This crucial sense of continuity is supported by the form of the referee who stares intently at the ongoing exchange of punches.

In certain ways, the Washington *Both Members of This Club* (fig. 29, pl. 5) is even more explosive than the Cleveland picture. Painted two months after *Stag at Sharkey's*, the fighters in *Both Members* are also literally head-to-head. But in the Washington painting, Bellows reversed the preceding composition. Here, the black fighter on the right creates the strong diagonal, his leg almost stretched out in a straight line into the lower right corner. Like his counterpart in *Stag at Sharkey's*, he lifts his left leg to increase his power. His opponent, a white boxer, is not as coiled as his parallel in the Cleveland oil. His leg, trunk, and head form a strong vertical line of resistance. These forces underscore the powerful meeting of the two

boxers' punches in mid-air, indeed their gloves almost touch the top edge of the canvas.[18] Again, Bellows chose a moment of great activity but one which exists in the midst of a continuing conflict.

There is another thematic aspect of *Both Members* which further supports its convulsive imagery and which sets it apart from the other boxing oils. This is the subject of a white man versus a black one. Fueled by racial intolerance, contests of this sort were popular in this era; they gained in strength and unpleasantness until Jess Willard, the "Great White Hope," met and defeated Jack Johnson, the black champion, in 1915. In fact, Bellows' original title for *Both Members of This Club* was *A Nigger and a White Man*, an

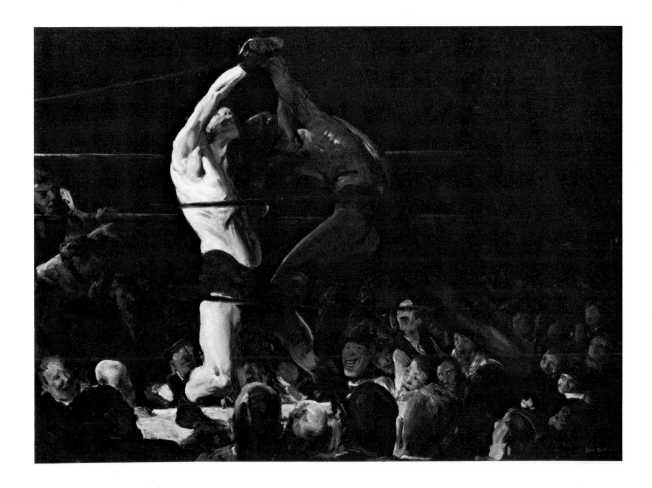

appellation which he subsequently changed. The larger theme of the work, however, remains a document to this unfortunate attitude, a clear echo of which was seen in the recent Holmes-Cooney fight.

Sources

Despite the seeming veracity of the black fighter's pose, it should raise our art-historical interest. The scissored stance, diagonal leg, lengthened back, and uplifted arms of Bellows' figure recall directly those of the *Borghese Gladiator* at the Louvre, which the artist could have known from reproductions, plaster casts, or illustrations (fig. 30). Indeed, the identification of the *Gladiator* as a warrior was questioned in the eigh-

teenth century, certain art historians preferring to see the figure as a boxer, a reading which led to extensive discussions comparing fighting in the ancient and in the modern worlds.[19] Even if Bellows were ignorant of these art-historical interpretations, his interest in portraying "muscles in action" could have been caught by those shown in this sculpted figure.

Discussion of other artistic sources for these paintings has already appeared in the Bellows literature but has been directed at the crowd rather than the fighters. In his monograph, Charles Morgan points out the artist's continuing interest in Honoré Daumier, especially pertinent in light of Bellows' own work as a graphic artist. Beyond a similarity

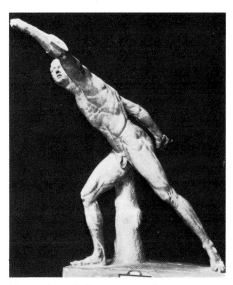

30. *Borghese Gladiator*. Musée du Louvre, Paris

between Bellows' slightly caricatured boxing crowds and the expressions of Daumier's figures, the artists shared a particular interest in recording an audience's reaction to an event (fig. 31). It is also interesting to note that Bellows painted a rather exact copy of Daumier's *Rue Transnonain, le 15 Avril 1834* in 1908, a year before completing *Stag at Sharkey's* and *Both Members of This Club*.[20]

Francisco de Goya is the other artist mentioned in association with Bellows' boxing crowds. Morgan has observed that the work of Goya was held in especially high regard by Henri, who on several occasions took his students to Spain to study the master.[21] Although Bellows did not make any of these trips, he would have had direct access to the Goya paintings then hanging at the Metropolitan, to etchings by the artist, and to reproductions of his work. Eleanor Tufts, in an article devoted to this queston, has shown how certain faces in *Both Members of This Club* resemble those seen in Goya's *The Pilgrims of San Isidro* (fig. 32). Beyond this, she observes: "the mass of ringside seats, sketchily depicted and highlighted with impasto, is remarkably Goyesque" and "Bellows restricts himself in this oil to a dark palette almost as dark as Goya's Black Paintings."[22]

Professor Tufts' remarks about the darkness of *Both Members of This Club* are certainly accurate in reference to the background areas where Bellows used almost solid black tones. But her observation that the rest of his palette is somber was made in 1971 and must now be slightly revised in the light of a new perspective gained through the cleaning of the Cleveland oil in 1974 and the Washington work this year. In both paintings the removal of severely yellowed layers of varnish has revealed that rather than being ob-

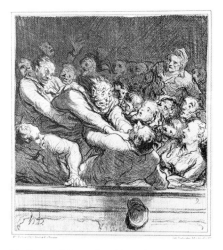

31. Honoré Daumier (French, 1808-1879), *Croquis pris au théâtre*, 1864, National Gallery of Art, Washington, D.C., Ailsa Mellon Bruce Fund, 1980

served through a supposed haze of tobacco smoke, the boxers and the crowd stand out in flashes of brilliant color.

Both Members of This Club

A survey of the Bellows literature shows surprisingly little appreciation of the artist's abilities as a painter, most discussions focusing either on biographical or iconographic aspects of his work. But the cleaning of *Stag at Sharkey's* and *Both Members of This Club* has now made Bellows' considerable battery of techniques and pictorial concepts much more readily apparent.[23]

Stag at Sharkey's was begun with a light wash of blue green rubbed into the white primer layer, and *Both Members* was started in a similar fashion, only using a brown tone over the lead white ground. In each picture, portions of this initial wash have been left exposed. One such area forms part of the background at the upper right corner in *Stag at Sharkey's*; another, the left arm and glove of the black boxer in *Both Members*; and a third, the glove of the right fighter in *Stag*, only here Bellows partially used a brown tone over the green. In all of these sections, we can also see small white areas where the canvas has been left uncovered by the paint.

Bellows' application of a colored ground ties his pictures to the old master tradition, rather than to emerging modernism. A significant

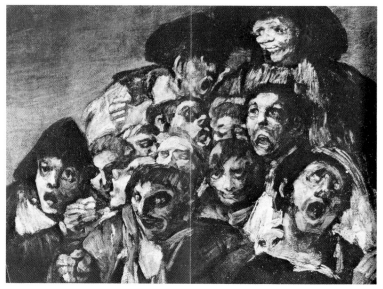

32. Francisco José de Goya (Spanish, 1746-1828), *The Vision of the Pilgrims of San Isidro*, 1820-1823, Museo del Prado, Madrid

element in the revolution in French painting was the direct use of a white primer and of pure color tones, creating the high-keyed palette. By contrast, the old masters' reliance on a colored ground produced subtle shifts of tone, broken by dramatic flashes of more colorful, heavier pigment layers.

Bellows' use of a comparable system in these boxing works is especially important in the background areas. In both pictures, the deep background is painted in shades of black, virtually covering any passage of contrasting color. As a release from this density, in each work a green-lighted exit door appears in the midst of the darkness, at the upper left in *Stag at Sharkey's* and on the right center margin in *Both Members*.

Stag at Sharkey's is the more atmospheric of the two pictures starting with its lighter area of green ground at the upper right, a reflected light on the far wall which illuminates the figures below as dark silhouettes. In a more extraordinary touch, moving through the black background toward the ringside fans, we discover very subtle traces in the paint, textured almost like fingerprints. Each of these marks serves as a figure, but enveloped in black they stand out in ghostly fashion. Their presence is further revealed by small dabs of red, placed throughout the darkness, which indicate glowing cigar ends scattered among the crowd.

On the left side of *Stag at Sharkey's* Bellows established a gradual transition from the background crowd to the ringside, painting faces more broadly. This movement culminates with those on the far side of the ring, rendered with thicker impasto, including passages applied with a palette knife. By contrast such transition is not present on the right

side: here the overall tone is darker and the middle-ground spectators are blocked from our view by the heads of two black fans flanking the corner post.

The handling of the background in *Both Members of This Club* is far more dramatic. The black layer now fully covers the upper two thirds of the canvas, beginning at the line of the lower rope. Aside from the boxers, only the two figures pushing on the ropes at the far left margin and the exit lights at the far right break this zone. Furthermore, Bellows eliminated the more subtle references to a crowd, so the first figures to emerge in the audience are actually those in the middle ground at the right. As in *Stag at Sharkey's* Bellows creates a gradual transition from these images to the richly painted figures at ringside. A key difference between the works, however, lies in the far looser facture Bellows used for the faces in the Washington oil.

The background and audience of each picture are, of course, ancillary to the figures of the boxers. In defining them, Bellows began by painting the fighters in a conventional manner, then adding very wide strokes of heavy paint, especially to create highlights or muscle formations. In both paintings, certain of these areas are so bold in their application, so intense in their white and red color, and so divorced from traditional rendering that they appear virtually as abstract passages (fig. 33). Many of these sections were apparently improvised and are among the later touches in the picture.

Hand-in-hand with this richly painted definition of the boxers goes their separation from their surroundings. Bellows' maneuvered the faces of the audience at their feet so that none of them intrudes directly into the fighters' space. This too was somewhat improvised, for the

Cleveland oil shows a correction late in the formulation of the work where Bellows lowered the left foot of the left boxer so it blocks out what might have been a distracting head. In the Washington oil, a parallel correction was made, also in the area of the left leg of the left fighter. But here, rather than rearranging the boxer's stance, Bellows boldly painted a wide, black passage over the intruding section of the audience, an abstract band matching the profile of the figure's leg.

This band is distinguished by its width and somewhat transparent character. But it is not unique; in both works Bellows painted a dense black outline around the boxers, creating a firm contour for each form that further sets it off from the background. Bellows could have learned this silhouetting procedure from Edouard Manet, whom Henri also especially admired. But in Manet's work, contouring served to under-

33. Detail of *Stag at Sharkey's* (fig. 28)

score the general two-dimensional quality of his pictures. In Bellows' boxing paintings it serves as a contrast to the richly impasted areas of the fighters' bodies, giving them a more corporeal presence. This definition reaches its most dramatic form in the left figure in *Both Members of This Club* where the jet black

space is juxtaposed to his back and upraised arm, producing an edge of brilliant highlights which culminate in pure white. This ultimate tonal contrast is made even more spectacular by the rich, subtle passages below. The fine black and white line seems a flash in the darkness of Sharkey's back room, a sudden glare of light which underscores the momentary nature of Bellows' overall theme.

Introducing John L. Sullivan

After completing *Both Members of This Club* in October 1909, Bellows dropped the boxing theme from his paintings until 1923. We have yet to discover the reasons for this decision. We can rule out any strong fears of being identified exclusively with boxing, because during this period he made sixteen lithographs and published at least seven illustrations of the subject. Nor had Bellows lost his interest in sports paintings, as his polo, golf, and tennis canvases all date from this same time. A possible reason for this lapse may have been Bellows' feeling that with *Club Night*, *Stag at Sharkey's*, and *Both Members of This Club*, he had exhausted the world of back-room boxing for large-scale images.

In this regard, it should be noted that prize fighting entered a period of transition after *Both Members of This Club* was finished. The bill against public boxing was repealed in 1910 and replaced by the Frawley law. This allowed ten rounds, no decision bouts; the winner could only be determined by a knockout. Thus boxing began to leave its back-room location, but solely for the more limited contests allowed under the new regulations. In 1917 the Frawley law itself was repealed, and it was then that the sport began to grow in popularity. By 1923, when Bellows re-

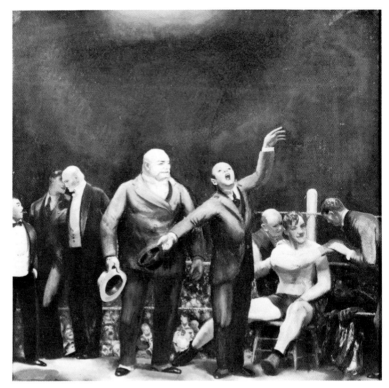

34. Bellows, *Introducing John L. Sullivan*, 1923, Mrs. John Hay Whitney (cat. no. 4)

sumed his fight paintings, boxing had changed radically, having become a fully public event with the heavily promoted Dempsey-Carpentier fight held in July two years earlier. During this period of transition, Bellows' art had also undergone radical changes, some of them caused by the Armory Show of 1913.

In one of the first of his boxing lithographs Bellows had portrayed the ceremonies held in the ring preceding the fight. The first of the later oil paintings, *Introducing John L. Sullivan* (fig. 34, pl. 3), also in the John Hay Whitney collection, continues this subject. Painted in June of 1923, the work has been connected to the Dempsey-Carpentier fight by Donald Braider. Bellows had been commissioned by the *New York World* to illustrate the bout, which he did in his *Introducing Georges Carpentier* (fig. 75). Drawing from this association,

Braider defines the Whitney picture as "an amiable caricature of the current boxing scene [showing] Sullivan [who] had made an appearance in the ring at Boyle's Thirty Acres just before the start of the Dempsey-Carpentier fight."[24] As convenient as this connection may be, it is also impossible, since Sullivan could not have appeared at that match, having died three years before the event took place. In fact the Whitney oil is based on a 1916 Bellows lithograph showing the same subject (fig. 35).

The presentation of former title-holders before important fights had become popular during this period, establishing a ceremony which continues as part of boxing today. In the 1916 composition, former heavyweight champion (1882-1892) Sullivan is presented by the ring announcer, while the ringmaster, behind him at the left and dressed

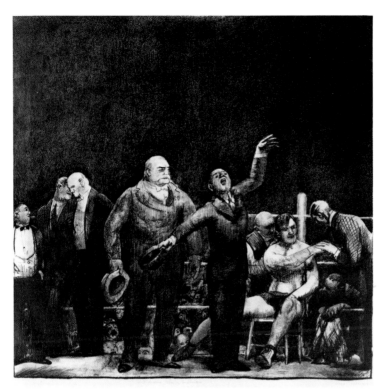

35. Bellows, *Introducing John L. Sullivan*, 1916, lithograph, National Gallery of Art, Washington, D.C., Andrew W. Mellon Fund, 1956

in tails, chats with other celebrities. In the right corner, the somewhat disheveled victor of the preliminary bout receives congratulations.

The fact that Bellows based the Whitney oil on a earlier graphic image explains the picture's illustrational style, a character which sets it apart from the other boxing paintings. Furthermore, *Introducing John L. Sullivan* is quite modest in size in comparison with the larger scale of the remaining boxing paintings, and unlike these oil on canvas works, the Whitney picture is oil on paper (now mounted on canvas). These features identify the work as an oil sketch, which is in harmony with its lithographic origin. However, Bellows' masterful handling of subtle shades of gray, brown, and black gives *Introducing John L. Sullivan* authority as a painting and sets it apart from the graphic versions. These tones were

used with real strength in the initial trio of boxing pictures. But Bellows had largely abandoned this palette in 1916, so its reemergence here marks his return to certain of the formal as well as thematic concerns of his boxing paintings.

Ringside Seats

Like *Introducing John L. Sullivan*, Bellows' *Ringside Seats* (fig. 36, pl. 2) of the following year is based on a graphic work (fig. 86). In this case, the original composition was a drawing made as an illustration for a short story in *Collier's* magazine, but whereas seven years elapsed between the creation of the previous oil and its lithographic source, *Ringside Seats* and its drawing were made at virtually the same time. The largest of the Bellows boxing paintings, *Ringside Seats* also contin-

ues the theme of prefight ceremonies. Like that of the Dempsey-Carpentier illustration, the subject here is the introduction of the boxers to the audience. But this later composition has a more narrative quality; the activities of the various figures derive not from observation but from the description of events in the *Collier's* piece.

Jonathan Brooks' "Chins of the Fathers," with its Bellows illustration, appeared in the 3 May 1924 issue of the magazine. A rather sentimental story, it relates the adventures of an elderly trainer who discovers a young boxer named Jimmo Shea. Jimmo is the son of Stinger Shea and the nephew of Dutch Brooke, both former boxers renowned for their ability to take a punch on the jaw, and the story's central issue becomes: Does Jimmo have the "chin of his father and uncle?" The trainer arranges a series of increasingly difficult fights, culminating with a bout against a Sailor Slosson. Jimmo wins them through decisions, never testing his "chin" in pursuit of a knockout and also not pleasing the crowd. When a rematch is scheduled with Slosson, the trainer attempts to make Jimmo angry enough to really fight by first allying him with Sailor Slosson's former girlfriend then having her say that Slosson has called Jimmo "Yella, won't fight." Jimmo fails to respond to this taunting, but when Slosson shouts that he has "a glass chin, like y'r old man" Jimmo knocks him out.

In keeping with his earlier interests, Bellows chose to illustrate the prefight portion of Brooks' story. The pertinent passage, told by the trainer, runs:

I've got two ringside seats, one for me and one for the girl. I bring her there, and stay with her until Frank and a towel swinger comes out with the kid. Jimmo gets only a small hand from the

36. Bellows, *Ringside Seats*, 1924, Estate of Joseph H. Hirshhorn, Courtesy the Hirshhorn Museum and Sculpture Garden, Smithsonian Institution, Washington, D.C. (cat. no. 5)

crowd, and then Sailor Slosson comes swaggerin' out. The crowd raises the roof.

Bellows' illustration and *Ringside Seats* focus on the introduction of Sailor Slosson at the center of the ropes. In the right foreground, on Slosson's side of the ring, the crowd "raises the roof," while in the left corner the trainer and Jimmo's new girlfriend sit discussing the situation. Jimmo is shown seated on his stool in the corner of the ring, with "Frank [another trainer] and a towel swinger" on either side. Interestingly, Bellows chose to depict Jimmo

as dejected by the crowd's applause for his opponent.

The publication of the "Chins of the Fathers" drawing in *Collier's* resulted in a strange episode in Bellows' career. Rather than reproducing the sheet as submitted by the artist, *Collier's* cropped portions of the right margin, the upper edge, and, perhaps most serious, eliminated a vertical area from the middle of the composition (see fig. 87 for comparison). Bellows was enraged by this "mutilation" and filed suit against the magazine.

Why did this cropping lead to

such an aggressive response on Bellows' part? Beyond the obvious outrage of an artist at the alteration of his work, Bellows felt this deletion of portions of his composition changed the very heart of his pictorial conception. In the fifteen years between *Both Members of This Club* and *Ringside Seats*, his art had undergone a radical change; Bellows' style was now governed primarily by the use of a geometric pattern applied to a field of a specific shape. Thus the elimination of part of this field, even the edges, but especially the center, would drastically alter a geo-

37. Diagram of *Ringside Seats* (fig. 36)

the entire field of the painting. This division crosses the head of the seated trainer, the face of the man standing at ringside, and, more importantly, the exact central point of the larger lozenge.

Jay Hambidge

Although *Ringside Seats* is not Bellows' only picture to use a geometric plan, this large painting does employ such a scheme at its most complex. Bellows became interested in this kind of composition in the fall of 1917 when he attended a series of lectures by Jay Hambidge. Hambidge described geometric formulas used in pictorial organization, a system he called "dynamic symmetry." These talks had a profound effect on Bellows who wrote to Henri, "A new star has arisen in the field of art analysis. Jay Hambidge . . . we're on the trail of something which may be worthwhile." In a short time, Bellows was converted to Hambidge's methods, so much so that by 1921 he would regard dynamic symmetry as "probably more valuable than the study of anatomy. It comes within the range of positive knowledge." This kind of thinking meant a radical shift in Bellows' work, especially the boxing paintings, since in earlier canvases of fighters the realist concept, "it's his muscles that count," prevailed.

Hambidge's theories are primarily known today from his book, *The Elements of Dynamic Symmetry*, posthumously edited from earlier writings and published two years after his death in 1924. We know that Bellows was familiar with the text and its arguments as he had served as the initial editor of the material, at the request of Hambidge's widow. Indeed, such a request indicates how close Bellows was to the theorist.

Hambidge's central belief was

metrically ordered scheme. Moreover, such a change in *Ringside Seats* would have been of the utmost seriousness, as this composition, and particularly that of the larger painting, has the most complex organization of any of the artist's works.

Much of the geometrical planning of *Ringside Seats* is readily visible by simply looking at the work, primarily at the extended diagonal lines formed by the gesturing arms of the crowd and by the light and shadow pattern at the top of the arena. Underpinning these elements is a far more rigidly designed scheme, one which is best seen in a diagram (fig. 37).

This plan reveals that the painting field is a subsection of a larger compositional rectangle. Diagonal markings within this bigger field pass through the smaller area and give the picture its basic design. Foremost of the shapes created is the large triangle at the center of the diagram, which runs from the middle left to the upper center to the middle right. As we can see, this form is

aligned with the pattern of shadows visible in the roof of the arena. A second, inverted triangle adjoins the first, inscribing a lozenge. With this lozenge, Bellows established a major vertical axis, a line which passes through the face of Sailor Slosson. He also created a smaller diamond and a square inside the larger diamond. The innermost figure is a rectangle within which the referee and Sailor Slosson stand. This form marks the focal area of the composition.

Bellows may have used still other geometric shapes to determine the organization; however, we must be careful not to identify a nonexistent pattern in the work. Some divisions do seem to be deliberate, for example, a diagrammed line from the lower point of the left ring post up to the corner of the small rectangle. This line not only intersects the forward edge of Jimmo's stool and his gloves but passes exactly through the trainer's hand on the rope. An even more convincing secondary pattern is the long diagonal across

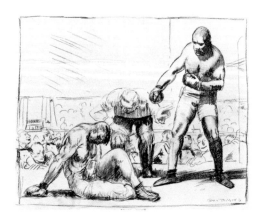

that "the basic principles underlying the greatest art so far produced in the world may be found in the proportions of the human figure and in the growing plant . . . [and] have been given the name 'Dynamic Symmetry.' This symmetry is identical with that used by the Greek masters in almost all the art produced during the great classical period." But in his text, which he called "lessons," Hambidge did not analyze plants, figures, or Greek art. Rather, he published a series of mathematical theories and corresponding diagrams, arguing that "to recover these themes of classical design it is necessary to use arithmetical analysis" (fig. 38).[25]

Although Bellows' belief in the concept of dynamic symmetry has long been recognized, no art-historical analysis has been undertaken of the relationship between his paintings and these theories. Yet, simply looking at certain drawings done after 1918, such as A Knock Down, reveals a strong geometric organization (fig. 39). In this sheet the rectangular field is divided by the long diagonal which begins at the lower left and ends with the standing boxer. This pattern recalls a diagram used by Hambidge to illustrate his "Root Three Rectangle," although the drawing's proportions do not match those of the arithmet-

ically generated figure. Of course, these measurements do not need to correspond with those of any published diagrams, as Hambidge may have used other illustrations in his lectures or Bellows may have invented his own arithmetical systems.

This general, rather than specific, relationship also applies to these theories and the grand Ringside Seats. The painting's complex symmetrical pattern suggests certain designs found in dynamic symmetry but again does not match them exactly. Furthermore, the composition's derivation from only a part of a larger geometrical pattern makes it and Hambidge's illustrations even more dissimilar. In this case, Bellows may have looked at a different Hambidge analysis, namely that published in his 1920 text Dynamic Symmetry: The Greek Vase.[26] Here his arithmetical patterns are applied to only portions of the vase, thus determining the profile points (fig. 40). The illustration employs a diagonal design very much akin to that found in the 1924 oil.

Whether Bellows drew upon one or more of Hambidge's Greek vase analyses or chose to devise his own system, the decision to use only a section of a larger geometric pattern was pictorially important. A strictly symmetrical design coinciding with

the field could have created a static composition, one not only inappropriate to the depiction of a boxing ring but especially difficult to overcome in such a wide-angle view, where the small size of the individual figures would make the design more readily apparent. By using only a portion of the pattern Bellows allowed the energies of the composition to extend beyond the margins of the canvas. This format produces a visual effect similar to that resulting from the "photographically" cropped images in the three earlier works.

Ringside Seats may also reflect another Hambidge interest, the Greek temple. Just as Hambidge had believed the Greek vase was made according to the principles of dynamic symmetry, so he sought to demonstrate that classical architecture in general, and the Parthenon in particular, were equally governed by these arithmetical rules. While the composition of Ringside Seats does not follow any of Hambidge's patterns for the Parthenon, Bellows' handling of the major figures suggests he may have gone beyond Hambidge's interests and studied the sculptural program of the building itself. Even in the Collier's drawing we see how the figures in the ring are pulled up to the foreground rope, rather than being placed at

various depths within this enclosed space. In the painting, this tendency toward a more two-dimensional image is further emphasized; figures are more frontal and seem to only slightly overlap. In this regard, a clear precedent would have been the relief sculpture from the Parthenon, where a similar flattening effect is produced by the elimination of the space between the forms (fig. 41). Furthermore, the processional theme of the friezes can also be related to Bellows' ceremonial subject. We should note that Bellows himself wrote: "A fight, particularly under the night light, is of all sports the most classically picturesque."[27]

Bellows' figures bear another relation to those of the Parthenon's pediment. While the angle is steeper, the way in which the figure with the towel fits into the space formed by the shadow and the ring's floor suggests the very similar compositional adjustment seen in the acute angles of the pediment where the figures are reduced in scale and stretched to fill the limited space (fig. 42). Bellows' use of intervals between the figural groupings may also derive from that in the pediment, not the original composition but the arrangement of the few sur-

Top left: 40. Photograph taken from Jay Hambidge, *Dynamic Symmetry: The Greek Vase* (New Haven, 1920), page 22, fig. 8

Top right: 41. Parthenon, Athens, north frieze, detail, completed 450 B.C.

42. Parthenon, Athens, figure from the east pediment, completed 450 B.C.

43. Elgin Marbles, Trustees of the British Museum, London Detail of *Ringside Seats* (fig. 36)

viving figures in the Elgin Marbles (fig. 43). In seeking such an alignment with Greek art, Bellows could have drawn upon boxing's position as an ancient sport, in fact one of the events in the Olympics.

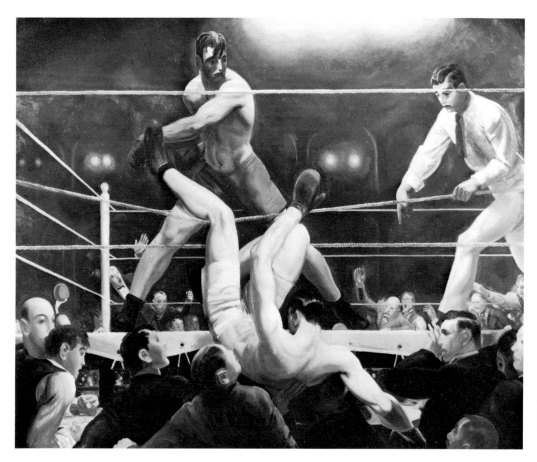

44. Bellows, *Dempsey and Firpo*, 1924, Whitney Museum of American Art, New York, 1931 (cat. no. 6)

Dempsey and Firpo

Bellows finished his last boxing painting, the large *Dempsey and Firpo*, in June 1924 only a month after *Ringside Seats* had been completed (fig. 44, pl. 1). Here, the artist abandoned the theme of prefight ceremonies used in the preceding two oils and returned to the action subject he had presented in the initial paintings. But despite this thematic change, Bellows continued to use a Hambidge-like scheme to organize the essential layout of the picture.

The basic composition of *Dempsey and Firpo* had been developed in drawings and prints during the preceding twelve months. The first drawing had been commissioned from the artist by the *New York Eve-*ning *World* for use as an illustration of the Dempsey-Firpo title bout, a project similar to the commission for the Dempsey-Carpentier fight. The award of these assignments to Bellows underscores the wide fame his boxing works had acquired by the 1920s. This is especially true of the second assignment, in light of the importance of the event. As Morgan observes:

The Dempsey-Firpo match, brief but violent, has been called the fight of the century. Since his victory over Carpentier two years before, the Champion's unpopularity had undergone a sharp revision. His opponent, aggressive and powerful, was almost unknown outside his native Argentina. Paying customers packed the Polo Grounds, and it was ap-parent from the opening bell that the mayhem they had paid to see would be worth the price. During the first round, the Champion floored the Challenger seven times and was himself knocked flying through the ropes and into the press box. Back in the ring, Dempsey then proceeded to knock out Firpo in the second round.[28]

Because of his status as a "reporter," Bellows was seated in the press box, indeed in the row directly next to the ring. Thus his own view of the fight was actually the close-up perspective he chose to use in *Dempsey and Firpo*, a view also matching that employed in the earlier boxing paintings. Not only was Bellows witness to the action, he was part of it. As he described.

in a letter to Henri:

When Dempsey was knocked through the ropes he fell in my lap. I cursed him a bit and placed him carefully back in the ring with instructions to be of good cheer.

In spite of Dempsey's ultimate victory in the fight, Firpo's knocking him through the ropes was regarded in the press accounts as the most exciting point of the match. This incident was also famous from a visual standpoint, as Dempsey's dramatic exit had been captured in a photograph, camera and film now having evolved sufficiently to make stop-action photography possible. It was this same moment that Bellows chose to illustrate and finally to paint.

Dempsey and Firpo shows the Argentine standing straddle-legged in the ring, his left arm extended after delivering the "knockout" punch. Dempsey, having fallen through the space between the middle and upper ropes, is depicted tumbling directly into the press row. At the right the referee points his finger downward, beginning the count. The crowd reacts by gesturing and yelling, although we should note that these fans are given less prominence than the Goyesque ones in the early paintings. The reporters also respond to the action, although not as dramatically. Among these faces we may find Bellows' self-portrait. Morgan believes the artist departed from his account to Henri and portrayed himself as the balding figure at the far left who is a more passive observer of the activities.[29] However, the man lifting Dempsey also has a receding hairline — the top of his head is obscured by Dempsey's arm — and thus can conceivably be identified as the artist. Indeed, while the long features of the left-hand figure match those of Bellows as captured

in well-known photographs, these are earlier images. A later photograph, taken the same summer as the Dempsey-Firpo fight, shows his face with much broader features and a slight double chin, elements more in common with those of the face of the lifting figure at the center (fig. 45).

45. Nicholas Muray, *George Bellows*, 1924, International Museum of Photography at George Eastman House, Rochester, New York

Color and Composition

As we have seen, by 1923 and the Dempsey-Firpo bout, the world of New York boxing had changed radically. Now given public sanction and huge attendance, boxing matches had moved from the dark back-room atmosphere of the athletic club to the bright incandescent lights of the municipal arena. The differences between the Sharkey oils and the last pictures follow that change.

Although there is still dramatic illumination in *Dempsey and Firpo*, both the participants and the crowd are seen under much more even lighting, as opposed to the sharp contrasts in *Stag at Sharkey's* or *Both Members of This Club*. Furthermore, the dense black of the earlier paintings, which captured the back-room am-

biance, is replaced in *Dempsey and Firpo* by a lighter, dominant green tone, reflective of the new public space. This overall color of the 1924 oil is made especially vibrant by Bellows' use of a second hue, a directly contrasting pinkish purple. Indeed, this color pervades the painting as well, but as an undertone. Rather than working from a brown or green ground as he had in the earlier oils, here Bellows began the picture directly on the white priming, subsequently rubbing certain areas with the pink purple color. Portions of this layer are left exposed in the ropes crossing the composition — other parts of the ropes are painted a dull gray.

Because of this higher-keyed background and more even lighting, the boxing figures in *Dempsey and Firpo* are not defined by the strong highlights or richly impasted areas used in *Stag at Sharkey's* or *Both Members of This Club*. Nevertheless, they do stand out with a sculpturesque force, since Bellows again painted a solid band of color around the profile of their bodies, here the rich green of the background.

As we might expect, Bellows ordered the realist forms of *Dempsey and Firpo* with a strong geometric pattern. We can gain a clear idea of part of this organization through a print of the image which Bellows squared; this sheet may have provided the starting point for the oil (fig. 46). Horizontal and vertical lines divide the print into equally sized areas. Certain key elements of the composition correspond to these divisions: the floor of the ring, the lower rope, and the upper rope fall on horizontal lines; while the left ring post, Firpo's left foot, and the referee's finger conform to vertical markings.

Although this grid indicates an aspect of the overall organization of

the painting, it does not show the more dynamic diagonal patterns Bellows also employed. To this end we have superimposed a linear diagram over *Dempsey and Firpo* marking these major compositional elements (fig. 47). Unlike *Ringside Seats*, *Dempsey and Firpo* is constructed symmetrically, a bold choice for an action scene, but one tempered by Bellows' use of a close-up perspective. The underlying pattern consists of two large overlapping triangles. Other smaller forms can also be found; the resulting diagram, as illustrated here, again recalls Hambidge's analytical studies without matching any specific design (fig. 48).

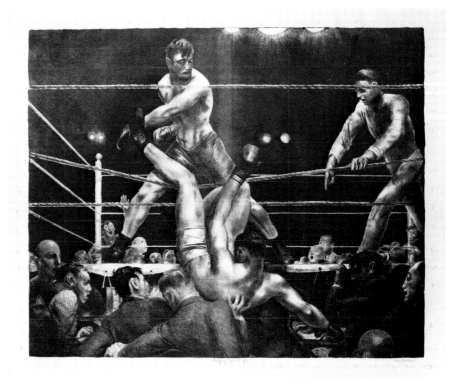

46. Bellows, *Dempsey and Firpo*, 1923-1924, lithograph, Mead Art Museum, Amherst College, Mass., Gift of Mrs. George Bellows, 1959

48. Photograph taken from Jay Hambidge, *Dynamic Symmetry: The Greek Vase* (New Haven, 1920), page 68, fig. 8

Action and Classicism

It is to Bellows' great credit that this very strong geometric pattern is not readily apparent in *Dempsey and Firpo*. The powerful diagonal from Firpo at the upper left to Dempsey at the lower center challenges any feeling that the composition has a symmetrical underpinning. The design's greatest effect rests in the calming, ordered sense it gives to the scene, creating a classical clarity beneath the action of the prize fight.

A central issue for the later boxing works, and for *Dempsey and Firpo* in particular, is Bellows' reason for using such a rigid system in portraying a sporting scene with its implied or depicted action. Part of the answer may lie with his response to the Armory Show of 1913 and especially to the "star" of the exhibition, Marcel Duchamp's *Nude Descending the Staircase*. Although it was scorned by the press and by realist artists, Duchamp's work was taken seriously by Bellows, and he defended it in arguments.[30] A painter of action scenes, he would have found *Nude Descending* particularly interesting as a depiction of a figure in motion. Furthermore, the painting stood as a symbol for a whole movement of artists then engaged in similar experimentation. Begun by the futurists in Italy, this movement was influencing Americans by 1913, and even pictures of baseball games, a subject close to that of Bellows' own works (fig. 49), were painted in the futurist manner.

Almost all Bellows authors agree that he was affected by the exhibition but cite different results. Morgan, for example, writes that:

The impact of the Armory Show upon him was immediate and profound. Reacting to Post Impressionism and Fauvism, Bellows' palette grew more intense and clear hued the following summer.[31]

49. James R. Daugherty (American, 1887-1974), *Three Base Hit (Opening Game)*, 1914, Whitney Museum of American Art, New York

47. Diagram of *Dempsey and Firpo* (fig. 44)

ously neoclassical paintings by Pablo Picasso but also later cubist pictures by Juan Gris, Georges Braque, and Fernand Léger (fig. 51).

Just as these cubist works of the 1920s are now undergoing reevaluation, so too Bellows' late paintings can be seen in a new light. While Frederick A. Sweet, in 1946, described the creation of *Dempsey and Firpo* as a sign of the artist's decreasing abilities and Mahonri Sharp Young applied terms such as "unconvincing," "ghastly," and "unreal" to the picture, *Dempsey and Firpo* as well as the other later paintings has

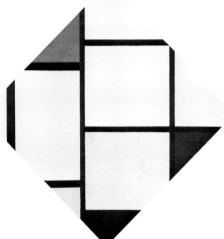

50. Piet Mondrian (Dutch, 1872-1944), *Lozenge in Red, Yellow and Blue*, 1925, National Gallery of Art, Washington, D.C., Gift of Herbert and Nannette Rothschild, 1971

51. Juan Gris (Spanish, 1887-1927), *Le canigou*, 1921. Albright-Knox Art Gallery, Buffalo, Room of Contemporary Art Fund, 1947

As we have seen, *Dempsey and Firpo* does use the white ground and contrasting palette of fauve paintings. There is no evidence, however, that Bellows even experimented with the Duchamp/futurist vocabulary, itself a dynamic arrangement of cubist planar elements. And, for him to have done so would have meant going strongly against his other realist tendencies. The difficulty of acknowledging modernism's approach to capturing motion but at the same time rejecting its abstraction may have been solved with Bellows' discovery of Hambidge's systems. Now, rather than breaking his subjects into facets, he could use this geometrical system to establish instead a kind of eternal order and rhythm beneath the appearance of reality. This more metaphysical attitude may be exactly what Bellows expressed in his opinion that dynamic symmetry "comes within the range of positive knowledge." Furthermore, as Morgan observes: "Dynamic Symmetry seemed . . . an answer to the puzzle the Cubists had presented, a demonstrable relationship between flat planes."[32]

In taking this course, Bellows curiously aligned his art with two differing directions in European modern painting. On the one hand, his use of a rigid, two-dimensional construction parallels the work of Piet Mondrian and the de Stijl artists. Both believed in geometric principles as key to presenting reality, a geometry which lies underneath Bellows' figures and which is exposed for itself in Mondrian's abstractions (fig. 50). Conversely, Bellows' classicism, with its restraint and order, finds its counterpart in the works of the French school in postwar Paris, not only the obvi-

45

never been totally dismissed by critics.[33] Today, however, we can also understand that their underlying geometric structure allies these works with a much broader stylistic current, one with its own intrinsic value. This connection is not drawn to suggest Bellows was a "secret modernist" or to imply his art is in some way more valuable because it shares these modern elements. Indeed, despite these characteristics, the artist's late works are remarkably free of any sense of European influence.

Bellows' geometry and classicism obviously inform his later portraits, but to a much smaller degree. And when he used these elements in panoramic landscapes, the result is frequently a feeling that the space is too constructed and the landscape's design too artificial. It is perhaps ironic that his system worked best in the last two boxing paintings, and especially *Dempsey and Firpo* with its dramatic, active subject. Here, Bellows took the theme of boxing and made it work pictorially as he had in the earlier canvases. And, as before, his grasp of the theme is so assured that Bellows' realism lies over his genius as an artist, and the image he paints seems simply convincing.[34]

Notes

1. The *New York Evening Journal* called *Club Night* "a wonder" in its review, cited by Charles H. Morgan in *George Bellows: Painter of America* (New York, 1965), 78. A clipping of the *New York American* (4 April 1910) illustration is in the files on *Stag at Sharkey's* at the Cleveland Museum of Art. The *Harper's Weekly* issue was from 16 August 1913.

2. Jerome Mellquist, *The Emergence of an American Art* (New York, 1942), 289.

3. John R. Tunis, "Painter of the Prize Ring Drama," *New York Times Magazine* (7 January 1945), 18. The *Times* article is especially interesting in regard to the National Gallery's acquisition of *Both Members of This Club*: "Today the painting will be hung in the National Gallery in Washington, D.C., the gift of Chester Dale. The National Gallery is not permitted to acquire a painting for its permanent collection until the artist has been dead for twenty-five years. Bellows died on Jan. 8, 1925. [He] is therefore being honored by inclusion in our national museum at the earliest possible second." This policy has since been changed.

4. The idea that the boxing paintings are as "real" as photographs or other boxing memorabilia continues to this day. During the 1981-1982 television season, an episode of the program *Taxi* featured a scene set in a New York boxing bar. Included among numerous photographs of boxers and bouts was a large reproduction of the Whitney Museum's *Dempsey and Firpo*.

5. Details of Bellows' career are based on Morgan's biography.

6. Bellows lived in the Lincoln Arcade Building at 1947 Broadway. On 10 June 1922, he wrote to William Milliken, then director of the Cleveland Museum of Art: "Before I married and became semi-respectable, I lived on Broadway opposite the Sharkey Athletic Club where it was possible under the law to become a 'member' and see the fights for a price." Letter in the Cleveland Museum Archives.

7. See Mahonri Sharp Young,

The Eight (New York, 1973).

8. Bellows did cartoons and illustrations in the manner of Charles Dana Gibson for *Makio*, his university yearbook.

9. Part of the confusion about the Cleveland painting's date derives from Bellows' letter to Milliken in which he dated the picture to 1907.

10. Letter from Copyright Office, Library of Congress, Washington, D.C., to Cleveland Museum of Art, 21 February 1974.

11. Letter from Edward B. Henning, chief curator of modern art, Cleveland Museum of Art, to Linda Ayres, 14 September 1981.

12. In Bellows' letter to Milliken he implies all three paintings are set in Sharkey's.

13. Note Bellows' 1909 election to the conservative National Academy of Design as its youngest member.

14. Boxing has made a recent return to television, but its popularity now seems as much attributable to the presence of media personalities as to visual drama.

15. See John Szarkowski's "Introduction" to *From the Picture Press* (New York, 1973), 3-6.

16. All Bellows quotations are from Morgan, *George Bellows*, unless noted.

17. Shinn's work was clearly based on precedents in pictures by Degas, but Shinn used cropping less forcefully. On this point see note 18.

18. The gloves may have originally been cut off by the edge of the picture, as examination of *Both Members of This Club* shows *two* extensions were made along the upper edge.

19. See Francis Haskell and Nicholas Penny, *Taste and the Antique* (New Haven, 1981), 222 and 224.

20. Morgan, *George Bellows*, 86.

21. Morgan, *George Bellows*, 98.

22. Eleanor M. Tufts, "Bellows and Goya," *Art Journal* 30 (Summer 1971), 363.

23. My appreciation to the conservation staff of the National Gallery for their assistance in studying the Washington painting and to Edward Henning of the Cleveland Museum of Art who helped

my study of *Stag at Sharkey's*.

24. Donald Braider, *George Bellows and the Ashcan School of Paintings* (Garden City, N.Y., 1971), 134.

25. Jay Hambidge, *The Elements of Dynamic Symmetry* (New York, 1926), xiii.

26. Jay Hambidge, *Dynamic Symmetry: The Greek Vase* (New Haven, 1920).

27. Bellows' letter to Milliken.

28. Morgan, *George Bellows*, 263-264.

29. Morgan, *George Bellows*, 264.

30. Morgan, *George Bellows*, 165, 176.

31. Morgan, *George Bellows*, 165.

32. Morgan, *George Bellows*, 216-217.

33. Frederick A. Sweet, "George Wesley Bellows," in *George Bellows: Paintings, Drawings and Prints* [exh. cat., The Art Institute of Chicago] (Chicago, 1946), 25, and Mahonri Sharp Young, *The Paintings of George Bellows* (New York, 1973), 144.

34. On the question of realism, abstraction, and depiction, see the very important article by Charles Rosen and Henri Zerner, "What is, and is not, Realism?" in *New York Review of Books* (18 February 1982), 21-26.

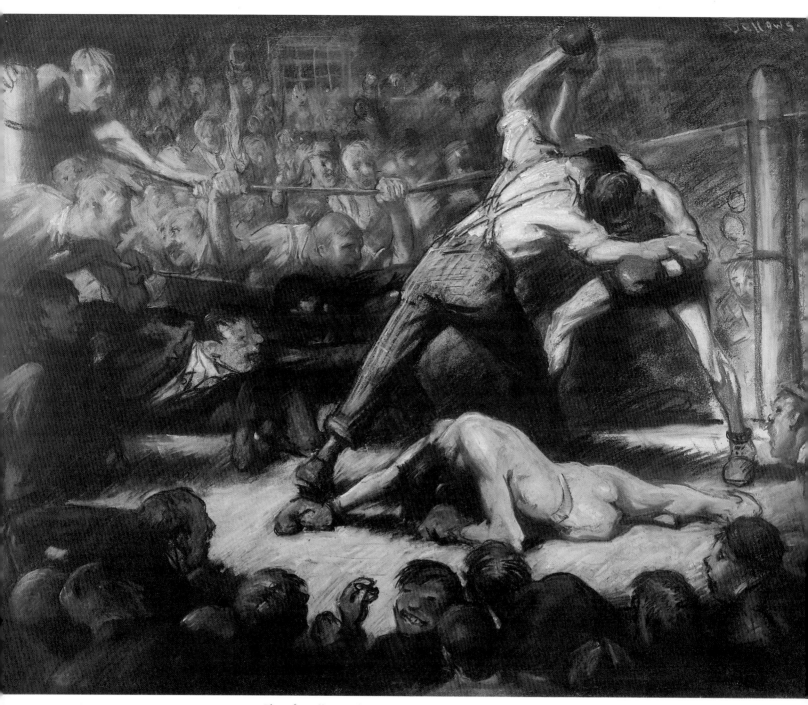

Plate 6. Bellows, *The Knock Out*, Private collection (cat. no. 7)

Bellows: The Boxing Drawings

Linda Ayres

George Bellows, one of America's finest draftsmen, was drawing prolifically by the age of five. He was active as a draftsman in his teens, producing page head decorations for his high school weekly, engaging in newspaper and other commercial work outside of school, and in 1900 exhibiting his work at Baker's Art Gallery, in his home town of Columbus, Ohio. In school, he drew from draped models, using pen and wash and charcoal, and copied squared-off drawings by Charles Dana Gibson in pen and ink.

At Ohio State University, the young Bellows drew illustrations for his school yearbook, *Makio*, as well as the Kenyon College yearbook and contributed illustrations to local periodicals. During vacations, he reportedly made sporting cartoons for the *Ohio State Journal*. These early works emulate the highly fashionable and elegant style of popular artists Howard Chandler Christy, James Montgomery Flagg, and Charles Dana Gibson, whose pen and ink drawings Bellows would have seen regularly in the periodicals of the day.[1]

When Bellows reached New York in 1904, he was a skillful imitator of this prevalent, tightly penned Gibsonesque style of illustration, causing Robert Henri to comment sarcastically when shown his new student's *Makio* drawings, "Haven't I seen these before?"[2] Henri, with

whom Bellows was to study for several years, had a profound influence on the younger artist's work. Here, Bellows said, was where his life began.[3] Known for rapid, slashing brushstrokes, direct observation of his subject, the depiction of movement, and deep chiaroscuro, Henri employed broad and vigorous techniques that were the direct opposite of the style Bellows had learned during his midwestern youth.

Drawing was the foundation for all of Bellows' work. He considered color to be an elaboration, secondary in importance to drawing. He believed that painting is "inseparable from the act of drawing; depends for its artistic value on its beauty and significance, on the shapes, directions, contrasts and relations with which it is drawn. In fact … all drawing carries the element of color both in fact and in suggestion and … all painting is dependent on drawing or is otherwise a shapeless and formless mess."[4] His drawings not only provided plastic volume, then, but in fact and suggestion, as he said, achieved a surprisingly wide range of color and tonal variations.

Most of Bellows' drawings are complete works in themselves and they cover a wide variety of subjects: portraits, prize fights, street scenes, religious themes, current events, and nude studies. He was a versatile and facile draftsman in

many media — initially using pen and ink, pencil, wash, charcoal, and pastel; later preferring lithographic crayon. But he was not averse to employing a combination of materials to achieve the effect he desired. *Ringside Seats* (fig. 86), for instance, is executed with graphite, crayon, black ink, and white wash. Bellows was always ready to experiment. This is one reason why it is difficult to organize his drawings chronologically. His style often changed from drawing to drawing, depending on the subject and his reaction to it. Thus, the extremely vigorous techniques used in many of his boxing scenes may be compared to the delicate, even fragile, portraits of his daughters Jean and Anne. But whatever the theme, Bellows drew with a free and sure hand, sensitive to the materials, to the subject, and to the purpose of the drawing.

One general stylistic change that can be observed, however, is the difference between the earlier, more spontaneously executed sheets influenced by Henri and the drawings produced after about 1918 when Bellows became a disciple of artist Jay Hambidge and his theory of dynamic symmetry. The influence of dynamic symmetry, which involved a series of geometric formulas governing a painting's composition, was just as pervasive as the earlier influence of Henri had been, affecting every aspect of his work — draw-

ings, lithographs, and paintings.

A crucial aspect of Bellows' draftsmanship was his activity as an illustrator, for his drawings for magazines played an important role in his career. Of necessity, his illustrations were bold, simple, vivid, and lively to capture the reader's interest, and this realistic and direct style translated into his paintings and lithographs. Beginning in 1912, his drawings (including several on boxing) appeared in popular periodicals such as American, Everybody's, Delineator, Metropolitan, Collier's, Masses, Harper's Weekly, and Harper's Monthly, which he considered to be forums for the best in contemporary American art and which supplemented his income by paying him $100 to $200 per drawing.[5] Harper's Weekly and Masses, especially, were in the forefront of modern illustration, hiring the most innovative artists of the day — ash can artists like Bellows, John Sloan, Everett Shinn — who produced bold sketches, exciting and often humorous in their anecdotes about city life, sports, adventures, and the American personality. This was the golden age of journalism and the era of the artist-reporter who spurned the more conservative stereotypes made popular by Charles Dana Gibson and his colleagues. Some illustrations of this period, like Bellows' four drawings for "The Last Ounce" (figs. 56, 59, 62, and 63) in American magazine, were specifically geared to a narrative, while others, like the boxing scenes, Playmates (fig. 67) and Savior of His Race (fig. 61) for Masses, were independent compositions unconnected to the articles that appeared in the magazines. Bellows' association with Masses, a radical journal, lasted from 1913 to 1917, during which time he contributed twenty-five illustrations and served as one of its art editors.[6] Although Bellows sympathized with the socialist philosophy behind this magazine, he did not agree that the journal should be propagandistic (its editors were tried for sedition in 1916), and his drawings for it rarely were didactic.[7]

In comparing Bellows' prize-fight drawings and lithographs, one finds little difference. Both, after all, are drawings, one on paper and one on stone. The prints reflect the simple, free, and often painterly aspects of the sheets. The difference is especially minimal when the drawings are executed with lithographic crayons, which Bellows began using by 1910, increasingly preferred, and toward the end of his career, used almost exclusively. In general, Bellows seems less concerned in his prints with anecdote and more attuned to formal considerations.[8] And there is a feeling of solidity and volume, especially, in these works that is sometimes lacking in the more quickly rendered caricature drawings.

It should be noted that when Bellows was new at lithography, he made preliminary drawings on paper, but soon dropped that practice, so, as Charles Morgan has observed, "some of his finest drawings never existed as such because he transcribed them, with his crayon, directly on to the lithographic stone."[9] Except for Introducing John L. Sullivan and Stag at Sharkey's, however, Bellows' prize-fight lithographs were based on drawings (sometimes executed many years earlier) and were extensions of them.

Bellows worked rapidly, but surely with a firm, unhesitating line. By relying on his visual memory for most of his fight pictures, Bellows was able to simplify, to omit the nonessentials, to capture the very essence of the human figure and the violence, smoke, and light of the boxing ring in a very few slashing strokes.[10]

Action and form were what he cared about. In a letter to Katherine Hiller in 1910, Bellows wrote, "I do not care about the expression of a prize fighter's mug. A prize fighter's muscles are his e pluribus unum. The expression on his face is about as important as the polish on a locomotive's headlight. . . . Prize fighters and swimmers are the only types whose muscular action can be painted in the nude legitimately."[11] Most of the pugilists he drew did not have readily identifiable faces, and many of the spectators are caricatures of men Bellows observed at Sharkey's. This changed in the later years when boxing became more accepted and Bellows, in his role of artist-reporter, was commissioned to draw scenes that included Jack Dempsey, Jess Willard, and Georges Carpentier.

Although Bellows was an athlete, and he and Henri often attended prize fights together for relaxation, he did not consider it of paramount importance to depict accurately the placement of the boxer's hands and feet. Rather, he sought — and accomplished — the perhaps more difficult task of capturing the brutality, physical energy, and human drama inherent in prize fighting.

In 1922, Bellows would reiterate his statement, made to Miss Hiller twelve years earlier, that boxing was the only instance in everyday life where the nude figure could be seen and studied, and he observed that "a fight, particularly under the night light, is of all sports the most classically picturesque."[12] Bellows, who excelled as a figure painter, was keenly interested in anatomy and had taken a college course in surgery, "to find out how the body reacted, what happened when a muscle tensed or a tightened fist shot forward."[13] And, in 1906, he, John Sloan, and Robert Henri, among

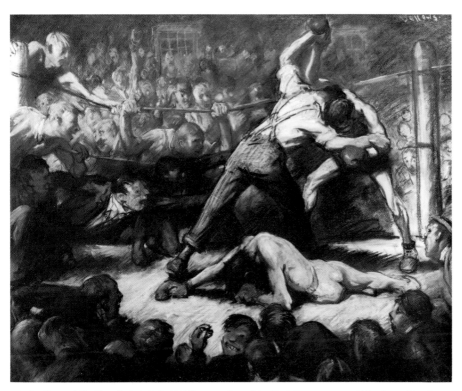

52. Bellows, *The Knock Out*, July 1907, pastel and India ink on paper, Private collection (cat. no. 7)

others, had attended anatomy lectures at the New York School of Art, given by Thomas Eakins' pupil, Thomas Anshutz.[14] In his boxing drawings, Bellows' interest appears to focus on the way the body moves rather than on the perfection of the human figure seen in the classical depictions of athletes.

Bellows' first rendition of a boxing scene is also one of his finest drawings. Based on his initial visit to Tom Sharkey's Athletic Club near his studio, this large (21 x 27 1/2 in.) pastel, entitled *The Knock Out* (1907, fig. 52, pl. 6), is not only an early display of the artist's powerful draftsmanship and bravura line but also a successful summary of the atmosphere at Sharkey's. As Charles Morgan has described it, the crowd was:

so small and so compact that it bred an instant intimacy and partisanship over the beer mugs and the smell of resin and cigars. Each clout and grunt from the ring rallied boos and cheers demanding a dramatic finish. Science went by the board in the excitement. No one wanted a decision, only a comatose body on the canvas and a blood-stained, hysterical victor standing above him in the ring, held back by the referee to prevent sheer murder.[15]

That Bellows captured on paper the heat and smell of the ring, the haze of cigar smoke, the noise and intensity of the event is a testament to this drawing's power. *The Knock Out* is a social statement, a satiric commentary on the brutality of boxing: the referee has to restrain bodily the winner to stop him from continuing to beat the man who has collapsed on the floor, while the crowd presses into the ring and screams for more. One gross figure hangs on the ropes, apelike, as he

tries to climb into the ring for a closer look. Bellows has also placed a "commentator" at ringside. The cigar-smoking man at the lower center of the composition turns to look at us with a demented grin, like a caricature that one finds in a work by Goya or Daumier. This is a character and pose that Bellows would reuse in other boxing pictures. He wrote, three years after he drew *The Knock Out*, "I am not interested in the morality of prize fighting. But let me say that the atmosphere around the fighters is a lot more immoral than the fighters themselves."[16] Except for figures in the sketchier preliminary drawings, Bellows shows us the crowds as well as the fighters, and often, as in *The Knock Out*, *Stag at Sharkey's*, and *Both Members of This Club*, spectators who are stereotypes of the American sports fan.

In *The Knock Out*, Bellows does not allow the viewer to remain detached from the scene, but puts him at ringside for the most dramatic moment of the fight. Although we know there must be ropes on all four sides of the ring, Bellows has omitted those nearest us (as George Luks omitted all ropes in his 1905 painting, *The Wrestlers*) to further the sense of our immediate participation.

This pastel, with its finished look, seems an academic work. The composition is unified and divided into a foreground, middle ground, and background. Bellows emphasized the anatomical structure of the fighters, especially the twisted body of the loser which reminds us of the straining wrestlers painted by Luks two years earlier. Indeed, the large, simple forms of the three main figures also bring to mind the work of Thomas Eakins, an artist whom Bellows greatly admired. A strong pyramidal structure dominates the composition. The defeated boxer provides the base of the triangle,

while the winner and referee, under the bright overhead light and pushing against each other, form the side diagonals. This is a motif that will appear again and again in Bellows' boxing works (*Stag, Playmates, Club Night, Both Members of This Club*, for example). The larger pyramid is echoed by smaller ones, noted especially in the spread legs of the two standing figures and in the defeated man's torso, as he tries to push himself up from the canvas floor. His twisted pose is reminiscent, in its noble spirit and muscular tension, of that of the ancient classical sculpture the *Fallen Warrior* which had been created to fit the triangular space of a Greek temple pediment.

Yet, for all its academic leanings, *The Knock Out* is also a very painterly work, with the lively strokes of colored crayons visible especially in the referee's shirt. Upon close inspection, it becomes apparent that the drawing is unfinished in several areas, notably the loser's legs below the calf and his boxing trunks, which are virtually nonexistent. While the pastel is almost monochromatic, consisting of varying tones of browns, grays, and blacks, it displays unexpected and delightful passages of colors such as green and rust. The artist explored all the expressive possibilities of the pastel crayons, from the thin, wiry lines of the suspenders on the gesticulating background spectator to the broad, full strokes on the referee's pants. With an economy of line, he captured the animated crowd and with just a few strokes drew the features of those at ringside. Yet he did not choose to show us the faces of any of the three principal figures in the ring.

Bellows, influenced by Henri, employed strongly contrasting lights and darks in this work. The figures in

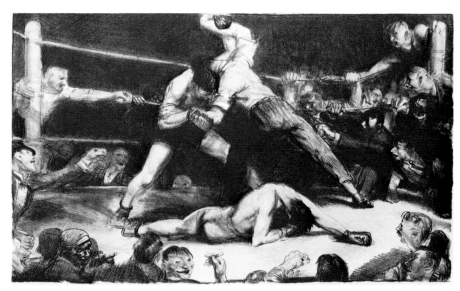

53. Bellows, A K*nockout*, first state, 1921, lithograph, Mead Art Museum, Amherst College, Mass., Gift of Professor Emeritus and Mrs. Charles H. Morgan, 1975 (cat. no. 36)

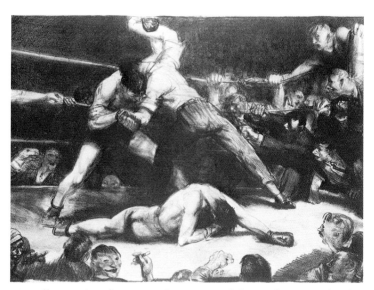

54. Bellows, A K*nockout*, second state, 1921, lithograph, National Gallery of Art, Washington, D.C., Andrew W. Mellon Fund, 1956 (cat. no. 37)

the foreground are in deep shadow, while the protagonists are in full view. White highlighting emphasizes the areas that would have been hit by the hot arena spotlight — the victor's shoulders, right knee, and thigh; the loser's right arm and shoulders; the referee's back; the upper part of the rope at right; and the right cheek of the grinning man in the foreground. Black strengthens

the curves of the figures, and broad, opaque strokes of India ink appear on the seat of the referee's pants and the hair of both the loser and the winner.

Although *The Knock Out* is a fully realized statement, complete in and of itself, Bellows used the composition fourteen years later as the basis for two lithographs entitled *A Knockout* (1921, figs. 53 and 54). In the first

state of the lithograph, Bellows has blanketed most of the spectators in darkness, save for those at ringside, has changed several figures, and has brought the triangular group a little closer to the center of the ring. In the second state, as in the first, we are one row closer to the fighters than we are in the pastel. The composition has been further tightened by the deletion of the figures and post to the left. The crowd seems more sedate and the emotions less intense, while the fans at ringside have taken on more individuality (note the man at far right, with attenuated features).

The pastel gives us a more intense feeling of immediacy, of participating in the human drama being acted out in the ring. The space that the fighters inhabit seems smaller and less protected from the gesticulating, shouting crowd as it begins to surge forward. And while the defeated boxer in the lithograph seems resigned to his fate, the downed man in the drawing, in pain, agonizes to push himself up to fight again.

Bellows' boxing scenes shocked many people who considered them vulgar. When the artist included *The Knock Out* in a 1911 exhibition in Columbus, Ohio (that city's first showing of contemporary art), the sponsors were so offended by the partial nudity in the drawing that it was placed in a locked and guarded room, accessible only to adult males.[17]

It was not until five years later that Bellows drew his next boxing scene, although a spirited pastel and charcoal entitled *Street Fight*, produced during those years, depicts two young boys fighting in a city park area, surrounded by a crowd of children (fig. 55). In 1912 *American* magazine commissioned Bellows — by now known for his

56. Bellows, *Introducing the Champion*, September 1912, black crayon and India ink wash on paper, unlocated (cat. no. 11)

55. Bellows, *Street Fight* (double-sided drawing), c. 1910, pastel and charcoal on paper, Fran and Arthur Horowitz, Minneapolis

three boxing paintings — to produce four drawings, for $150, as illustrations to accompany a story by L. C. Moise entitled "The Last Ounce." The story concerned a challenge fight between Jimmy Nolan, former lightweight champion of the world, and Tornado Black, Jimmy's sparring partner who had subsequently taken both Jimmy's title and wife. It was rumored that Nolan had lost his punch, but as he was about to be knocked out, he used his "last ounce" of strength to win the fight. The four drawings develop this narrative from beginning to end: *Introducing the Champion, Between Rounds, The Last Ounce,* and *Counted Out.*

Introducing the Champion (fig. 56, originally titled *Lightweight Champion*) depicts the theatrics of the ring as

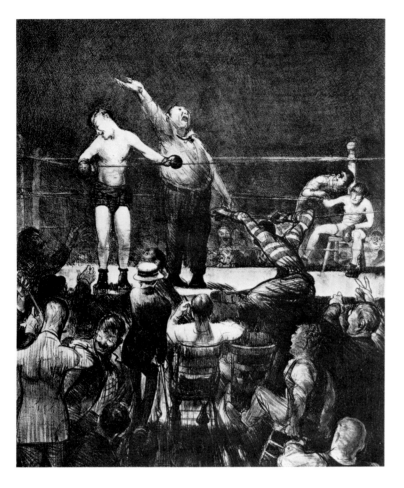

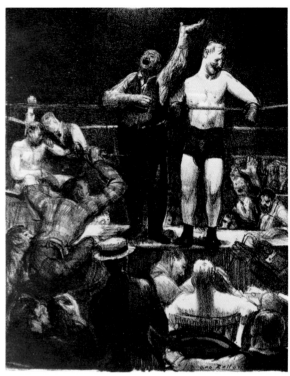

Left: 57. Bellows, *Introducing the Champion*, No. 1, 1916, lithograph, National Gallery of Art, Washington, D.C., Andrew W. Mellon Fund, 1956 (cat. no. 33)

Right: 58. Bellows, *Introducing the Champion*, No. 2, 1921, lithograph, National Gallery of Art, Washington, D.C., Andrew W. Mellon Fund, 1956 (cat. no. 42)

the announcer, with a dramatic sweep of his arm, introduces the current champion, Tornado Black, who cockily accepts the crowd's applause. Light is used to emphasize various figures in the arena and audience and to unify the composition, while one dominant line runs from the left foreground up the back of the spectator climbing into the ring and then up the left arm of the referee.

The drawing served as a source for two lithographs of the same title in which Bellows experimented with various designs. There is not much difference between the drawing and the larger print, *Introducing the Champion*, No. 1 (1916, fig. 57), but in the smaller version, *Introducing the Champion*, No. 2 (1921, fig. 58), we are

brought much closer to the referee and fighters and find ourselves directly behind the ringside spectators.

Between Rounds (fig. 59), which along with *Introducing the Champion* was included in the 1913 Armory Show, depicts a one-minute rest period during the boxing match in which the exhausted fighters retire to their respective corners and lean back against the ropes. This was a scene that Thomas Eakins had portrayed in 1899 in his painting of the same title. In Bellows' drawing, we are closer to the ring than in Eakins' painting, and we focus on Tornado Black, the champion and favored winner, who sits in the foreground as his crew surrounds and cares for him. One gives him water, another

whispers advice in his ear, and one fans him. This figure holds aloft a fan that picks up the strong overhead light and almost becomes a symbolic torch above the champion's head, as if his victory had been pre-ordained. Meanwhile, the audience also takes a break to discuss the previous round, to shout their own advice to the boxers, and perhaps to place bets on the outcome of the fight.

The Between Rounds theme keenly interested Bellows; he not only created two lithographs on the subject (one in 1916 and another, more technically accomplished, version in 1923, figs. 89 and 90), but two more drawings as well. The artist apparently kept a sketchbook of studies from which certain poses

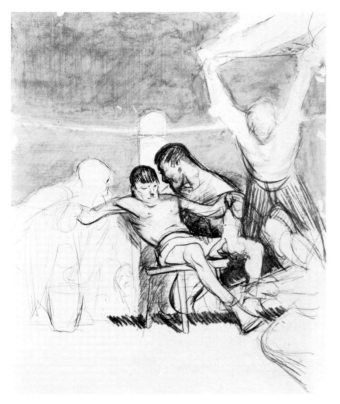

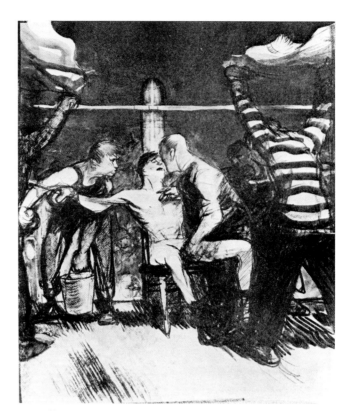

61. Bellows, *Savior of His Race*, c. 1912-1915, probably black crayon with India ink wash on paper, unlocated (cat. no. 13)

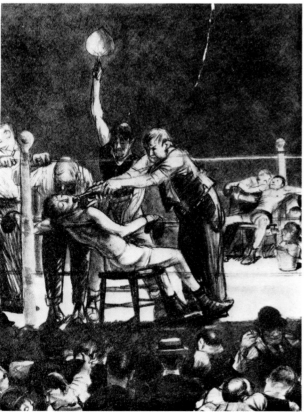

Top left: 60. Bellows, *Between Rounds*, 1912, black crayon on paper, Private collection (cat. no. 8)

Bottom left: 59. Bellows, *Between Rounds*, September 1912, probably black crayon on paper, unlocated (cat. no. 9)

and figures could be taken, and in all the Between Rounds graphics, many figures and gestures are used again and again.[18] However, the focal point of the other two drawings on this theme, *Between Rounds* (1912, fig. 60) and the *Savior of His Race* (c. 1915, fig. 61), is not Tornado Black, but his enervated opponent. Only the challenger's corner of the ring is shown, in close-up. His manager bends over with advice, one assistant fans the fighter with a towel, another brings a pail and, with pursed lips, blows air on the boxer's face. The breath is indicated, in shorthand fashion, by three lines.

The earlier Between Rounds drawing, quite sketchy but beautifully rendered, probably served as a preliminary study for the *Savior of His*

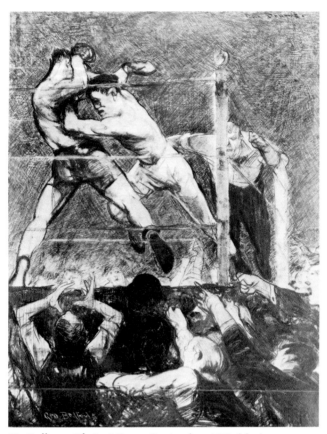

62. Bellows, *The Last Ounce*, September 1912, black lithographic crayon and India ink wash on paper, Mr. and Mrs. Peter R. Blum (cat. no. 12)

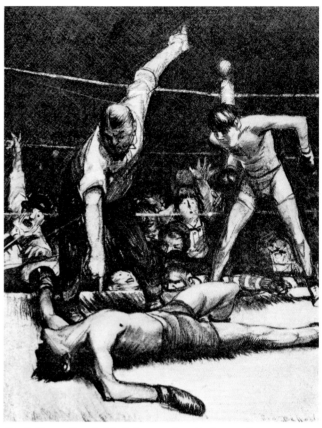

63. Bellows, *Counted Out*, September 1912, pencil on paper, Private collection (cat. no. 10)

Race which is more complete in execution. *Savior of His Race* is one of six illustrations that Bellows contributed in 1915 to the *Masses*. A comparison of the title and the exhausted fighter described suggests a satiric reference which may also allude to contemporary events that involved a succession of white boxers who fought the black champion, Jack Johnson. Jess Willard eventually took the title from Johnson in 1915, a month before this drawing appeared, and it is interesting to note that Jimmy Nolan, the character in the story from which this work derives, was fighting a boxer named Black.

The Last Ounce (fig. 62, originally titled *Against the Ropes*) was the only drawing from the *American* magazine

series on which Bellows did not base a lithograph. It depicts the most dramatic moment in the fight when we, at ringside with the frenzied spectators, witness Jimmy Nolan's surprise comeback and revenge. This illustration is similar to the others in the series in that it is powerfully drawn, but its lively action makes it the most interesting of the four. The fighter on the right lunges, in a fierce diagonal line, into his opponent with such intensity that it looks as if the combatants might come through the ropes (as Bellows would later depict Jack Dempsey falling). But the artist has inserted a strong, heavy line at the far left to stabilize the mass of their bodies. Bellows captured a moment of wild pandemonium. The crowd

roars, points, jabs, and punches in concert with the boxers.

Counted Out (fig. 63, known in recent years as *The Knockout*) gives us the culmination of the match as Tornado Black lies knocked out, flat on his back with arms outstretched like a crucified figure. Jimmy Nolan stands back and waits for the count but appears ready to knock Black down again, should the fighter get up. The strong horizontal line of the loser is offset by the verticals of the referee (theatrically posed, with his left arm in the air) and the challenger. All three figures form the pyramidal composition of which Bellows was so fond. The verticals are further accentuated by the post and the fans' upreaching arms. There is no longer a foreground; the viewer

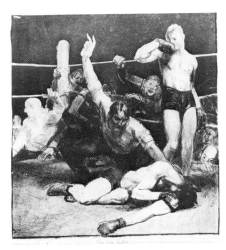

64. Bellows, *The Last Count*, 1921, lithograph, Boston Public Library, Print Department (cat. no. 38)

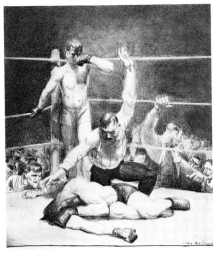

65. Bellows, *Counted Out, No. 1*, 1921, lithograph, National Gallery of Art, Washington, D.C., Andrew W. Mellon Fund, 1956 (cat. no. 39)

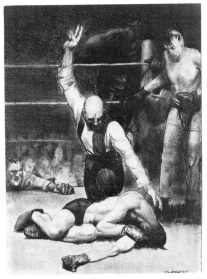

66. Bellows, *Counted Out, No. 2*, 1921, lithograph, National Gallery of Art, Washington, D.C., Andrew W. Mellon Fund, 1956 (cat. no. 40)

is right in the ring with the fighters. As in the other "Last Ounce" illustrations, lighting is arbitrary, with Bellows emphasizing certain figures while hiding others in shadow or darkness.

Counted Out served as the basis for three 1921 lithographs (figs. 64, 65, and 66), which all differ from the drawing and each other (while retaining the basic elements) as Bellows attempted to work out the composition. In one of the lithographs *The Last Count* (fig. 64), the audience becomes especially active and important, the spectators hanging onto the ropes to hear the count. And, for the first time in a boxing drawing, we see the artist himself in the audience, his bald pate visible at the far right.

In this series of four illustrations, Bellows drew in a very free and bold manner. He created broad shadows, using rapid, parallel strokes that were often smudged together, and alternated between strongly contrasting passages of light and dark that bring to mind the

quickly executed drawings of Theophile Steinlen and Jean-Louis Forain and the lighting seen in the graphics of Honoré Daumier.[19] Daumier, in fact, was a favorite of the ash can artists, particularly Robert Henri who introduced many of his students to Daumier's prints because they were excellent models for teaching that "art must always deal with *life*."[20] Daumier, who had vividly portrayed the common man in dramatic scenes, must have been a kindred spirit for Bellows.

By the time of the "Last Ounce" series, Bellows had discovered a medium highly sympathetic and responsive to his style of drawing. This was the lithographic crayon. Its beautiful texture and ability to achieve rich gradations of blacks and grays appealed to him, as did its supple edge and inherent flexibility; he could easily manipulate the crayon to create a variety of tonalities and lines. From this point on, lithographic crayon would be Bellows' preferred graphic medium.

A boxing drawing with the ironic

title of *Playmates* (fig. 67) appeared on the cover of the March 1915 issue of the *Masses*. It at once brings to mind the earlier boxing paintings, particularly *Stag at Sharkey's* (1909) and its portrayal of the collision of two human bodies. However, the foreground is now gone, and we are in the ring itself. In addition, the diagonals here are even stronger than those in *Stag*. The legs of the fighters are splayed (so much so that one boxer looks as if his hip might detach from his body), creating an even more perfect triangular composition. The figures seem to be moving with greater speed and force, as Bellows gives us the moment just before collision. The fighters, placed parallel to the picture plane, take up almost all of the space, with the left leg of the boxer at far right extending beyond the frame of the drawing. Again, Bellows has placed himself in the image as one of the relatively few spectators and can be seen peering over the ring left of center.

Although *Playmates* does not have

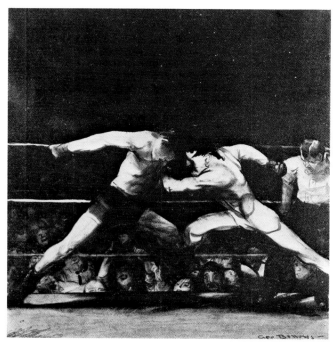

67. Bellows, *Playmates* (on cover of *Masses*), c. 1915, probably pen and ink, wash and crayon on paper, Delaware Art Museum, Wilmington, John Sloan Archives (cat. no. 14)

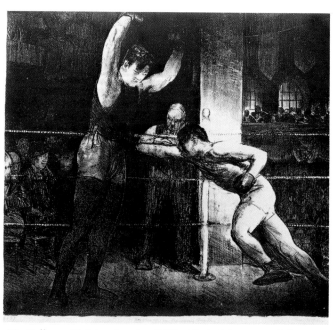

68. Bellows, *Training Quarters* (*Willard in Training*), 1916, lithograph, National Gallery of Art, Washington, D.C., Andrew W. Mellon Fund, 1956 (cat. no. 30)

the graceful dance of *Club Night* or the S-curved figure of *Stag*, it is imbued with an animalistic intensity of combat, as if two rams were charging head on. As in *Stag*, the figures are loosely drawn. The media appear to be pen and ink (the thin, delicate lines on the referee's face and shirt), wash (the referee's hair and wide lines on the right fighter's torso), and crayon (the rich overlay on the ring's canvas floor); for a black and white image, *Playmates* reveals a relatively wide range of tonal variations.[21]

Jess Willard defeated Jack Johnson in Havana, Cuba, on 15 April 1915, and *Collier's* commissioned Bellows, at a price of $300, to do three drawings, illustrating the boxing style of the new American fighting hero. Bellows reportedly studied Willard as he trained in his gym and was particularly intrigued by the way the "Pottawatomie Giant" would raise his powerful arms above his head

and allow his small sparring partners to hit him at will.[22]

A preliminary study for the lithograph entitled *Training Quarters* (fig. 68) shows us Bellows' sketches of the boxers' arms in various positions with the musculature stressed by firm lines and light shading of black crayon. One drawing (bottom right) in *Study of Arms* (1916, fig. 69) seems to be a sketch of the sparring partner's right arm, pulled back before letting go with the next punch.

A magnificent crayon and India ink wash drawing, *Preliminaries to the Big Bout* (c. 1916, fig. 70), was executed by Bellows after he went to the first boxing match in Madison Square Garden to which women were admitted.[23] The focus is not on the fight, but on the entrance of the women who are fashionably dressed and who remind us of the elegant ladies portrayed by Everett Shinn. In fact, the women could just as easily be arriving at the theater —

69. Bellows, *Study of Arms*, 1916, lithographic crayon on paper, Private collection (cat. no. 15)

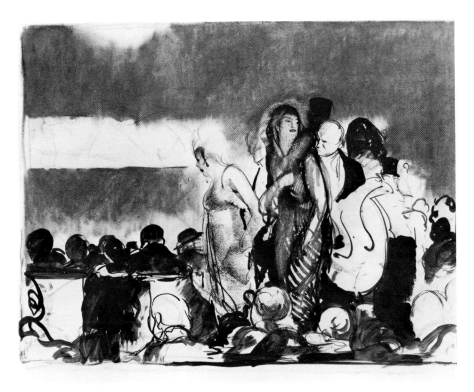

which Bellows loved to attend — as at a prize fight, for the lit area in the background looks like a stage. There are no signs of ropes or boxers. Yet, when comparing the drawing to the 1916 lithograph of the same title (fig. 71), for which it served as a study, one can see that in the former Bellows has lightly sketched a pyramidal composition in the area where he would later place the triangular group of figures consisting of the referee and fighters. Apart from the women, the spectators are sedately seated, as if in the orchestra section of a theater or symphony hall, unlike the unruly crowd shown in the earlier works at Sharkey's that depict a purely masculine world.

The lithograph is much more detailed in all respects, and here Bellows paid particular attention to the men in their top hats (who were deemphasized in the drawing in favor of the ladies) and to amusing vignettes such as the woman wearing a fur collar with a fox head peering out. But it is the drawing, with its harsh illumination, rich, glossy blacks, strong contrasts between light and dark, and swirling lines that captures our attention. There is a sense of liveliness and immediacy evoked by the extremely free handling of the brush, the sketchy way in which the wash has been applied to the paper. One feels the sheet was created very quickly, but with a sure, facile, and gifted hand.

Another drawing that was executed very freely and quickly is *Prize Fight* (fig. 72). Although it is difficult to date because of the way Bellows varied his style and the fact that it did not serve as a study for a lithograph or painting, the work probably comes from the period around 1919 when Bellows began using the special lithographic crayons that printer Bolton Brown devised for him.[24] According to Brown, Bellows used the

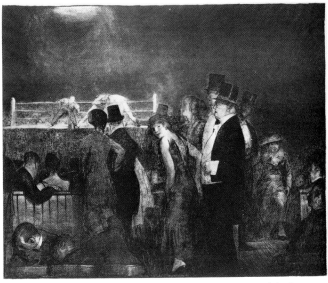

Top: 70. Bellows, *Preliminaries to the Big Bout*, c. 1916, black crayon and India ink wash on paper, Boston Public Library, Print Department (cat. no. 16)

Bottom: 71. Bellows, *Preliminaries to the Big Bout*, 1916, lithograph, National Gallery of Art, Washington, D.C., Andrew W. Mellon Fund, 1956 (cat. no. 31)

72. Bellows, *Prize Fight*, c. 1919,
lithographic crayon on paper, Mead Art
Museum, Amherst College, Mass., Gift of
Charles H. Morgan, 1976 (cat. no. 18)

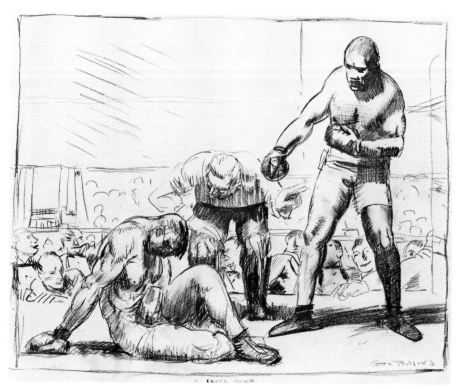

73. Bellows, A *Knock Down*, c. 1918-1921, black crayon on paper, Boston Public Library,
Print Department (cat. no. 17)

new medium "with a joy that was an actual avidity."[25] The dark marks of the crayon — the heaviness of the stroke — relate the drawing to some of the artist's later lithographs that also display these thick, greasy lines.

A *Knock Down* (c. 1918-1921, fig. 73) served as a preliminary study for the 1921 lithograph, *The White Hope* (fig. 74). The drawing is sketchy, very open, with much of the white of the paper showing through as in a cartoon. The hands and fingers of the spectator at far left are indicated by only several diagonal strokes, while cigars and bow ties consist of one or two heavy lines and the heads of the background spectators are a series of rounded lines. The scene probably depicts the 4 July 1910 fight in Reno, Nevada, between heavyweight champion Jack Johnson and James J. Jeffries, the "white hope" of that time. The *New York Eve-*

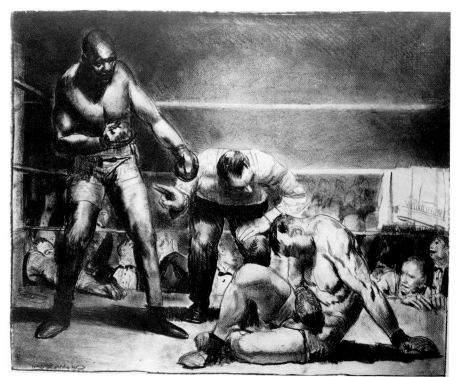

74. Bellows, *The White Hope*, 1921, lithograph, National Gallery of Art, Washington, D.C.,
Andrew W. Mellon Fund, 1956 (cat. no. 41)

60

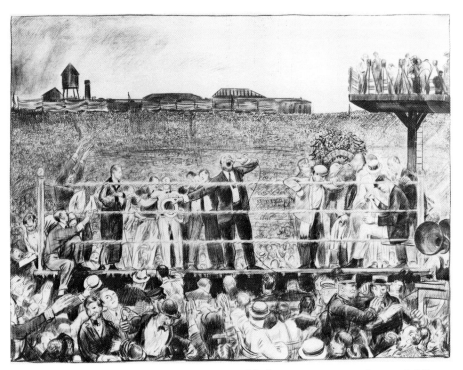

75. Bellows, *Introducing Georges Carpentier*, 1921, black crayon on paper, Boston Public Library, Print Department (cat. no. 20)

crayon. In the drawings Bellows chose not to depict intense and violent action, as he had in so many previous boxing pictures, but instead Carpentier's introduction to the audience (which, by this period, included motion picture cameramen). The introduction was the only moment of victory for "The Orchid Kid" that day. The crowd preferred Carpentier to Dempsey (who was considered a draft dodger), but the Frenchman was knocked out in the fourth round. Carpentier, a light heavyweight, looks quite frail in the drawing compared to the hulking figure of Dempsey, who tapes his hands in preparation for the fight.

Because he was on a reporting assignment, Bellows drew in detail the figures and faces of the fighters, distinguished guests, and spectators, so that many of the portraits would

ning Journal reported the fight in front page headlines, and its description exactly fits the drawing Bellows made: "Johnson was as eager as a wild cat at the end. Jeffries was like a bear mortally wounded."[26]

The sketch and lithograph, which are very close in composition (although the latter is a reverse image, as usual), depict the moment when the referee is counting out Jeffries, during one of the three times the white man was knocked unconscious in the fight. The lithograph is more finished and identifies the fighter with the round, bald head more clearly as a black man. Another lithograph, *Male Torso* (fig. 88), is a study for the downed figure of James Jeffries and allows us to concentrate on the very academically drawn and modelled male nude with special attention given to the musculature that Bellows had studied.

Bolton Brown reported that when the grand fight of 1921 between world heavyweight champion Jack Dempsey and Georges Carpentier was announced, the *New York World* engaged George Bellows "to be present and to make sketches of the event. George did, and . . . had notes and ideas for another prize-fight lithograph."[27] Having artists cover prize fights was not new, for in the 1860s, illustrators like Thomas Nast had been sent abroad to cover boxing matches for American newspapers.

Two drawings (one in the Boston Public Library and one unlocated), each a fully realized statement in its own right, are a result of Bellows' reporting assignment for the Dempsey-Carpentier fight. Both sheets are entitled *Introducing Georges Carpentier* (fig. 75) and are almost identical except that in one work Bellows has used India ink wash in addition to

76. *Dempsey-Carpentier Fight, Dempsey in Corner with Press*, 1921, photograph, Chicago Historical Society (ICHi-14211)

be identifiable to the newspaper readers. He gave equal attention to the ring, where announcer Joe Humphreys made the introduction, and the foreground audience of reporters (including the artist himself, from the back, at lower left). Contemporary photographs (fig. 76) of the event show us how well Bellows captured the crowd with its many boater hats, the uniformed police-

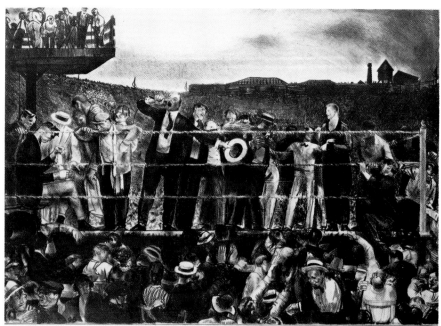

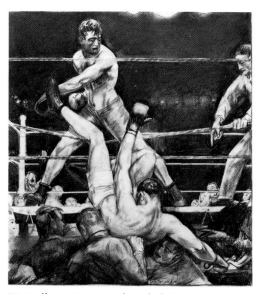

77. Bellows, *Introducing Georges Carpentier*, 1921, lithograph, National Gallery of Art, Washington, D.C., Andrew W. Mellon Fund, 1956 (cat. no. 43)

78. Bellows, *Dempsey through the Ropes*, September 1923, black crayon on paper, The Metropolitan Museum of Art, New York, Rogers Fund, 1925 (cat. no. 22)

man, and the floral wreath (with a ribbon wishing the fighter "success") in Dempsey's corner. The lithograph, of the same title and date (fig. 77), is based on the drawings, but Bellows has tightened up the composition somewhat (cutting the image at each side) and given us a closer view.

The Dempsey-Carpentier drawings, and those that follow, reveal the deep influence that Jay Hambidge and his theory of dynamic symmetry had upon Bellows' work. Bellows, after first hearing Hambidge speak in 1917, began to develop compositions based on strict mathematical formulas. His drawings had always shown a strong architectonic sense, but these compositions are so precisely calculated that they lack naturalness and spontaneity. Bellows came to regard dynamic symmetry as "probably more valuable than the study of anatomy," and forms, which used to be

rounded, are now more angular and flat (note the figure of Carpentier).[28] The unselfconscious strokes cherished in his early boxing pictures are gone.

The strict formal considerations of dynamic symmetry continued to preoccupy Bellows in his six drawings, two lithographs, and one painting of the 1923 "fight of the century" between Jack Dempsey and Luis Firpo. The first work of this series was created in September 1923, as a commission for the *New York Evening Journal*. In this initial crayon drawing entitled *Dempsey through the Ropes* (fig. 78) Bellows captured one of the most spectacular moments of boxing history. Dempsey, more popular than two years earlier when he fought Carpentier, was knocked completely out of the ring by his Argentinian opponent.

In contrast to *Introducing Georges Carpentier*, the Dempsey-Firpo images depict a scene of great excite-

ment and action. The artist has undertaken the difficult task of showing Dempsey's body falling backwards through the ropes, his right elbow projecting out of the picture plane. Yet it is a very controlled, graceful fall, frozen in time and stabilized by the triangular stance of Firpo and the horizontal lines of the ropes. In both the drawing and the lithograph (fig. 79) the composition seems overly contrived — with its tidy crisscross of arms and legs — and the figures seem wooden, though not as rigid and slick as those in the finished painting, *Dempsey and Firpo* (1924, fig. 44). Here, and in the lithograph of the same title (fig. 80), Bellows has given us a wider-angled view of the scene, creating a horizontal composition. But, the painting and lithograph are less successful than the relatively more spontaneous initial drawing with its lively hatch marks, stronger contrasts between lights

62

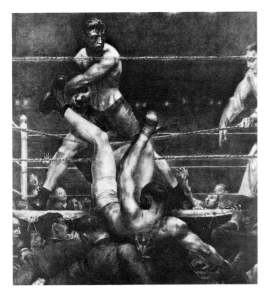

79. Bellows, *Dempsey through the Ropes*, 1923-1924, lithograph, National Gallery of Art, Washington, D.C., Andrew W. Mellon Fund, 1956 (cat. no. 46)

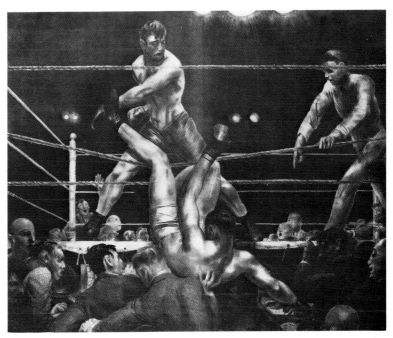

80. Bellows, *Dempsey and Firpo*, 1923-1924, lithograph squared off in pencil, Mead Art Museum, Amherst College, Mass., Gift of Mrs. George Bellows, 1959 (cat. no. 45)

and darks, and evocative depiction of Firpo's intense coal-black eyes.

The five sketches for *Dempsey and Firpo* (figs. 81-85) reveal that Bellows was still concerned with the study of the human body, its muscles and movement. But, although Frederick Sweet reported that Bellows made sketches on the spot at the fight, the studies have the cleaner lines of the 1924 painting rather than the more energetic ones of the early drawing.[29] The outlines

Left to right : 81. Bellows, *Study for "Dempsey and Firpo": Referee's Hands*, c. 1923-1924, lithographic crayon on paper, Private collection (cat. no. 23). 82. Bellows, *Study for "Dempsey and Firpo": Figure of Dempsey*, c. 1923-1924, lithographic crayon on paper, Mead Art Museum, Amherst College, Mass., Gift of Charles H. Morgan, 1976 (cat. no. 24). 83. Bellows, *Study for "Dempsey and Firpo": Head and Shoulders of Dempsey*, c. 1923-1924, lithographic crayon on paper,

Mead Art Museum, Amherst College, Mass., Gift of Charles H. Morgan, 1976 (cat. no. 25). 84. Bellows, *Study for "Dempsey and Firpo": Referee*, c. 1923-1924, lithographic crayon on paper, Mead Art Museum, Amherst College, Mass., Gift of Charles H. Morgan, 1976 (cat. no. 26). 85. Bellows, *Study for "Dempsey and Firpo": Arm of Firpo*, c. 1923-1924, lithographic crayon on paper, Mead Art Museum, Amherst College, Mass., Gift of Charles H. Morgan, 1976 (cat. no. 27)

63

of the five sketches are almost mechanically rendered, although the shading is still spirited and the artist's feeling for form and volume has not been lost. The appearance of the referee (with his necktie) and the close-up of his hands also resemble elements in the painting rather than those in the earlier work. The drawings of Dempsey's head and shoulders, his falling body, and the truly stunning study of Firpo's arm, especially, seem to be sketches from studio models.

In 1924 *Collier's* commissioned Bellows to illustrate a sentimental prize-fight story called "Chins of the Fathers." The result, a drawing entitled *Ringside Seats* (fig. 86), is another version of the "introductions" theme, portraying the moment before the "stampin' and slammin' of feet and the smash and thud of gloves . . . creakin' and groanin' of ropes and posts."[30] While the figures in the ring are relatively static, the audience is markedly active. Of particular interest is the woman at lower left who bears a strong resemblance to the stylized figures being painted in the 1920s by Bellows' colleague, Guy Pène du Bois.[31]

A comparison of the drawing and the painting of the same year and title indicates Bellows' talent as a draftsman, rather than as a colorist, in his later years. It also reveals the freshness of the drawing, with its livelier strokes, although the rigid geometric patterns of dynamic symmetry give an overall static feeling to both works. The mathematical system of proportion was all important to the followers of dynamic symmetry; Bellows believed proportion to be "almost everything in a work of art . . . fundamental in a fine thing, and must be held sacred."[32] Therefore, it is not surprising that when *Collier's* cropped the image for reproduction (fig. 87), Bellows sued

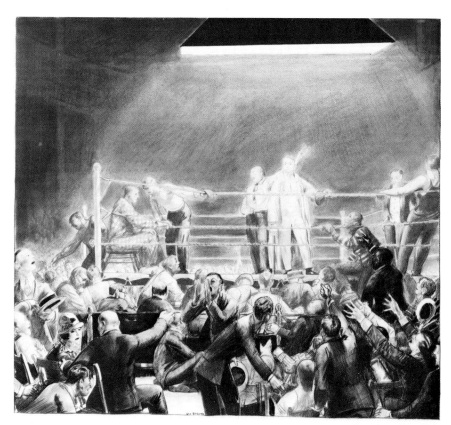

86. Bellows, *Ringside Seats*, March 1924, graphite, crayon, black ink, and white wash with scratch work and stumping on cream wove paper. Fogg Art Museum, Harvard University, Cambridge, Grenville L. Winthrop Bequest (cat. no. 28)

the magazine for destroying its light, shade, and proportion.

Bellows' drawings are remarkable in their boldness and in their feeling for form and movement. Those produced at his best — and earliest — are spontaneous and direct. And while one may not always find refinement in his execution, there is, above all, apparent delight in the *act* of drawing. This is revealed in the restless lines charged with energy and life and emotion, a vivacity reminiscent of Goya and Daumier. The later works, under the influence of dynamic symmetry, become more linear and planned, as the formal arrangement of the composition takes precedence over draftsmanship as such. But despite this, Bellows remained an unsurpassed draftsman who deftly used his line to express the American character, a feat few artists had previously or have since accomplished.

Notes

1. For information on Bellows' drawing during his youth, see: Frank Seiberling, Jr., "George Bellows, 1882-1925: His Life and Development as an Artist" (Ph.D. dissertation, University of Chicago, 1948), 14-15.
Charlene S. Engel, "The Realist's Eye: The Illustrations and Lithographs of George W. Bellows," *Print Review* 10 (1979), 70.
Charles H. Morgan, *George Bellows: Painter of America* (New York, 1965), 32-33.
Louis H. Frohman, "Bellows as an Illustrator," *International Studio* 78 (February 1924), 421.

87. Double-page reproduction of *Ringside Seats* (fig. 86) in the 3 May 1924 issue of *Collier's*

Charles Grant manuscript, 1937, National Gallery of Art's curatorial files for *Both Members of This Club*.

2. Morgan, *George Bellows*, 37.

3. Morgan, *George Bellows*, 37.

4. Marvin Sadik and Harold Francis Pfister, *American Portrait Drawings* |exh. cat., National Portrait Gallery| (Washington, D. C., 1980), 124.

5. Charlene Stuart Engel, "George W. Bellows' Illustrations for the *Masses* and Other Magazines and the Sources of His Lithographs of 1916-17" (Ph.D. dissertation, University of Wisconsin, Madison, 1976), 33, 44, 65.

6. John Sloan was its senior art editor, and it was he who persuaded many of his fellow artists to participate. He could not offer money for the illustrations, but could guarantee large, high quality reproductions of their work.

7. Engel, dissertation, 74. However, Bellows contributed a group of illustrations to an exposé of the Rev. Billy Sunday that appeared in *Metropolitan* magazine in May 1915.

8. Engel, dissertation, 66.

9. Charles H. Morgan, "Introduction," in *The Drawings of George Bellows* (Alhambra, California, 1973), n.p.

10. Morgan, *George Bellows*, 77, states that *Club Night*, like all his early figure compositions, was done from memory. In later years, Bellows would "make a quick sketch and then verify some of the points from a posed model." According to an article in the *New York Times Magazine* (John R. Tunis, "Painter of the Prize Ring Drama," 7 January 1945, 46), "Bellows made no sketches at the fight, but would jot down notes on a piece of paper, such as the back of an envelope. The next morning, he would work from memory."

11. Thomas Beer, "George Bellows," in *George Bellows: His Lithographs* (New York and London, 1928), 15.

12. Letter, 10 June 1922, from George Bellows to William Milliken, Cleveland Museum Archives.

13. John R. Tunis, "Painter of the Prize Ring Drama," 19.

14. Bruce St. John, ed., *John Sloan's New York Scene* (New York, 1965), 7.

15. Morgan, *George Bellows*, 76.

16. George Bellows to Miss Hiller, 1910, quoted in Beer, *George Bellows: His Lithographs*, 15-16.

17. Donald Braider, *George Bellows and the Ashcan School of Painting* (New York, 1971),

68. Four nudes by Arthur B. Davies and a group of etchings by John Sloan were also kept in the locked room. *The Knock Out* had been exhibited four times previous to the Columbus show.

18. Engel, dissertation, 57-59. Bellows said that *Between Rounds* portrays Madison Square Garden. See Lauris Mason, *The Lithographs of George Bellows: A Catalogue Raisonné* (Millwood, New York, 1977), 65.

19. Seiberling, dissertation, 78, 82, 96.

20. Francine Tyler, "The Impact of Daumier's Graphics on American Artists: c. 1863-1923," *Print Review* 11 (1980), 119.

21. Since the original is unlocated, we cannot be certain of the media.

22. Morgan, *George Bellows*, 198.

23. "The Passing Shows: Drawings," *Art News* 41 (1 October 1942), 27.

24. Letter, 9 October 1981, from Clinton Adams, director of the Tamarind Institute, to Deborah Chotner, National Gallery of Art.

25. Bolton Brown, "My Ten Years in Lithography (part 2)," introduction and notes by Clinton Adams, *The Tamarind Papers*, University of New Mexico, 5, no. 2 (summer 1982), forthcoming.

26. *New York Evening Journal* (5 July 1910), 1.

27. Bolton Brown, "My Ten Years in Lithography."

28. Morgan, *George Bellows*, 216.

29. Frederick A. Sweet, "George Wesley Bellows," in *George Bellows: Paintings, Drawings and Prints* |exh. cat., The Art Institute of Chicago| (Chicago, 1946), 24.

30. Jonathan Brooks, "Chins of the Fathers," *Collier's* (3 May 1924), 33.

31. Bellows would have known Pène du Bois well, since he also had been Henri's student and had often served as a spokesman for Henri's group. Pène du Bois and Bellows were among the artists who organized the Armory Show, and Bellows contributed decorative illustrations to *Arts and Decorations*, edited by Pène du Bois.

32. Morgan, *George Bellows*, 274, reprints Bellows' letter to *Collier's*.

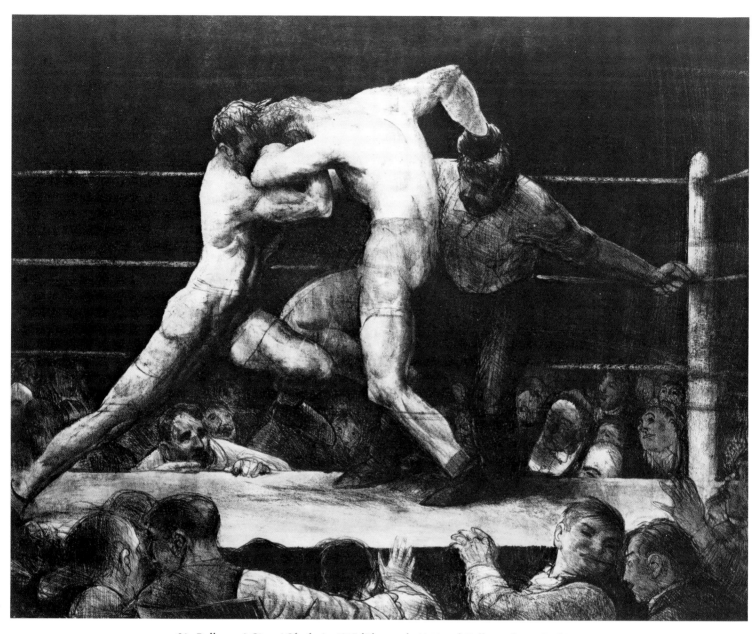

91. Bellows, *A Stag at Sharkey's*, 1917, lithograph, National Gallery of Art, Washington, D.C., Andrew W. Mellon Fund, 1956 (cat. no. 35)

Bellows: The Boxing Lithographs

Deborah Chotner

During the winter of 1915-1916, on the balcony inside his 19th Street studio, George Bellows first installed a lithographic press. He came to the medium ignorant of its technical challenges, yet full of enthusiasm for its expressive possibilities.

As an admirer of realist John Sloan's etchings showing people in everyday pursuits, Bellows had produced one such work himself, an etching of Robert Henri's night class. Although the print was successfully completed, he never again used intaglio methods, preferring instead the directness of drawing on stone. The lithographic technique was well suited to Bellows' style, which was forceful and muscular rather than delicate, in keeping with his own active character. Lithographer Bolton Brown aptly summed up the particular attraction of the medium: "art is not merely visual; partly it is, as Ruskin declared, athletics. That is, it is manual: . . . when we think of the relative possibilities of ploughing metal and controlling crayon — words are superfluous."[1]

Along with Joseph Pennell, John Sloan, Childe Hassam,Boardman Robinson, and Arthur B. Davies, Albert Sterner was among the early proponents of lithography in twentieth-century America. It was Sterner, the husband of Bellows' then dealer Marie Sterner, who first encouraged the artist in his early printmaking attempts and, most importantly, introduced him to master lithographer George Miller. With Miller as his technician Bellows printed the majority of the lithographs he executed between 1916 and 1919.[2] In his first year as a printmaker he produced thirty-five images and sold a sufficient number of impressions to earn a tidy sum.[3] The great popularity of his work helped to change the prevalent conception of the medium as a strictly commercial enterprise. At this time, American print collectors were purchasing plate-printed works almost exclusively: intricately detailed etchings, often landscapes or architectural subjects, were prevalent. Thus Bellows was the artist perhaps most responsible for lithography's growth as a fine art in this century.

It has been said that Bellows' graphic work was influenced by that of both Goya and Daumier. In his 1918 series depicting the atrocities committed by the enemy during World War I, Bellows attempted to emulate, though not effectively, Goya's shocking *Disasters of War*. His humorous prints with cartoonlike figures and situations, such as *Business-Men's Class* (1916), and his street scenes, such as *The Hold-Up* (1921), owe a certain debt to the social commentary of Daumier. Although Bellows gleaned a good deal from his renowned predecessors' choice of subject matter, his boxing subjects seem to spring up independent of any such influence. In addition, the style of Bellows' renderings was more bold and direct than that of either of the earlier artists. The remarkable richness, strength, and surety of line in his drawings was translated, unchanged, into his lithographs. In one of his earliest prints, *Male Torso* (fig. 88, 1916, later used as the basis for one of the figures in *The White Hope*), the artist tentatively experiments with the lithographic medium. The drawing, transferred from paper to stone, remains unfinished — with head, hands, and feet barely suggested. The print fully retains the spontaneity of the rough sketch made from life. Indeed, Bellows looked upon lithography as a direct extension of drawing rather than as a separate medium.

This view was shared by Bolton Brown, the artist and craftsman who was Bellows' printer from 1919 to 1925.[4] Brown declared that "considered physically, lithographs are prints; esthetically, they are drawings."[5] In the images he pulled, he successfully captured the delicate nuances and subtle gradations possible in crayon or pencil drawings and was so attuned to his medium that he developed lithographic crayons "of a very wide range of effects of great variety and profoundly divergent."[6] Brown's printing had an important impact on Bellows' work.

88. Bellows, *Male Torso*, 1916, lithograph, Mead Art Museum, Amherst College, Mass., Gift of Malcolm Stearns, 1947 (cat. no. 29)

His grinding of the stones as well as the use of his special crayons helped to provide a velvety surface texture and range of tones not present in the lithographs pulled by George Miller. In this manner Brown also moved Bellows away from the coarser, strongly contrasting renderings of black and white that he had first created as an illustrator for periodicals. While the fine quality of Brown's printing has generally been acknowledged, it may be said that Miller's consistent and professional but rougher, more vigorous treatment of Bellows' subjects did them equal justice. This is particularly evident in a comparison of prints such as *Between Rounds, No. 1* (1916,

fig. 89), printed by Miller, to *Between Rounds, No. 2* (1923, fig. 90), printed by Brown.

Although the works' sizes differ, their compositions are nearly identical. *Between Rounds, No. 1*, however, has a scratchy texture that is wiry and energized. The light areas jump out from the dark ones to duplicate the harsh glare of the ring lights. *Between Rounds, No. 2* displays greater clarity in the restless ringside crowd and increased modeling in the bodies of the boxers. The other difference between the two prints is a minor, but interesting, one. The fighter in the foreground in *Between Rounds, No. 2* is given a slightly less reclining position than in the earlier

version. His spine curves and sags and his head falls back, creating a sense of leaden and exhausted weight. This position, not incidently, places the boxer's head closer to the center of the scene where it becomes the thematic as well as compositional focus.

During his nine years as a printmaker, Bellows produced approximately 193 lithographs. The editions of each varied considerably in size and may not have always been accurately recorded. Bellows' daughter recalls: "a great many prints that came off the press were discarded[.] How well I remember that upstairs balcony — strewn with discarded lithographs! Anne and I would often use the reverse side to draw pictures on."[7] Of the nearly 200 different images Bellows created, the largest group (53) were portraits, often of his wife and daughters. Other subjects were episodes from literary sources, social and religious commentary, nudes, and a number of urban genre scenes typical of the ash can school. However, the most popular of his prints during his lifetime and after his death continued to be his boxing images, even though he created a relatively small number of them, just 16 in all. They are the lithographs which commanded the highest prices, and the works most often discussed in reviews of his print exhibitions. Yet according to Ruth Pielkova, writing in 1928, they were not immediately successful:

And Bellows' sardonic humour, his vivid depiction of the brutalities and vulgarities of his fellows gave him only a kind of *succès de scandale* with the public, to whom his virtuosity seemed of less importance than that most of his subject matter was decidedly unpleasant. Yet now, only three years after his death, these lithographs have become highly priced rarities.[8]

What had at first seemed "un-

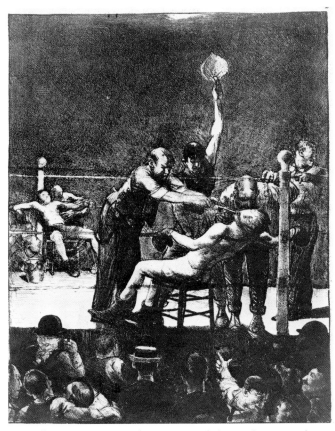

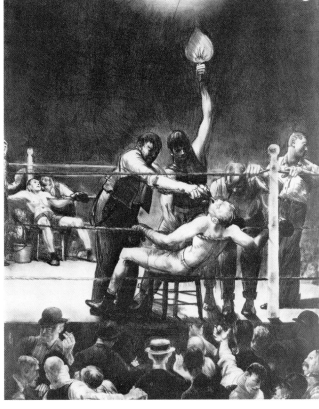

89. Bellows, *Between Rounds, No. 1*, 1916, lithograph, National Gallery of Art, Washington, D.C., Andrew W. Mellon Fund, 1956 (cat. no. 32)

90. Bellows, *Between Rounds, No. 2*, 1923, lithograph, National Gallery of Art, Washington, D.C., Andrew W. Mellon Fund, 1956 (cat. no. 44)

pleasant" was soon deemed to be a spirited and accurate representation of a great American sport. The most violent, yet finest and most sought after of these lithographs is A *Stag at Sharkey's* (fig. 91) which successfully duplicates the drama of the tightly composed, action-filled painting of the same title. The struggling figures in *Stag* illustrate an element characteristic of the most active of the boxing subjects. Though each part of the fighters' bodies may be drawn with care, the small passages, gestures, and details do not by themselves evoke a fraction of the power and dynamism that results from the entire composition, pitting force against force. Examination of an isolated figure in some of the boxing prints will sometimes

show primarily a concern with the feeling evoked by the placement, the gesture, of the entire body. Such is the case in A *Knockout* (fig. 92) in which the legs of the fallen fighter are ambiguously placed, but the figure's entire posture strongly suggests the exhaustion of defeat.

Some of Bellows' prize-fighting subjects were first seen as magazine illustrations. The images of *Between Rounds, No. 1* and *Introducing the Champion, No. 1* (both of 1916) were found, in reverse, as illustrations for a story called "The Last Ounce," which appeared in *American* magazine in April 1913. The print *Dempsey through the Ropes* (1923-1924) was derived from a drawing which the *New York Evening Journal* had commissioned the artist to make of the famous Dempsey-

Firpo fight. The graphic versions of the subject formed the basis for the painting *Dempsey and Firpo* (1924). Other Bellows boxing subjects, including paintings and drawings which are discussed elsewhere in this catalogue, are closely related to the prints. In the case of *Introducing John L. Sullivan*, the painting (1923) of the episode is based upon the lithograph (1916), while the well-known *Stag at Sharkey's* existed for eight years as a painting before Bellows made the lithograph of the same subject.

Nearly all the boxing lithographs, particularly the most action filled, have the appearance of being made from sketches taken from life. Although Bellows attended matches, including the Dempsey-Firpo bout,

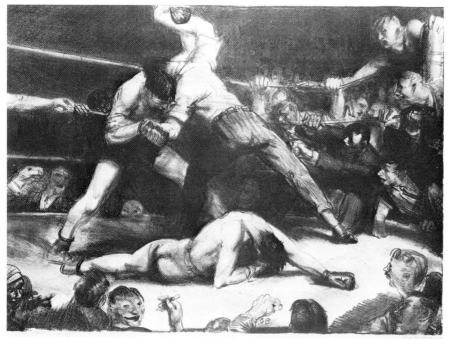

92. Bellows, A *Knockout*, second state, 1921, lithograph, National Gallery of Art, Washington, D.C., Andrew W. Mellon Fund, 1956 (cat. no. 37)

1. Bolton Brown, *Lithography* (New York, 1923), 10.

2. Several others from this period may have been printed by Edward Kraus(e). As noted in Lauris Mason, *The Lithographs of George Bellows: A Catalogue Raisonné* (Millwood, New York, 1977), 24: "Those lithographs, if any, that were pulled by Edward Kraus(e) are unknown, but it is possible that Kraus(e) pulled the War Series for Bellows while George Miller was serving in the U.S. Navy."

3. In the year after Bellows began to practice lithography he made almost $1,000 on the sale of his prints. Bellows Accounts, Box 5, Folder 16, Frost Library, Amherst, Mass., as noted in Charlene S. Engel, "George Wesley Bellows' Illustrations for the *Masses* and Other Magazines and the Sources of His Lithographs of 1916-17," (Ph.D. dissertation, University of Wisconsin, Madison, 1976), 118.

4. These dates, which differ from those previously published, are taken from Brown's manuscript "My Ten Years in Lithography." Discovered in the collection of the Bryn Mawr College Library, this manuscript has been published for the first time in *The Tamarind Papers*: Bolton Brown, "My Ten Years in Lithography (part 1)," introduction and notes by Clinton Adams, *The Tamarind Papers*, University of New Mexico, 5, no. 1 (Winter 1981-1982), 18.

5. Brown, *Lithography*, 6.

6. Bolton Brown, "Lithography as a Fine Art," *The American Printer* (July 20, 1922), 28.

7. Letter of 8 September 1981 from Jean Bellows Booth (Mrs. Earl M. Booth) to Linda Ayres, assistant curator of American art, National Gallery of Art.

8. Ruth Pielkova, "The Lithographs of George Bellows," *Creative Art* (June 1928), 413.

9. One account records both Bellows' on-the-spot sketching and the process of transforming these notes: "When the Carpentier-Dempsey prizefight was put on, one of the newspapers engaged

most accounts indicate that his prints were created in good part from his imagination.[9] The sense of immediacy one feels upon viewing them is due to Bellows' excellent memory of events, his great talent for composition, and the vivacity of his drawing which, according to Emma Bellows, was done directly on stone.[10]

The least natural in feeling of Bellows' prize-fighting lithographs are the last two he made. These are examples of the rigid system of "dynamic symmetry" which the artist used increasingly after 1916. Employing the precise geometric formulas devised by the system's founder, Jay Hambidge, Bellows carefully chose the poses and placement of his figures within the composition. As a result of his conscientious adherence to these precepts, the figures in both *Dempsey and Firpo* and *Dempsey through the Ropes* have a peculiar, stilted quality. Nevertheless critic Henry McBride recommended the *Dempsey and Firpo* print to collectors in a 1924 review, calling it, despite reservations, "a stirring account of the most lively prize fight that ever occurred . . . a wonderful souvenir of a historic occasion."[11]

The popularity of the boxing prints would seem to be due in great part to their function as remembrances. While Bellows' portraits carry very personal statements and his literary subjects convey restrained messages, these lithographs document a shared national awareness of a sport which ranged from the brutal and banal to the supremely athletic and triumphant. But Bellows goes beyond recording the specifics of important matches between well-known opponents to capture the full range of emotions which boxing evokes.

George to be present and to make sketches of the event. George did, and as a result had notes and ideas for another prizefight lithograph. This lithograph he drew in the summer, at my place. I fixed him a table and a stone by a north window in the woodshed, and everyday he drove over and worked a while on his design." Brown, "My Ten Years in Lithography (part 2)," *The Tamarind Papers*, 5, no. 2 (Summer 1982), 39.

10. Mason, *Lithographs of George Bellows*, 43. An exception is the earliest print, *Male Torso*, which was transferred from a drawing on paper.

11. Henry McBride, "Dempsey-Firpo Lithograph Attracts Art Collectors," *New York Herald* (17 February 1924), sec. 7, 13.

Plate 7. Bellows, *Club Night*, Mrs. John Hay Whitney (cat. no. 1)

Catalogue
Linda Ayres and Deborah Chotner

The following is a complete catalogue of the known boxing images by George Bellows, including paintings, drawings, and lithographs. Within each group, works are arranged chronologically. Dimensions are in centimeters followed by inches, height preceding width. All known information regarding provenance and exhibition history is given. In the provenance listings, brackets indicate that the work was in the possession of a commercial gallery. Each catalogue entry has a reference photograph of the object, and some entries list a figure or plate number that corresponds to an illustration in the text.

A indicates that the work is in the exhibition.

Paintings

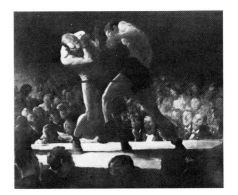

1. *Club Night* (originally titled A *Stag at Sharkey's*), August and September 1907

 fig. 25, pl. 7
oil on canvas
109.2 x 134.6 cm. (43 x 53 in.)
Mrs. John Hay Whitney

Provenance
The Artist
Estate of George Bellows
[Hackett Galleries, New York, 1930]
Mr. and Mrs. John Hay Whitney, 1930-1982

Exhibitions
National Academy of Design, New York, *Winter Exhibition* (December 14, 1907–January 11, 1908), no. 383, as *Stag at Sharkey's*.

Pennsylvania Academy of the Fine Arts, Philadelphia, *103rd Annual Exhibition* (January 20–February 29, 1908), no. 251, p. 29, as A *Stag at Sharkey's*.

Carnegie Institute, Pittsburgh, *Twelfth Annual Exhibition* (April 30–June 30, 1908), no. 20, as *Stag at Sharkey's*.

Cleveland Athletic Club, Ohio, 1909.

Pen and Pencil Club, Columbus, Ohio, 1909.

Southern Hotel, Columbus, Ohio, 1909.

Texas State Fair, 1909.

Corcoran Gallery of Art, Washington, D. C., *Commemorative Exhibition by Members of the National Academy of Design (1825-1925)* (October 17–November 15, 1925), p. 99, lent by Mrs. George Bellows.

Grand Central Galleries, New York, *Commemorative Exhibition by Members of the*

National Academy of Design (1825-1925) (December 1, 1925–January 3, 1926), no. 200, p. 99.

The Junior League of the City of New York, *Sport in Art from Ancient to Modern Times, for the Benefit of the Artists and Writers Dinner Club* (April 11–26, 1934).

National Gallery of Art, Washington, D.C., *George Bellows: A Retrospective Exhibition* (January 19–February 24, 1957), no. 5, pp. 14, 40 (illus.).

Whitney Museum of American Art, New York, *The Museum and Its Friends: Twentieth-Century American Art from Collections of the Friends of the Whitney Museum* (April 30–June 15, 1958), no. 6, pp. 8 (illus.), 17.

Corcoran Gallery of Art, Washington, D.C., *The American Muse* (April 4–May 17, 1959), no. 14.

Delaware Art Center, Wilmington, *The Fiftieth Anniversary of the Exhibition of Independent Artists in 1910* (January 9–February 21, 1960), no. 2, and Graham Gallery, New York (March 8–April 2, 1960). Although the exhibition catalogue indicates that this painting was in the 1910 exhibition, it was really the painting now called *Stag at Sharkey's* (known as *Club Night* prior to 1921) that was in the original 1910 show. The measurements given are also those for Cleveland's *Stag*.

Yale University Art Gallery, New Haven, Connecticut, *Paintings, Drawings, and Sculpture Collected by Yale Alumni* (May 19–June 26, 1960), no. 131, p. 124 (illus.).

Gallery of Modern Art, New York, *George Bellows: Paintings, Drawings, Lithographs* (March 15–May 1, 1966), no. 8 (of paintings), p. 12 (illus.).

Yale University Art Gallery, New Haven, Connecticut, *American Art from Alumni Collections* (April 25–June 16, 1968), no. 143 (illus.).

M. Knoedler & Co., Inc., New York, *What is American in American Art* (February 9–March 6, 1971), as *Club Night at Sharkey's*, no. 89, pp. 37, 67 (illus.).

This is the earliest of Bellows' oil paintings on the boxing theme and depicts a fight at Tom Sharkey's Athletic Club in New York. Originally titled *A Stag at Sharkey's*, the painting was retitled before or in 1921. A documentary sketch of this work appears in the artist's Record Book A, page 40.

2. *Stag at Sharkey's* (originally titled *Club Night*), August 1909

fig. 28, pl. 4
oil on canvas
92.1 x 122.6 cm. (36¼ x 48¼ in.)
signed, upper left: *Geo. Bellows/Copyrighted* 190(?); signed and inscribed on back: *Geo. Bellows, 146 E. 19th St., N.Y.* "*Club Night*" 67.
Cleveland Museum of Art, Hinman B. Hurlbut Collection

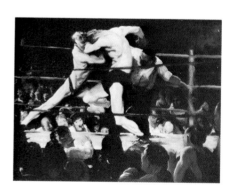

Provenance
The Artist
[Marie Sterner, New York]

Exhibitions
Pennsylvania Academy of the Fine Arts, Philadelphia, *105th Annual Exhibition* (January 23–March 20, 1910), no. 323, p. 37, as *Club Night*.

Exhibition of Independent Artists, New York (April 1–27, 1910), no. 20, as *Club Night*.

Madison Gallery, 306 Madison Avenue, New York, early in 1911.

Syracuse Museum of Fine Arts, New York, *Summer Exhibition of Paintings by American Artists* (May 10–October 1, 1911), no. 1, as *Club Night*.

Marshall Field, Chicago, 1911.

Curtis Studios, 1911.

The Cedar Rapids Art Association, Art Gallery, Public Library, Iowa, *Fifth Annual Art Exhibition* (February 5–14, 1913), no. 2, as *For the Title*.

Rochester, New York, *Rochester Industrial Exposition* (September 7–19, 1914), no. 6, as *Club Night*.

San Francisco, 1915, according to the Record Book.

The Art Institute of Chicago, *Paintings by George Bellows* (December 10, 1914–January 3, 1915), no. 16, as *Club Night*.

Detroit Museum of Art, *Exhibition of Paintings by George Bellows* (January 6–29, 1915), no. 16, as *Club Night*.

Los Angeles Museum of History, Science, and Art, *Paintings by George Bellows, N.A.* (February 7–28, 1915), no. 16, as *Club Night*.

The Minneapolis Institute of Arts, *Paintings by Lester D. Boronda; Paintings by George Bellows* (May 4–31, 1915), no. 37, as *Club Night*.

Hackley Art Gallery, Muskegon, Michigan, *Exhibition of Oil Paintings by George Bellows* (June 9–August 1915), as *Club Night*.

Worcester Art Museum, Massachusetts, *Exhibition of Paintings by George Bellows, New York City* (September 5–26, 1915), no. 13, as *Club Night*.

Cincinnati Art Museum, *Special Exhibition of Paintings by Mr. George Bellows* (October 1915), no. 4, as *Club Night*.

First Retrospective Exhibition of American Art, sponsored by Junior Art Patrons of America, Fine Arts Building, New York (May 7–21, 1921), no. 10.

Cleveland Museum of Art, *Second Exhibition of Contemporary Painting* (June 8–July 8, 1922), p. 106 (illus.), lent by Mrs. Albert Sterner.

The Metropolitan Museum of Art, New York, *Memorial Exhibition of the Works of George Bellows* (October 12–November 22, 1925), no. 7, pp. 24, 48 (illus.), as *Sharkey's*.

Columbus Gallery of Fine Arts, Ohio, *Important Paintings by George Wesley Bellows* (January–February 1931), no catalogue, but a checklist was published in *Bulletin of the Columbus Gallery of Fine Arts*, 1, no. 1 (January 1931), 16.

Los Angeles Museum of History, Science, and Art, *Olympic Competition and Exhibition of Art* (July 30–August 31, 1932), no. 728, p. 50 (illus.).

The Museum of Modern Art, New York, *American Painting and Sculpture, 1862-1932* (October 31, 1932–February 11, 1933), no. 1, p. 25.

The Art Institute of Chicago, *Century of Progress: Exhibition of Paintings and Sculpture* (June 1–November 1, 1933), no. 434, p. 60, pl. LXXXVIII.

Cleveland Museum of Art, *Twentieth Anniversary Exhibition of the Cleveland Museum of Art: The Official Art Exhibit of the Great Lakes Exposition* (June 26–October 4, 1936), no. 346.

Whitney Museum of American Art, New York, *New York Realists* 1900-1914 (February 9–March 5, 1937), no. 8, p. 12 (illus.).

Cleveland Museum of Art, *American Painting from 1860 until Today* (June 23–October 4, 1937), no. 5, p. 12.

Musée du Jeu de Paume, Paris, *Trois siècles d'art aux Etats-Unis* (May 24–July 31, 1938), no. 5, p. 34, fig. 28.

The Metropolitan Museum of Art, New York, *Life in America* (April 24–October 29, 1939), no. 279 (illus.).

Art Gallery of Toronto, *An Exhibition of Great Paintings in Aid of the Canadian Red Cross* (November 15–December 15, 1940), no. 121, pp. 24 (illus.), 26.

Museum of Fine Arts, Boston, *Sport in American Art* (October 10–December 10, 1944), no. 3, p. 8.

The Art Institute of Chicago, *George Bellows: Paintings, Drawings and Prints* (January 31–March 10, 1946), no. 5, pp. 14 (illus.), 37.

Tate Art Gallery, London, *American Painting* (June–July 1946), no. 16, p. 9.

The Buffalo Fine Arts Academy, Albright Art Gallery, *Sport in Art* (January 23–February 22, 1948), no. 5.

Addison Gallery of American Art, Phillips Academy, Andover, Massachusetts, *The Ring and the Glove* (September 17–November 14, 1948). Although the exhibition originated at the Museum of the City of New York, *Stag at Sharkey's* was only shown at Addison and did not appear in the catalogue.

Institute of Contemporary Art, Boston, *American Painting in Our Century* (January 20–March 1, 1949), no. 3, pp. 29, 38, 39 (illus.); traveled to:
Art Association of Montreal (March 15–April 15, 1949); Colorado Springs Fine Arts Center (May 5–June 25, 1949); M. H. de Young Museum, San Francisco (July 10–August 25, 1949); Los Angeles County Museum (September 7–October 16, 1949); Cleveland Museum of Art (November 3–December 18, 1949).

The Century Association, New York, *Aspects of New York City Life* (March 1–April 30, 1950).

The Century Association, New York, *Exhibition of Sporting Art* (January 13–March 28, 1954).

Cleveland Museum of Art, *Art: The International Language* (October 2–November 4, 1956).

National Gallery of Art, Washington, D.C., *George Bellows: A Retrospective Exhibition* (January 19–February 24, 1957), no. 13, pp. 16, 47 (illus.).

Columbus Gallery of Fine Arts, Ohio, *Paintings by George Bellows* (March 21–April 21, 1957), no. 11, cover (illus.).

The Minneapolis Institute of Arts, *Four Centuries of American Art* (November 27, 1963–January 19, 1964), pp. 23 (illus.), 45.

The City Art Museum of St. Louis, *200 Years of American Painting* (April 1–May 31, 1964), p. 35 (illus.).

The Brooklyn Museum of Art, *Triumph of Realism: An Exhibition of European and American Realist Paintings, 1850-1910* (October 3–November 19, 1967), not in catalogue and did not go on tour.

Whitney Museum of American Art, New York, *The Painter's America: Rural and Urban Life, 1810-1910* (September 20–November 10, 1974), no. 154, pp. 125, 131 (illus.); traveled to: Museum of Fine Arts, Houston (December 5, 1974–January 19, 1975); and The Oakland Museum, California (February 10–March 30, 1975).

Albright-Knox Art Gallery, Buffalo, *Heritage and Horizon: American Painting 1776-1976* (March 6–April 11, 1976), no. 38 (illus.); traveled to: The Detroit Institute of Arts (May 5–June 13, 1976); The Toledo Museum of Art (July 4–August 15, 1976); Cleveland Museum of Art (September 8–October 10, 1976).

Columbus Museum of Art, Ohio, *George Bellows: Paintings, Drawings, and Prints* (April 1–May 8, 1979), no. 12, p. 23 (illus.), this painting did not go to other stops on tour.

Depicts a fight at Sharkey's Athletic Club. A documentary sketch for this painting appears in the artist's Record Book A, page 67.

3. *Both Members of This Club*
(originally titled *A Nigger and a White Man*), October 1909

fig. 29, pl. 5
oil on canvas
115.0 x 160.5 cm. (45¼ x 63⅛ in.)
signed, lower right: *Geo Bellows*
National Gallery of Art, Washington, D.C., Gift of Chester Dale, 1944

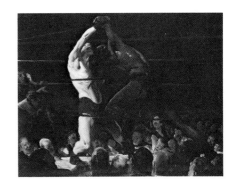

Provenance
The Artist, 1909-1925
Estate of George Bellows, 1925-1944
[H. V. Allison & Co., New York]
Chester Dale, New York, 1944

Exhibitions
Pennsylvania Academy of the Fine Arts, Philadelphia, *105th Annual Exhibition* (January 23–March 20, 1910), no. 338, p. 38.

Exhibition of Independent Artists, New York (April 1–27, 1910), no. 53.

The Buffalo Fine Arts Academy, Albright Art Gallery, *Fifth Annual Exhibition of Selected Paintings by American Artists* (May 11–September 1, 1910), no. 12, p. 14.

The City Art Museum of St. Louis, *Fifth Annual Exhibition of Selected Paintings by American Artists* (September 15–November 15, 1910), no. 11.

MacDowell Club, New York, 1917.

The Metropolitan Museum of Art, New York, *Memorial Exhibition of the Works of George Bellows* (October 12–November 22, 1925), no. 10, pp. 24, 55 (illus.).

Columbus Gallery of Fine Arts, Ohio, *Thirty-six Paintings by George Bellows* (October 3–November 6, 1940).

H. V. Allison & Co., New York, *Paintings by George Bellows* (March 27–April 29, 1944).

The Museum of Modern Art, New York, *Art In Progress: 15th Anniversary Exhibition: Painting, Sculpture, Prints* (May 24–October 15, 1944), pp. 38, 39 (illus.), 218, lent by Mrs. George Bellows.

The Art Institute of Chicago, *George Bellows: Paintings, Drawings and Prints* (January 31–March 10, 1946), no. 6, pp. 18 (illus.), 37.

The Century Association, New York, *Robert Henri and Five of His Pupils* (April 5–June 1, 1946), no. 6, pl. 6.

National Gallery of Art, Washington, D.C., *George Bellows: A Retrospective Exhibition* (January 19–February 24, 1957), no. 14, pp. 16, 46 (illus.).

Originally titled *A Nigger and a White Man*, the work was retitled by the artist within three months after its execution. The painting depicts a fight at Sharkey's, possibly the one in March 1909 between the black Joe Gans, former lightweight champion, and Jabez White. The title, *Both Members of This Club*, refers to the practice of holding prize fights in "clubs," since boxing was illegal in New York State at the time. Spectators and fighters were made members of the club, usually for one night. A documentary sketch of this painting appears in the artist's Record Book A, page 68.

4. *Introducing John L. Sullivan*, June 1923

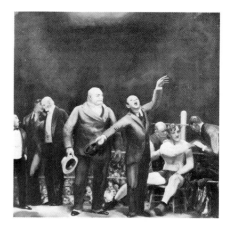

fig. 34, pl. 3
oil on paper mounted on canvas
53.3 x 53.3 cm. (21 x 21 in.)
signed, lower right: *Geo. Bellows* 1923
Mrs. John Hay Whitney

Provenance
The Artist
Estate of George Bellows
[Marie Sterner, New York]
Colonel Joseph J. Kerrigan
Mrs. Joseph J. Kerrigan, by 1931
[Scott & Fowles, New York, c. 1946-1953]
[Wildenstein & Co., New York, by 1954]
Mr. and Mrs. John Hay Whitney, New York, 1954-1982

Exhibitions
Woodstock Art Association, New York, 1923.

Rehn Gallery, New York.

The Art Institute of Chicago, *Special Exhibition of Paintings by George Bellows, Leon Kroll, Eugene F. Savage, Walter Ufer, Paul Bartlett, Edgar S. Cameron, H. Aimard Oberteuffer, and George Oberteuffer* (December 23, 1924–January 25, 1925), no. 5, p. 7.

The Metropolitan Museum of Art, New York, *Memorial Exhibition of the Works of George Bellows* (October 12–November 22, 1925), no. 49, pp. 29, 87 (illus.).

Memorial Art Gallery, Rochester, New York, *Memorial Exhibition of Paintings by George Wesley Bellows* (December 1925), no. 17.

The Buffalo Fine Arts Academy, Albright Art Gallery, *Memorial Exhibition of the Work of George Bellows (1882-1925)* (January 10–February 10, 1926), no. 19 (of paintings), p. 11.

The Museum of Fine Arts, Houston, *Art in the United States, 1949* (January 9–30, 1949).

The Century Association, New York, *Exhibition of Sporting Art* (January 13–March 28, 1954), lent by Wildenstein.

The Tate Gallery, London, *The John Hay Whitney Collection* (December 16, 1960–January 29, 1961), no. 3 (illus.).

Grand Central Galleries, New York, *Sports in Art* (March 16–April 3, 1965).

Gallery of Modern Art, New York, *George Bellows: Paintings, Drawings, Lithographs* (March 15–May 1, 1966), no. 66 (of paintings).

This painting, executed in Woodstock in June of 1923, is listed on page 1 of Bellows' third Record Book. The scene depicts the old Madison Square Garden in New York before the beginning of a boxing match. The announcer, Joe Humphreys, introduces the former heavyweight champion, John L. Sullivan, to the crowd. Also in the ring are Frank Moran, Terry McGovern, Bob Fitzsimmons, and Jim Corbett.

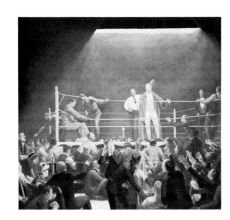

5. *Ringside Seats*, May 1924

fig. 36, pl. 2
oil on canvas
149.9 x 165.1 cm. (59 x 65 in.)
signed, lower right: *Geo Bellows*
Estate of Joseph H. Hirshhorn, Courtesy the Hirshhorn Museum and Sculpture Garden, Smithsonian Institution, Washington, D.C.

Provenance
The Artist
Estate of George Bellows
[Marie Sterner, New York]
[H. V. Allison & Co., New York]
C. Ruxton Love, Jr., New York, 1954-1971
Estate of C. Ruxton Love, Jr., 1971
[Hirschl & Adler Galleries, New York, 1971]
Joseph H. Hirshhorn, 1972-1981

Exhibitions
The Art Institute of Chicago, *Special Exhibition of Paintings by George Bellows, Leon Kroll, Eugene F. Savage, Walter Ufer, Paul Bartlett, Edgar S. Cameron, H. Aimard Oberteuffer, and George Oberteuffer* (December 23, 1924–January 25, 1925), no. 8, p. 7.

Durand-Ruel Gallery, New York, *Paintings by George Bellows* (February 2–14, 1925), no. 7.

Worcester Art Museum, Massachusetts, *Exhibition of Paintings by George Bellows* (February 22–March 8, 1925), no. 14.

Boston Art Club, *Exhibition of Paintings by George Bellows, Charles Hopkinson, Eugene Speicher* (March 11–28, 1925), no. 6.

Rhode Island School of Design, Providence, *Exhibition of Paintings by George Bellows, Charles Hopkinson, Robert Henri* (April 2–27, 1925), no. 6.

The Metropolitan Museum of Art, New York, *Memorial Exhibition of the Works of George Bellows* (October 12–November 22, 1925), no. 56, pp. 30, 89 (illus.).

Museum of Fine Arts, Boston, *Sport in American Art* (October 10–December 10, 1944), no. 8, p. 8, lent by Mrs. George Bellows.

The Art Institute of Chicago, *George Bellows: Paintings, Drawings and Prints* (January 31–March 10, 1946), no. 56, pp. 45, 64 (illus.).

H. V. Allison & Co., New York, *George Bellows* (November 11–December 20, 1947).

National Gallery of Art, Washington, D. C., *George Bellows: A Retrospective Exhibition* (January 19–February 24, 1957), no. 60, pp. 22, 96 (illus.), lent by C. Ruxton Love, Jr.

Columbus Gallery of Fine Arts, Ohio, *Paintings by George Bellows* (March 21–April 21, 1957), no. 63.

Gallery of Modern Art, New York, *George Bellows: Paintings, Drawings, Lithographs* (March 15–May 1, 1966), no. 71 (of paintings), p. 29 (illus.).

Hirschl & Adler Galleries, New York, *George Bellows* (1882-1925) (May 1971), no. 16 (illus.).

Painted in Woodstock in May of 1924, *Ringside Seats* is based on the drawing commissioned by *Collier's* in 1924 (cat. no. 28). Recorded on page 13 of the artist's third Record Book, with the notation "Following 8 pictures painted with 'Permabba' or Titian ox white Weimar Hartzmalmittel used as medium throughout all the following until further notice."

6. *Dempsey and Firpo*, June 1924
fig. 44, pl. 1
oil on canvas
129.5 x 160.7 cm. (51 x 63¼ in.)
Whitney Museum of American Art, New York, 1931. 31.95

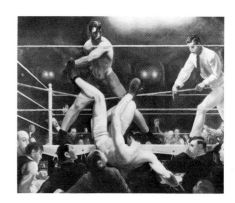

Provenance
The Artist
Estate of George Bellows

Exhibitions
Exhibition of American Art, Chambre syndicale de la curiosité et des beaux arts under the auspices of the Art Patrons of America, Paris (June 9–July 5, 1924), no. 221.

The Art Institute of Chicago, *Special Exhibition of Paintings by George Bellows, Leon Kroll, Eugene F. Savage, Walter Ufer, Paul Bartlett, Edgar S. Cameron, H. Aimard Oberteuffer, and George Oberteuffer* (December 23, 1924–January 25, 1925), no. 6, p. 7.

Durand-Ruel Gallery, New York, *Paintings by George Bellows* (February 2–14, 1925), no. 2.

Worcester Art Museum, Massachusetts, *Exhibition of Paintings by George Bellows* (February 22–March 8, 1925), no. 2.

Boston Art Club, *Exhibition of Paintings by George Bellows, Charles Hopkinson, Eugene Speicher.* (March 11–28, 1925), no. 2, as *Dempsey-Firpo.*

Rhode Island School of Design, Providence, *Exhibition of Paintings by George Bellows, Charles Hopkinson, Robert Henri* (April 2–27, 1925), no. 2.

The Metropolitan Museum of Art, New York, *Memorial Exhibition of the Works of George Bellows* (October 12–November 22, 1925), no. 57, pp. 30, 102 (illus.), as *Dempsey-Firpo.*

Memorial Art Gallery, Rochester, New York, *Memorial Exhibition of Paintings by George Wesley Bellows* (December 1925), no. 21.

The Buffalo Fine Arts Academy, Albright Art Gallery, *Memorial Exhibition of the Work of George Bellows* (1882-1925) (January 10–February 10, 1926), no. 23 (of paintings), p. 11.

Fine Arts Gallery of San Diego, *Memorial Exhibition of the Work of George Wesley Bellows* (November 10–December 15, 1926), no. 15.

The City Art Museum of St. Louis, *Memorial Exhibition of Paintings by George W. Bellows* (March 1927), no. 15.

XVIII *Biennale*, Venice (May–November 1932), no. 9 (in United States section), p. 192 (illus.).

The Art Institute of Chicago, *A Century of Progress: Exhibition of Paintings and Sculpture,* 1934 (June 1–November 1, 1934), no. 491, p. 70, pl. LXXIV (illus.).

M. H. DeYoung Memorial Museum and California Palace of the Legion of Honor, San Francisco, *Exhibition of American Painting* (June 7–July 7, 1935), no. 254.

Virginia Museum of Fine Arts, Richmond, *The Main Currents in the Development of American Painting* (January 16–March 1, 1936), no. 107, p. 39 (illus.).

The Baltimore Museum of Art, *Two Hundred Years of American Painting* (January 15–February 28, 1938), no. 8.

The Century Association, New York, *George Bellows, 1882-1925: Loan Exhibition of Paintings* (January 15–February 19, 1939), no. 10 (illus.).

Scottish Rite Temple, Bloomington, Illinois, *Central Illinois Art Exposition* (March 19–April 8, 1939), no. 47, pp. 19, 20 (illus.).

Carnegie Institute, Pittsburgh, *Survey of American Painting* (October 24–December 15, 1940), no. 187.

Museum of the City of New York, *The Ring and the Glove: A Survey of Boxing* (November 19, 1947–April 4, 1948), pp. 28-29 (illus.); traveled to Addison Gallery of American Art, Phillips Academy, Andover, Massachusetts (September 17–November 14, 1948).

American Federation for the Arts and *Sports Illustrated, Sport in Art,* no. 4 (illus.); traveling exhibition: Museum of Fine Arts, Boston (November 15–December 15, 1955); Corcoran Gallery of Art, Washington, D.C. (January 5–30, 1956); J. B. Speed Art Museum, Louisville, Kentucky (February 15–March 10, 1956); Dallas Museum of Fine Arts (March 25–April 20, 1956); Denver Art Museum (May 5–30, 1956); Los Angeles County Museum of Art (June 15–July 10, 1956); California Palace of the Legion of Honor, San Fran-

cisco (July 28–August 26, 1956); Australia (September 15–November 31, 1956).

National Gallery of Art, Washington, D. C., *George Bellows: A Retrospective Exhibition* (January 19–February 24, 1957), no. 61, pp. 22, 97 (illus.).

Columbus Gallery of Fine Arts, Ohio, *Paintings by George Bellows* (March 21–April 21, 1957), no. 64 (illus.).

Virginia Museum of Fine Arts, Richmond, *Treasures in America* (January 13–March 5, 1961), p. 98 (illus.).

Century 21 Exposition (World's Fair), Seattle, Washington, *Masterpieces of Art* (April 21–September 4, 1962), no. 14, p. 43 (illus.).

Grand Central Galleries, New York, *Sports in Art* (March 16–April 3, 1965).

Whitney Museum of American Art, New York, *Art of the United States: 1670-1966* (September 28–November 27, 1966), no. 12.

National Art Museum of Sport, Madison Square Garden Center Gallery of Art, New York, *The Artist and the Sportsman* (April 18–June 16, 1968), pp. 16, 17 (illus.), 91.

Mead Art Museum, Amherst College, Massachusetts, *George Wesley Bellows* (November 1–20, 1972), illus.

Whitney Museum of American Art, New York, *The Whitney Studio Club and American Art, 1900-1932* (May 23–September 3, 1975), p. 21.

Montgomery Museum of Fine Arts, *American Painting 1900-1939, Selections from the Whitney Museum of American Art* (June 29–August 8, 1976), no. 36, pp. 62 (illus.), 83.

Columbus Museum of Art, Ohio, *George Wesley Bellows: Paintings, Drawings, and Prints* (April 1–May 8, 1979), no. 52, p. 63 (illus.); traveled to: Virginia Museum of Fine Arts, Richmond (June 29–August 5, 1979); Des Moines Art Center, Iowa (September 17–October 28, 1979); Worcester Art Museum, Massachusetts (November 16–December 28, 1979).

Whitney Museum of American Art, New York, *The Figurative Tradition and the Whitney Museum of American Art* (June 25–September 28, 1980), pp. 78, 79 (illus., fig. 53), 185.

Whitney Museum of American Art, Stamford, Connecticut, branch museum, *Pioneering the Century: 1900-1940* (July 14–August 26, 1981).

Painted in Woodstock in June of 1924, the painting depicts the 14 September 1923 fight between Jack Dempsey and Luis Firpo. Related works include a finished drawing, *Dempsey through the Ropes* (cat. no. 22), two lithographs (cat. nos. 45 and 46), and five preparatory studies (cat. nos. 23–27). Recorded on page 15 of Bellows' third Record Book, with the description "Painted over a tone of Indian Red."

Drawings

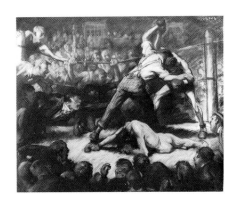

7. *The Knock Out*, July 1907

🏺 fig. 52; pl. 6
pastel and India ink on paper
53.3 x 69.9 cm. (21 x 27½ in.)
signed, upper right: *Bellows.*; and on back, in pencil: GEO BELLOWS/1947
BROADWAY/ N.Y./"A KNOCK OUT"
Private collection

Provenance
The Artist
Joseph B. Thomas, Esq., New York, by 1911
Mrs. Charles W. Clark, San Mateo, California, 1916
The Rosenbach Company, Philadelphia, ?-1952
The Philip H. and A. S. W. Rosenbach Foundation, Philadelphia, 1952-1976
[Herring Brothers, New York, 1976]
[Davis & Long Company, Inc., New York, 1976]

Exhibitions
Fellowship of the Pennsylvania Academy of the Fine Arts, Philadelphia,
Eighth Annual Exhibition (October 28–November 17, 1907).

Exhibition of 16 at 42nd Street Gallery, New York, 1907.

American Watercolor Society, New York, *Forty-first Annual Exhibition* (April 30–
May 24, 1908), no. 350, p. 34.

Chicago Water Color Club, 1909.

Exhibition of Independent Artists, New York (April 1–27, 1910), no. 185, as
A *Knockout*.

Gallery of Fine Arts and Art Association of Columbus, Ohio (held at Colum-
bus Public Library), *Exhibition of Paintings by American Artists* (January 1911), no.
70, as A *Knock-out*, lent by Joseph B. Thomas, Esq.

Powell Art Gallery, New York, 1912.

City Club, 1912.

Panama Pacific Exhibition, 1916, according to the Record Book but not in the
catalogue.

National Gallery of Art, Washington, D. C., *George Bellows: A Retrospective
Exhibition* (January 19–February 24, 1957), no. 73, pp. 24, 110 (illus.), lent by
Philip H. and A. S. W. Rosenbach Foundation.

Isaac Delgado Museum, New Orleans Museum of Art, *World of Art in* 1910 (No-
vember 15–December 31, 1960), no number, lent by Philip H. and
A. S. W. Rosenbach Foundation.

Delaware Art Center, Wilmington, *The Fiftieth Anniversary of the Exhibition of
Independent Artists in* 1910 (January 9–February 21, 1960), no. 5, lent by Philip
H. and A. S. W. Rosenbach Foundation.

Bellows documented this drawing — his first prize-fight scene — in his Rec-
ord Book A (page 38) with a sketch and description: "The Knock out"/ Prize

Fight ring/ Man down. Referee holding victor/ Crowds entering ring./ 22 x 27./ July. 1907./ Crayon in color." In 1921, Bellows executed two states of a lithograph, entitled A *Knockout* (see cat. nos. 36 and 37), based on this drawing.

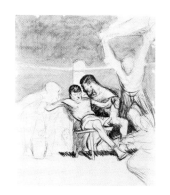

8. *Between Rounds*, 1912

fig. 60
black crayon on paper
56.8 x 48.3 cm. (22⅜ x 19 in.)
Private collection

Provenance
The Artist
[Frederick Keppel & Co., New York, by 1932]
J. William Middendorf II, New York
[Hirschl & Adler Galleries, New York, 1966]
[Main Street Galleries, Chicago, 1966]

Exhibitions
Los Angeles Museum of History, Science, and Art, *Olympic Competition and Exhibition of Art* (July 30–August 31, 1932), no. 853, p. 56, lent by Frederick Keppel & Co., New York.

Gallery of Modern Art, New York, *George Bellows: Paintings, Drawings, Lithographs* (March 15–May 1, 1966), no. 3 (of drawings), lent by Mr. J. William Middendorf II, New York.

Probably a preliminary drawing for *Savior of His Race* (cat. no. 13). It is also related to another drawing entitled *Between Rounds* (1912, cat. no. 9) and two lithographs, *Between Rounds, No. 1* (1916, cat. no. 32) and *Between Rounds, No. 2* (1923, cat. no. 44).

9. *Between Rounds*, September 1912

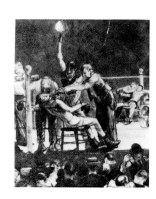

fig. 59
probably black crayon on paper
unlocated

Provenance
The Artist

Exhibitions
International Exhibition of Modern Art, Armory of the 69th Regiment, New York, sponsored by the Association of American Painters and Sculptors (February 17–March 15, 1913), no. 1044, p. 68.

Pennsylvania Academy of the Fine Arts, Philadelphia, *Eleventh Annual Philadelphia Watercolor Exhibition* (November 9–December 14, 1913), no. 1138.

Chicago, 1913, according to the Record Book.

St. Louis, 1914, according to the Record Book.

Columbus, Ohio, 1914, according to the Record Book.

This was one of four drawings Bellows created in September 1912 for *American* magazine as illustrations for a story entitled "The Last Ounce." It is recorded in the artist's Record Book A (page 142) and appeared on page 74 of the April 1913 issue of *American* with the caption "Quit playin' for a knockout. Cut 'im up." This drawing is related to two other drawings of the same theme, *Between Rounds* (1912, cat. no. 8) and *Savior of His Race* (c. 1912-1915, cat. no. 13), and served as the study for two lithographs, *Between Rounds, No. 1* and *Between Rounds, No. 2* (cat. nos. 32, 44), executed in 1916 and 1923, respectively.

10. *Counted Out*, September 1912

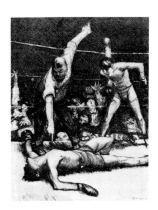

fig. 63
pencil on paper
63.5 x 53.3 cm. (25 x 21 in.)
signed, lower right: *Geo. Bellows*
Private collection

Provenance
The Artist
Estate of George Bellows
[Frank Rehn Galleries, New York, c. 1928]
Sam A. Lewisohn, New York, c. 1928-1951
Margaret Lewisohn, New York, 1951-1954
Mrs. Virginia Kahn, 1954
[R. M. Light, San Francisco]

Exhibitions
Possibly Pennsylvania Academy of the Fine Arts, Philadelphia, *Nineteenth Annual Philadelphia Water Color Exhibition* (November 6–December 11, 1921), no. 653, p. 60, as *Counted Out*. It is not known whether the drawing or lithograph of this title was included in the show.

Frank Rehn Galleries, New York, *Exhibition by George Bellows* (January 2–21, 1928).

Possibly Frederick Keppel & Co., New York, *Drawings by George Bellows* (March 20–April 20, 1929), no. 9, as *The Last Count*.

The Metropolitan Museum of Art, New York, *The Lewisohn Collection* (November 2–December 2, 1951), no. 100, p. 19, as *The Knockout*.

One of four drawings commissioned by *American* magazine as illustrations for a story entitled "The Last Ounce." Recorded in the artist's Record Book A (page 142) and appeared in the April 1913 issue of *American*, with the caption "The Tornado dropped senseless to the floor." Served as source for three lithographs: *Counted Out, No. 1* (cat. no. 39); *Counted Out, No. 2* (cat. no. 40); and *The Last Count* (cat. no. 38), all executed in 1921.

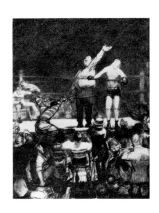

11. *Introducing the Champion* (originally titled *Lightweight Champion*), September 1912

fig. 56
black crayon and India ink wash on paper

62.9 x 52.7 cm. (24¾ x 20¾ in.)
signed, upper left: GEO. BELLOWS.
unlocated

Provenance
The Artist
Estate of George Bellows
Frederic S. Allen, Pelham Manor, New York
|Parke-Bernet Galleries, Inc., New York, *Valuable French and American Modern
Paintings, Drawings and Sculptures*, February 11, 1953, lot no. 16, p. 5 (illus.)|
|M. Knoedler & Co., Inc., New York, 1953|
Joan Whitney Payson, 1953

Exhibitions

International Exhibition of Modern Art, Armory of the 69th Regiment, New York,
sponsored by the Association of American Painters and Sculptors (February 17–March 15, 1913), no. 1043, p. 68, as *Lightweight Champion of the World*;
traveled to: The Art Institute of Chicago (March 24–April 16, 1913), no. 11,
as *Lightweight Champion.*

Pennsylvania Academy of the Fine Arts, Philadelphia, *Eleventh Annual Philadelphia Watercolor Exhibition* (November 9–December 14, 1913), no. 1140,
p. 80, as *Light Weight Champion of the World.*

St. Louis, 1914, according to the Record Book.

Columbus, Ohio, 1914, according to the Record Book.

Phillips Memorial Gallery, Washington, D.C., *Drawings and Lithographs: George
Bellows* (January 14–February 12, 1945), no. 16, lent by Mr. Frederic S. Allen.

The Art Institute of Chicago, *George Bellows: Paintings, Drawings and Prints* (January 31–March 10, 1946), no. 72, pp. 51, 76 (illus.).

This was one of four drawings that Bellows created in September 1912 for
American magazine as illustrations for a story entitled "The Last Ounce." It
was recorded in the artist's Record Book A (page 142) as *Lightweight Champion* and appeared on page 72 of the April 1913 issue of *American*, with the
caption "Tornado Black! Champion lightweight of the world." This drawing
served as a study for two lithographs, *Introducing the Champion*, No. 1 (1916,
cat. no. 33) and *Introducing the Champion*, No. 2 (1921, cat. no. 42).

12. *The Last Ounce* (originally titled *Against the Ropes*), September 1912

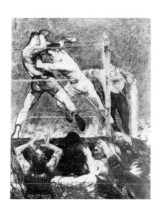

fig. 62
black lithographic crayon and India ink wash on paper
60.6 x 46.4 cm. (23⅞ x 18¼ in.)
signed, lower left: *Geo. Bellows*; and upper right: *Geo. Bellows*
Mr. and Mrs. Peter R. Blum

Provenance
The Artist
Estate of George Bellows
|Frederick Keppel & Co., New York|
Mr. Winthrop Taylor, New York, 1929

[Frederick Keppel & Co., New York]

Mr. Charles E. F. McCann, Oyster Bay, Long Island, New York

[Parke-Bernet Galleries, Inc., New York, *The Collection of the Late Mr. and Mrs. Charles E. F. McCann* . . ., November 18, 1942, sale no. 407, lot no. 388, p. 73 (illus.), as *They Thundered across the Ring*]

[H. V. Allison & Co., New York, 1942-1947]

Mrs. Jacob Rand, 1947

[The Milch Galleries, New York]

Albert L. Hydeman, York, Pennsylvania, and Martha's Vineyard, Massachusetts, by 1958

[Sotheby Parke Bernet, Inc., New York, *Important Twentieth Century American Paintings, Watercolors, and Sculpture*, December 13, 1973, sale no. 3585, lot no. 49 (illus.), as *The Last Ounce*]

Peter R. Blum, Hartford, Connecticut, 1973

[Joan Michelman, Ltd., New York, 1978]

[Steven Straw Gallery, Newburyport, Massachusetts, 1978]

[Phillips New England, Boston, *The Steven Straw Collection of American Paintings and Furniture*, May 2, 1980, sale no. 289, lot no. 114, pp. 72, 73 (illus.)]

Exhibitions
MacDowell Club, New York, 1913.

Frederick Keppel & Co., New York, *Drawings by George Bellows* (March 20–April 20, 1929), no. 53, as *The Crowd Surged to Its Feet as They Thundered across the Ring*.

Phillips Memorial Gallery, Washington, D.C., *Drawings and Lithographs: George Bellows* (January 14–February 12, 1945), no. 18, lent by Mr. H. V. Allison.

The Art Institute of Chicago, *George Bellows: Paintings, Drawings and Prints* (January 31–March 10, 1946), no. 77, pp. 51, 69 (illus.).

The Cooper Union Museum, New York, *An Exhibition of American Drawings Assembled for the United States Information Agency by the Smithsonian Institution Traveling Exhibition Service* (January–August 1954), no. 8; traveled to: Amerika Haus, Munich; Musée des Beaux Arts, Rouen; London Tea Centre.

New Britain Museum, Connecticut, *Contemporary American Prints — Paintings — Drawings from the Collection of Mr. and Mrs. Albert L. Hydeman* (May–June 1958), no. 36 (illus.).

Gallery of Modern Art, New York, *George Bellows: Paintings, Drawings, Lithographs* (March 15–May 1, 1966), no. 38 (of drawings), lent by Mr. Albert L. Hydeman, York, Pennsylvania.

Widener Gallery, Trinity College, Hartford, Connecticut, *The Albert L. Hydeman Collection* (December 1966–February 1967), no. 1.

Pennsylvania State Museum (William Penn Memorial), Harrisburg, *Collection of Albert Hydeman* (fall 1968).

Lyman Allyn Museum, New London, Connecticut, *The Hydeman Collection* (November 9–December 31, 1969).

Brockton Art Center, Massachusetts, *The Hydeman Collection* (March–April 1971), no. 28 (illus.).

Mead Art Museum, Amherst College, Massachusetts, *George Wesley Bellows* (November 1–20, 1972), lent by Mr. Albert C. [*sic*] Hydeman, Martha's Vineyard.

One of four drawings executed in September 1912 for *American* magazine as illustrations to a story entitled "The Last Ounce." Recorded in the artist's Record Book A (page 142), as *Against the Ropes*, it appeared in the April 1913 issue of *American* (page 73) with the caption, "The crowd surged to its feet as they thundered across the ring." This was the only drawing from that series on which Bellows did not base a lithograph.

13. *Savior of His Race*, c. 1912–1915

fig. 61
probably black crayon with India ink wash on paper
unlocated

Provenance
The Artist

Appeared as an illustration in the May 1915 issue of the *Masses* (vol. 6, no. 8, p. 11). Probably was based on the sketch entitled *Between Rounds* (1912, cat. no. 8). It is a study of the figure in the far corner of another drawing and two lithographs entitled *Between Rounds* (cat. nos. 9, 32, and 44).

14. *Playmates*, c. 1915

 fig. 67

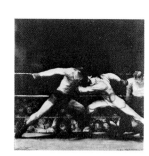

probably pen and ink, wash and crayon on paper
signed, lower right: *Geo Bellows* —
Original drawing is unlocated; copy of the *Masses* on whose cover this drawing appeared was lent by the Delaware Art Museum, Wilmington, John Sloan Archives.

Provenance
The Artist

This drawing appeared as an illustration (22.5 x 22.5 cm. or 8⅞ x 8⅞ in.) on the cover of the March 1915 issue of the *Masses* (vol. 6, no. 6), but does not appear to be related to any articles in that issue.

15. *Study of Arms*, 1916

fig. 69
lithographic crayon on paper
27.0 x 20.3 cm. (10⅝ x 8 in.)

signed, on reverse: *Geo. Bellows GKA*
Private collection

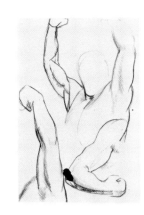

Provenance
The Artist
Estate of George Bellows
[H. V. Allison & Co., New York]
Charles H. Morgan, Amherst, Massachusetts, 1961
[H. V. Allison & Co., New York, 1976]

Exhibitions
Gallery of Modern Art, New York, *George Bellows: Paintings, Drawings, Lithographs* (March 15–May 1, 1966), no. 35 (of drawings), as *Study for Training Quarters*.

Mead Art Museum, Amherst College, Massachusetts, *George Wesley Bellows* (November 1–20, 1972), not illus.

Study for the 1916 lithograph, *Training Quarters* (cat. no. 30). *Collier's* in 1916 reportedly commissioned a series of three drawings, for $300, to illustrate the boxing style of Jess Willard. This is the only drawing from that series which has been located.

16. *Preliminaries to the Big Bout*, c. 1916

 fig. 70
black crayon and India ink wash on paper
43.2 x 57.2 cm. (17 x 22½ in.)
Boston Public Library, Print Department

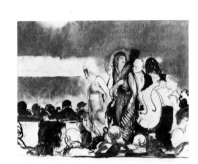

Provenance
The Artist
Estate of George Bellows
[Frederick Keppel & Co., New York, c. 1929]
[H. V. Allison & Co., New York]
Albert H. Wiggin, 1942

Exhibitions
Frederick Keppel & Co., New York, *Drawings by George Bellows* (March 20–April 20, 1929), no. 31.

Frederick Keppel & Co., New York (fall 1935). *Parnassus*, 7, no. 6 (November 1935), in "Current Exhibitions," by James W. Lane, reviews the show at Keppel and mentions that it contains *Preliminaries*, a conté crayon and wash drawing.

Frederick Keppel & Co., New York, *Drawings by George Bellows* (September 29–October 1936).

H. V. Allison & Co., New York, *Drawings and Lithographs by George Bellows* (April–May 1941).

Phillips Memorial Gallery, Washington, D.C., *Drawings and Lithographs: George Bellows* (January 14–February 12, 1945), no. 9.

The Art Institute of Chicago, *George Bellows: Paintings, Drawings and Prints* (January 31–March 10, 1946), no. 84, pp. 53, 72 (illus.).

National Gallery of Art, Washington, D.C., *George Bellows: A Retrospective Exhibition* (January 19–February 24, 1957), no. 79, pp. 25, 105 (illus.).

Smithsonian Institution traveling exhibition, *George Bellows, Prints and Drawings* (1957–1958), no. 57, pp. 17, 32 (illus.) .

Gallery of Modern Art, New York, *George Bellows: Paintings, Drawings, Lithographs* (March 15–May 1, 1966), no. 22 (of drawings).

Boston University Art Gallery, *The Graphic Art of George Bellows: Lithographs and Related Drawings* (February 7–March 2, 1975).

Study for the 1916 lithograph, *Preliminaries to the Big Bout* (cat. no. 31). Depicts the first prize fight at Madison Square Garden which women were allowed to attend.

17. *A Knock Down*, c. 1918-1921

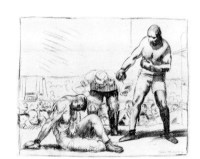

figs. 39, 73
black crayon on paper
38.1 x 47.6 cm. (15 x 18¾ in.)
signed, lower right: *Geo. Bellows*, and lower center: A KNOCK DOWN.
Boston Public Library, Print Department

Provenance
The Artist
[either Frederick Keppel & Co., New York, or H. V. Allison & Co., New York. Although the Boston Public Library records indicate that Albert Wiggin purchased the drawing from H. V. Allison, Gordon Allison can find no record of this sale in his ledger book. He thinks perhaps Wiggin bought the drawing from Keppel in 1939 or 1940.]

Albert H. Wiggin, 1943 (?)

Exhibitions
National Gallery of Art, Washington, D.C., *George Bellows: A Retrospective Exhibition* (January 19–February 24, 1957), no. 72, p. 24.

Smithsonian Institution traveling exhibition, *George Bellows, Prints and Drawings* (1957–1958), no. 53, p. 17.

Gallery of Modern Art, New York, *George Bellows: Paintings, Drawings, Lithographs* (March 15–May 1, 1966), no. 1 (of drawings).

Boston University Art Gallery, *The Graphic Art of George Bellows: Lithographs and Related Drawings* (February 7–March 2, 1975).

This drawing is a study for the lithograph, *The White Hope* (1921, cat. no. 41), and is related to a trial proof lithograph of about 1916 entitled *Male Torso* (cat. no. 29). Because of its strong geometrical organization and the fact that it is a preliminary drawing for the 1921 print, this drawing has been dated c. 1918-1921.

18. *Prize Fight*, c. 1919

 fig. 72
lithographic crayon on paper
30.5 x 27.9 cm. (12 x 11 in.)
signed, lower right (by Bellows' wife): *Geo.Bellows*,E.S.B.
Mead Art Museum, Amherst College, Massachusetts, Gift of Charles H. Morgan, 1976

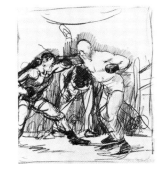

Provenance
The Artist
Estate of George Bellows
[H. V. Allison & Co., New York]
Charles Morgan, Amherst, Massachusetts, before 1960

19. *Sketch for a Referee*, c. 1920

conté crayon on paper
29.2 x 23.5 cm. (11½ x 9¼ in.)
signed, lower right (by Bellows' daughter): *Geo. Bellows*, J.B.B.
Thomas A. Mann

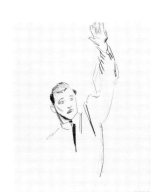

Provenance
The Artist
Estate of George Bellows
[H. V. Allison & Co., New York]
[Mann Galleries, Miami, Florida, 1973]

Exhibitions
Mann Galleries, Miami, Florida, *George Bellows, 1882-1925, Paintings, Drawings, Lithographs* (1973), no. 9.

The figure in this drawing appears to be related to a spectator in the 1923-1924 *Dempsey and Firpo* series: the man on the left side of the composition, his right arm on the ring's post and his left arm raised in the air.

20. *Introducing Georges Carpentier*, 1921

 fig. 75
black crayon on paper
48.3 x 64.1 cm. (19 x 25¼ in.)
signed, lower right: *Geo. Bellows*
Boston Public Library, Print Department

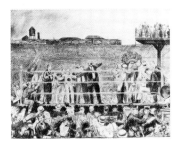

Provenance
The Artist
Estate of George Bellows
[H. V. Allison & Co., New York]
Albert H. Wiggin, 1943

Exhibitions

The Art Institute of Chicago, *George Bellows: Paintings, Drawings and Prints* (January 31–March 10, 1946), no. 71, pp. 49, 76 (illus.).

National Gallery of Art, Washington, D. C., *George Bellows: A Retrospective Exhibition* (January 19–February 24, 1957), no. 71, p. 24.

Smithsonian Institution traveling exhibition, *George Bellows, Prints and Drawings* (1957–1958), no. 52, p. 16.

Gallery of Modern Art, New York, *George Bellows: Paintings, Drawings, Lithographs* (March 15–May 1, 1966), no. 16 (of drawings).

Boston University Art Gallery, *The Graphic Art of George Bellows: Lithographs and Related Drawings* (February 7–March 2, 1975).

Amon Carter Museum of Art, Fort Worth, *The American Personality: The Artist-Illustrator of Life in the United States, 1860-1930* (July 8–August 22, 1976), no. 13, pp. 108 (illus.), 118; traveled to Frederick S. Wight Art Gallery, University of California at Los Angeles (October 12–December 12, 1976).

The *New York World* commissioned Bellows to cover the 2 July 1921 fight between Jack Dempsey and Georges Carpentier. The fight was held at Boyle's "30 Acres" in Jersey City and drew over 80,000 spectators. This and the following drawing served as the basis for a lithograph of the same title (cat. no. 43), printed in 1921.

21. *Introducing Georges Carpentier*, 1921

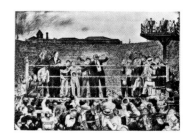

black crayon and India ink wash
45.7 x 64.5 cm. (18 x 25⅜ in.)
signed, lower right: *Geo. Bellows.*
unlocated

Provenance
The Artist
Frank Crowninshield, New York
[Parke-Bernet Galleries, Inc., New York, *Paintings, Sculpture, Drawings, and Lithographs by Modern French Artists . . . And Works by Eugene Speicher, Charles Demuth, George Bellows . . . Collection of Frank Crowninshield*, October 20–21, 1943, sale no. 489, lot no. 155, p. 70, as *Introducing Georges Carpentier: The Dempsey-Carpentier Fight*]

Chester Dale, New York, 1943

Exhibitions
Phillips Memorial Gallery, Washington, D. C., *Drawings and Lithographs: George Bellows* (January 14–February 12, 1945), no. 12, lent by Mr. Chester Dale.

National Gallery of Art, Washington, D. C., *George Bellows: A Retrospective Exhibition* (January 19–February 24, 1957), no. 70, pp. 24, 104 (illus.), lent by Chester Dale.

22. *Dempsey through the Ropes*, September 1923

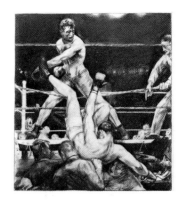

fig. 78
black crayon on paper
54.6 x 49.9 cm. (21½ x 19⅝ in.)
signed, lower center: *Geo. Bellows*
The Metropolitan Museum of Art, New York, Rogers Fund, 1925

Provenance
The Artist
[Frederick Keppel & Co., New York]

Exhibitions
Frederick Keppel & Co., New York, *Lithographs and Drawings by George Bellows* (March 24–April 25, 1925), no. 185.

The Art Institute of Chicago, *George Bellows: Paintings, Drawings and Prints* (January 31–March 10, 1946), no. 65, pp. 49, 77 (illus.).

The Metropolitan Museum of Art, New York, *20th Century Painters, A Special Exhibition of Oils, Water Colors and Drawings Selected from the Collections of American Art in the Metropolitan Museum* (June 16, 1950).

Gallery of Modern Art, New York, *George Bellows: Paintings, Drawings, Lithographs* (March 15–May 1, 1966), no. 6 (of drawings).

Amon Carter Museum of Art, Fort Worth, *The American Personality: The Artist-Illustrator of Life in the United States, 1860-1930* (July 8–August 22, 1976), no. 14, p. 118; traveled to Frederick S. Wight Art Gallery, University of California, Los Angeles (October 12–December 12, 1976).

Whitney Museum of American Art, New York, *American Prints: Process & Proofs* (November 25, 1981–January 24, 1982).

The Metropolitan Museum of Art, New York, *Homage to George Bellows: An Exhibition of Lithographs with Selected Drawings and Paintings* (May 4–July 4, 1982).

The *New York Evening Journal* paid Bellows $500 to make a drawing of the 14 September 1923 fight between Jack Dempsey and Luis Firpo, the Argentine fighter called "The Bull of the Pampas." The fight was held before 88,000 fans at the Polo Grounds, New York. Related works include two lithographs, *Dempsey through the Ropes* (cat. no. 46) and *Dempsey and Firpo* (cat. no. 45), five preparatory sketches (cat. nos. 23-27), and the painting, *Dempsey and Firpo* (cat. no. 6). The Metropolitan's drawing, *Dempsey through the Ropes*, was never published due to a printer's strike, but it is recorded on page 4 of the artist's third Record Book.

23. *Study for "Dempsey and Firpo": Referee's Hands*, c. 1923-1924

fig. 81
lithographic crayon on paper
31.1 x 26.0 cm. (12¼ x 10¼ in.)
signed, lower right (by Bellows' wife): *Geo Bellows* ESB
Private collection

Provenance
The Artist

Estate of George Bellows
[H. V. Allison & Co., New York]

Exhibitions
Gallery of Modern Art, New York, *George Bellows: Paintings, Drawings, Lithographs* (March 15–May 1, 1966), no. 33 (of drawings).

Mead Art Museum, Amherst College, Massachusetts, *George Wesley Bellows* (November 1–20, 1972).

This and the following four drawings are most likely preparatory studies for the 1924 painting, *Dempsey and Firpo* (cat. no. 6), rather than sketches made at the 1923 fight.

24. *Study for "Dempsey and Firpo": Figure of Dempsey*, c. 1923-1924

fig. 82
lithographic crayon on paper
31.1 x 25.4 cm. (12¼ x 10 in.)
Mead Art Museum, Amherst College, Massachusetts, Gift of Charles H. Morgan, 1976

Provenance
The Artist
Estate of George Bellows
[H. V. Allison & Co., New York]
Charles Morgan, Amherst, Massachusetts, 1960

Exhibitions
Gallery of Modern Art, New York, *George Bellows: Paintings, Drawings, Lithographs* (March 15–May 1, 1966), no. 29 (of drawings).

Mead Art Museum, Amherst College, Massachusetts, *George Wesley Bellows* (November 1–20, 1972).

25. *Study for "Dempsey and Firpo": Head and Shoulders of Dempsey*, c. 1923–1924

fig. 83
lithographic crayon on paper
32.7 x 26.0 cm. (12⅞ x 10 ¼ in.)
Mead Art Museum, Amherst College, Massachusetts, Gift of Charles H. Morgan, 1976

Provenance
The Artist
Estate of George Bellows
[H. V. Allison & Co., New York]
Charles Morgan, Amherst, Massachusetts, 1960

Exhibitions
Gallery of Modern Art, New York, *George Bellows: Paintings, Drawings, Lithographs* (March 15–May 1, 1966), no. 30 (of drawings).

Mead Art Museum, Amherst College, Massachusetts, *George Wesley Bellows* (November 1–20, 1972).

26. *Study for "Dempsey and Firpo": Referee*, c. 1923-1924

 fig. 84
lithographic crayon on paper
37.6 x 20.3 cm. (14 ³/₄ x 8 in.)
Mead Art Museum, Amherst College, Massachusetts, Gift of Charles H. Morgan, 1976

Provenance
The Artist
Estate of George Bellows
[H. V. Allison & Co., New York]
Charles Morgan, Amherst, Massachusetts, 1960

Exhibitions
Gallery of Modern Art, New York, *George Bellows: Paintings, Drawings, Lithographs* (March 15–May 1, 1966), no. 32 (of drawings).

Mead Art Museum, Amherst College, Massachusetts, *George Wesley Bellows* (November 1–20, 1972).

27. *Study for "Dempsey and Firpo": Arm of Firpo*, c. 1923-1924

 fig. 85
lithographic crayon on paper
26.0 x 32.7 cm. (10 ¼ x 12 ⅞ in.)
Mead Art Museum, Amherst College, Massachusetts, Gift of Charles H. Morgan, 1976

Provenance
The Artist
Estate of George Bellows
[H. V. Allison & Co., New York]
Charles Morgan, Amherst, Massachusetts, 1960

Exhibitions
Gallery of Modern Art, New York, *George Bellows: Paintings, Drawings, Lithographs* (March 15–May 1, 1966), no. 31 (of drawings).

Mead Art Museum, Amherst College, Massachusetts, *George Wesley Bellows* (November 1–20, 1972).

28. *Ringside Seats*, March 1924

fig. 86
graphite, crayon, black ink and white wash with scratch work and stumping, on smooth-surfaced multi-ply cream wove paper
57.6 x 66.6 cm. (22 ¹¹/₁₆ x 26 ¼ in.)
inscribed, bottom center of image area: *Geo Bellows*; lower border, in graphite: *Ring Side Seats–Drawn in* 1924; verso, in graphite: *Pub. May* 3/24/*Chins of*

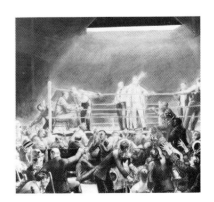

95

*the Fathers by Jonathan Brooks/ill by Geo. Bellows/*H 26/T4949 (scribbled over with graphite)
Fogg Art Museum, Harvard University, Cambridge, Grenville L. Winthrop Bequest

Provenance
The Artist
Estate of George Bellows
[Frederick Keppel & Co., New York]
Grenville L. Winthrop, New York, 1938

Ringside Seats was commissioned by *Collier's* magazine and appeared in its 3 May 1924 issue (vol. 73, no. 18, pp. 14-15) with the caption "Jimmo gets only a small hand from the customers. Then Sailor Slosson swaggers out, and the crowd cheers." The drawing illustrated a scene from a prize-fight story by Jonathan Brooks entitled "Chins of the Fathers." Because *Collier's* spread the drawing across two pages and cropped pieces from the right edge, top, and center, Bellows sued the magazine and asked for twice the agreed upon amount of $400. The artist argued that the magazine had made two drawings out of one.

Lithographs

All lithographs from the collection of the National Gallery of Art were purchased through the Andrew W. Mellon Fund from H. V. Allison & Co., New York, in 1956. Their titles are followed by National Gallery accession numbers. The dates used in the following list are taken from Lauris Mason's *The Lithographs of George Bellows* (Millwood, New York, 1977). Reference numbers listed refer to Mason's catalogue and to Emma Story Bellows' catalogue, *George W. Bellows: His Lithographs* (New York, 1927).

29. *Male Torso*, 1916
fig. 88
29.6 x 26.5 cm. (11¾ x 10½ in.)
inscribed on stone, lower left: *Geo. Bellows* (inverted)
B146 M2
Mead Art Museum, Amherst College, Massachusetts, Gift of Malcolm Stearns, 1947

30. *Training Quarters (Willard in Training)*, 1916 B21,755
fig. 68
39.1 x 44.0 cm. (15⅜ x 17⅜ in.)
inscribed in pencil, lower left: *No. 57*; lower center: *Williard in Trainging Quarters* [*sic.*]; lower right: *Geo. Bellows.*
B113 M23

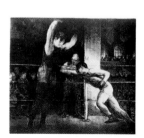

31. *Preliminaries to the Big Bout*, 1916 B21,752

🏺 fig. 71
40.0 x 49.8 cm. (15¾ x 19⅝ in.)
inscribed on stone, lower left: *Geo Bellows*.
inscribed in pencil, lower left: *No. 63*; lower center: *Preliminaries*; lower
right: *Geo. Bellows*
B21 M24

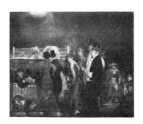

32. *Between Rounds, No. 1*, 1916 B21,741

🏺 fig. 89
51.8 x 41.6 cm. (20⅜ x 16⅜ in.)
inscribed in pencil, lower left: *No. 1*; lower center: *Between Rounds*; lower
right: *Geo. Bellows*
B52 M25

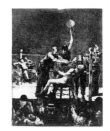

33. *Introducing the Champion, No. 1*, 1916 B21,749

🏺 fig. 57
62.5 x 53.3 cm. (24⅝ x 20⅞ in.)
inscribed on stone, lower center: *Geo. Bellows*
inscribed in pencil, lower left: *No. 54*; lower center: *Introducing the Champion*;
lower right: *Geo. Bellows*
B172 M26

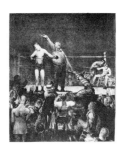

34. *Introducing John L. Sullivan*, 1916 B21,748

🏺 fig. 35
52.5 x 52.2 cm. (20⅝ x 20½ in.)
inscribed on stone, lower right: *Geo. Bellows*
inscribed in pencil, lower left: *No. 15/B133*; lower center: *Introducing John L.
Sullivan*; lower right: *Geo. Bellows*
B106 M27

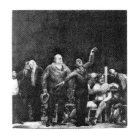

35. *A Stag at Sharkey's*, 1917 B21,753

🏺 fig. 91
47.4 x 60.6 cm. (18¾ x 23⅞ in.)
inscribed on stone, lower center: *Geo Bellows*
inscribed in pencil, lower left: *No. 62*; lower center: *A Stag at Sharkey's*;
lower right: *Geo. Bellows*.
B71 M46

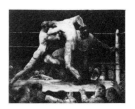

36. *A Knockout*, 1921

🏺 fig. 53
first state
38.7 x 65.4 cm. (15¼ x 25¾ in.)

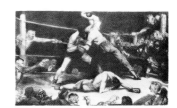

inscribed on stone, lower center: GB.
B78 M92
Mead Art Museum, Amherst College, Massachusetts, Gift of Professor
Emeritus and Mrs. Charles H. Morgan, 1975

37. *A Knockout*, 1921 B21,751

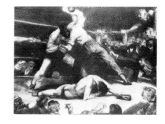

figs. 54, 92
second state
38.8 x 55.1 cm. (15¼ x 21¾ in.)
inscribed on stone, lower center: GB.
inscribed in pencil, lower left: *Bolton Brown-imp-*; lower right: *Geo. Bellows*
E.S.B.
B78 M92

38. *The Last Count*, 1921

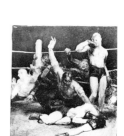

fig. 64
unique impression
28.9 x 26.2 cm. (11⅜ x 10⁵⁄₁₆ in.)
inscribed in pencil, lower center: *The Last Count*; lower right: *Geo. W.
Bellows*/E.S.B.
B5 M93
Boston Public Library, Print Department

39. *Counted Out, No. 1*, 1921 B21,743

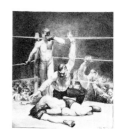

fig. 65
31.8 x 28.5 cm. (12½ x 11⅛ in.)
inscribed on stone, lower right: *Geo. Bellows*
inscribed in pencil, lower left: *Bolton Brown-imp-*; lower center: *Counted Out
1st Stone*; lower right: *Geo. Bellows*
B107 M95

40. *Counted Out, No. 2*, 1921 B21,744

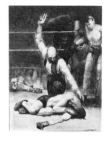

fig. 66
39.1 x 29.1 cm. (15¼ x 11⁷⁄₁₆ in.)
inscribed on stone, lower right: *Geo. Bellows*
inscribed in pencil, lower left: *Bolton Brown-imp.-*; lower right: *Geo. Bellows*.
B69 M95

41. *The White Hope*, 1921 B21,754

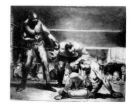

fig. 74
37.4 x 47.6 cm. (14¾ x 18¾ in.)
inscribed on stone, lower left: *Geo. Bellows*
inscribed in pencil, lower left: *Bolton Brown-imp*; lower center: *The White*

Hope; lower right: *Geo Bellows*
B44 M96

42. *Introducing the Champion, No. 2,* 1921 B21,750

fig. 58

21.8 x 17.7 cm. (8½ x 7 in.)
inscribed on stone, lower right: *Geo. Bellows*
inscribed in pencil, lower left: *Bolton Brown-imp-*; lower right: *Geo Bellows*
B31 M97

43. *Introducing Georges Carpentier,* 1921 B21,747

fig. 77

36.9 x 53.2 cm. (14½ x 20⅞ in.)
inscribed on stone, lower left: GB
inscribed in pencil, lower left: *Bolton Brown-imp.*; lower center: *Introducing Georges Carpentier*; lower right: *Geo Bellows*
B116 M98

44. *Between Rounds, No. 2,* 1923 B21,742

fig. 90

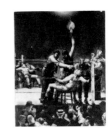

46.2 x 37.6 cm. (18⅛ x 14¾ in.)
inscribed in pencil, lower left: *Bolton Brown-imp.*; lower center: *Between Rounds 2nd Stone*; lower right: *Geo Bellows.*
B70 M144

45. *Dempsey and Firpo,* 1923-1924

figs. 46, 80

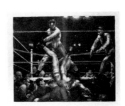

lithograph squared-off in pencil
45.9 x 56.8 cm. (18 x 22⅜ in.)
inscribed on stone, lower left: *Geo Bellows*
B89 M181
Mead Art Museum, Amherst College, Massachusetts, Gift of Mrs. George Bellows, 1959

46. *Dempsey through the Ropes,* 1923-1924 B21,746

fig. 79

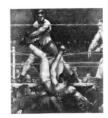

45.5 x 41.9 cm. (17⅞ x 16½ in.)
inscribed in pencil, lower left: *Bolton Brown, imp.*; lower center: *Dempsey through the Ropes*; lower right: *Geo Bellows*
B90 M192

Chronology

Trinkett Clark

1882 George Wesley Bellows is born 12 August, to George and Anna Bellows, in Columbus, Ohio. He is named after his father and after John Wesley, the founder of Methodism. Bellows' father, fifty-three at the time, is a successful architect and building contractor. Anna Smith Bellows, forty-four, is from Sag Harbor, Long Island. The Bellows family lives at 265 East Rich Street. Half-sister Laura Bellows, eighteen years old, and Anna's sister, Eleanor (Fanny) Smith, complete the household. Among the ancestors of George Bellows is Benjamin Bellows, who emigrated to America from England in 1632 and founded Bellows Falls, Vermont.

1884 Laura Bellows marries Ben Monett, leaving two-year-old George alone in a household of adults.

1890 Aunt Fanny, who has been encouraging Bellows' interest in drawing, marries Sam Daggett and moves to San Diego.

1892 Bellows develops lifelong interest in sports, especially baseball. Joins the neighborhood team, the "East Richers," also serving as team reporter to the local newspaper.

1897 After attending the Sullivant School, enters Central High School, which his father designed and built. He contributes drawings to the school's various publications, sings in the glee club, and plays on both the basketball and baseball teams.

1901 Upon graduating from Central High School, Bellows enters Ohio State University. His English professor, Joseph Taylor, provides much of the encouragement and incentive which Bellows needs to pursue his interest in drawing and painting.

Taylor remains a close friend throughout Bellows' life.

Contributes drawings to the yearbook, *Makio*, and other university publications.

Plays on both the basketball and baseball teams, earning the nickname "Ho."

Joins the marching band as a drummer to satisfy military requirements.

1902 In the summer, plays shortstop for a semi-professional baseball team managed by his coach from Ohio State; this experience helps Bellows become the shortstop for the Ohio State baseball team in his sophomore year.

He is invited to join a fraternity.

Attends art classes, now contributing his drawings to the yearbook of Kenyon College as well as that of Ohio State.

1904 Withdraws from Ohio State in spring of junior year. Plays semiprofessional baseball all summer and sells several drawings, earning enough money to leave Columbus in September, bound for New York City.

Enrolls in the New York School of Art (at 57th Street and Sixth Avenue), directed by William Merritt Chase (often called the Chase School). Is a student of Robert Henri, along with Edward Hopper and Rockwell Kent.

After residing for a brief time at the YMCA on 57th Street, Bellows moves into lodgings at 352 West 58th Street, with fellow student Ed Keefe from New London, Connecticut, and Fred Cornell from Columbus.

Meets Emma Louise Story, also an art student, at a dance at the art school. Emma, the daughter of a linen and lace merchant and a member of a de-

vout Christian Scientist family, lives in Montclair, New Jersey.

1905 During the summer, Bellows plays semiprofessional baseball to support himself.

As Henri is in Spain in September, John Sloan takes over his classes for a few weeks.

Bellows begins attending Henri's Tuesday evening gatherings, where the guests are predominantly artists.

Starts to court Emma Story, who has given up her artistic studies in order to pursue her interests in music. Spends Christmas with the Story family in New Jersey.

1906 In September, moves to Studio 616 in the Lincoln Arcade Building (1947 Broadway) with Keefe and Cornell; the new location provides Bellows with the space he needs to paint. Other tenants through the years include Glenn O. Coleman, Rockwell Kent, and Eugene O'Neill.

Introduced to Hardesty Maratta, a chemist and paint manufacturer, who makes premixed colors in tubes; Bellows would employ the innovative Maratta palette from then on.

1907 Introduced to Moses King through Keefe; King, the lightweight champion of Connecticut, boxes in a prize fight at Tom Sharkey's saloon (West 66th Street). Bellows is introduced to pugilism.

In March, enters *River Rats* in the spring exhibition of the National Academy of Design. It is accepted, and Bellows has a painting hanging in the Academy before he turns twenty-five.

Twelve "Chase School" students exhibit at a gallery at 80th and Broadway; show includes Bellows' *River Rats*, *Pennsylvania Excavation*, and *Dance in a Madhouse* (drawing).

First boxing picture is a pastel entitled *The Knock Out* (cat. no. 7), which records a scene inspired by a bout at Sharkey's.

In August and September, paints *Club Night* (cat. no. 1, the first of the boxing paintings), originally entitled *Stag at Sharkey's*.

In October meets Eugene Speicher, a student at the New York School of Art. Speicher becomes one of Bellows' closest lifetime friends.

Winter Exhibition, National Academy of Design, New York, 14 December to 11 January 1908: *Club Night* is no. 383, listed as *Stag at Sharkey's*.

The *Sun* wrote that *Club Night* was not pleasing or edifying as a subject and that "for the artist and amateur the play of muscles and the various attitudes and gestures are positively exciting" (Charles Morgan, *George Bellows: Painter of America* [New York, 1965], 78).

In the *New York Evening Journal*, TAD wrote: "No. 383 by George Bellows, is a wonder except that the ring is very shy of light. . . . It would be a pipe for the losing man to run in the dark corner and hide there. . . . I didn't notice any bartenders in the front row either. Why not a little color there, Bellows?" (Morgan, *George Bellows*, 78).

1908 *103rd Annual Exhibition*, Pennsylvania Academy of the Fine Arts, Philadelphia, 20 January to 29 February: *Club Night* is no. 251, listed as *A Stag at Sharkey's*.

The Eight exhibition opens at the MacBeth Gallery, New York, on 3 February. Organized by Henri, this show was a great success, providing much encouragement to his students.

In March *North River* is exhibited at the *83rd Annual Exhibition* at the National Academy of Design and awarded the second Hallgarten Prize. This is Bellows' first prize.

Twelfth Annual Exhibition, Carnegie Institute, Pittsburgh, 30 April to 30 June: *Club Night* is no. 20, listed as *Stag at Sharkey's*.

In the summer, Bellows teaches painting at the University of Virginia.

1909 Early in the year, Henri leaves the Chase School, setting up his own school in the same building as Bellows' apartment. Henri holds evening life classes which Bellows attends.

In January, Bellows, Keefe, and O'Neill go to O'Neill's family home in Zion, New Jersey, where Bellows picks up the brush again after a restless, uncreative period.

In March sells *North River* to the Pennsylvania Academy of the Fine Arts for $250. This is his first painting to enter a major museum.

In April Bellows is elected to the National Academy of Design as an associate member, making

him the youngest member ever elected.

In August paints *Stag at Sharkey's* while at Sag Harbor with his family. This work was originally entitled *Club Night* (cat. no. 2).

In October *A Nigger and a White Man* is painted; Bellows later renames this work *Both Members of This Club* (cat. no. 3).

Toward Christmastime, Bellows and Charlie Grant, a sportswriter on his way to a job in Cleveland, arrange to send *Club Night* to Cleveland, with the idea of selling it to the Cleveland Athletic Club. The canvas hung in the Club's dining room, but only for a few days, as the painting was thought to be offensive to some of the lady visitors.

1910 Participates in an exhibition of contemporary American art in Germany, organized by Hugo Reisinger.

105th Annual Exhibition, Pennsylvania Academy of the Fine Arts, Philadelphia, 23 January to 20 March: *Stag at Sharkey's* is no. 323, listed as *Club Night*; *Both Members of This Club* is no. 338.

Exhibition of Independent Artists, 29 West 35th Street, New York, 1 to 27 April: *Stag at Sharkey's* is no. 20, listed as *Club Night*; *Both Members of This Club* is no. 53; *The Knock Out* is no. 185.

Bellows is made a lifetime member of the National Arts Club in Gramercy Park.

Appointed instructor at the Art Students League, teaching life and composition classes and earning $1000 a year.

In May visits the Gould estate in Lakewood, New Jersey, where he watches his first polo match, a game which would inspire many paintings throughout his life.

Buys a house at 146 East 19th Street, where he designs and builds a studio. This will remain his home until his death.

In May, after a long courtship, Emma Story agrees to marry Bellows.

Fifth Annual Exhibition of Selected Paintings by American Artists, The Buffalo Fine Arts Academy, Albright Art Gallery, New York, 11 May to 1 September: *Both Members of This Club* is no. 12.

Fifth Annual Exhibition of Selected Paintings by American Artists, The City Art Museum of St. Louis, 15 September to 15 November: *Both Members of This Club* is no. 11.

23 September, Emma Story and Bellows marry in Williamsbridge, New York; their honeymoon is spent at Montauk Point.

1911 In January, Bellows' first one-man exhibition is held at the Madison Gallery, New York; twenty-four canvases are shown.

Bellows organizes an exhibition of "Independents" (including The Eight and himself) in Columbus.

In April Hugo Reisinger buys *Up the Hudson* for $300, subsequently donating it to The Metropolitan Museum of Art.

The Columbus Art Association buys *Polo Game* for $900.

The Bellows go to Upper Montclair, New Jersey, to escape the heat of New York. Bellows, in a creative slump, spends August on Monhegan Island (Maine) with the Henris, in order to paint.

8 September, birth of first daughter, Anne.

In mid-December the Association of American Painters and Sculptors is founded by Walt Kuhn, Jerome Myers, Elmer MacRae, and Henry Fitch Taylor. The Association proposes to exhibit works of art by contemporary painters and sculptors, including those usually neglected by the more traditional societies. Bellows is among the artists invited to join.

1912 Bellows begins illustrating stories for various periodicals.

Summer is spent in Montclair, New Jersey; October is spent in the Catskills.

Paintings by George Bellows, Art Students League, Columbus, Ohio, 16 to 26 November; travels to Toledo in December and Detroit in January.

1913 *International Exhibition of Modern Art* (the Armory Show), organized by the Association of American Painters and Sculptors, Armory of the 69th Regiment, New York, 17 February to 15 March; traveled to The Art Institute of Chicago, 24 March to 16 April; Copley Hall, Boston (sponsored by the Copley Society of Boston), 28 April to 19 May.

Numbers 919 to 922, 1043 to 1046, and 1104 are works by Bellows: *Introducing the Champion* is no. 1043, *Between Rounds* is no. 1044.

Bellows is intrigued by the European entries and does not paint during February or March (the duration of the Armory Show in New York).

Serves on jury for the National Academy of Design's spring exhibition.

23 March, Bellows' father dies.

Wins first prize in the Hallgarten competition ($300) for *Little Girl in White*.

Contributes twenty-five drawings over the next four years to a periodical, the *Masses*, of which John Sloan is the art editor.

Carnegie International Exhibition awards Bellows their third class medal for *Circus*.

The National Academy of Design elects Bellows a full member or "National Academician."

Spends summer and part of fall on Monhegan Island, where he paints 117 canvases by 1 November.

1914 In April, Bellows, Henri, and others resign from the Association of American Painters and Sculptors, after a meeting in which financial matters related to the Armory Show are discussed.

Wins the Maynard Prize for a portrait of *Dr. William Oxley Thompson*; a third prize in the Carnegie International Exhibition, Pittsburgh, for *Cliff Dwellers*; and a gold medal for the best picture — *River Front* — in the Panama-Pacific Exposition in San Francisco.

Charles L. Buchanan writes "George Bellows, Painter of Democracy" for *Arts and Decoration*, 4, August 1914.

Bellows family again spends summer on Monhegan Island

Paintings by George Bellows, The Art Institute of Chicago, 10 December to 3 January 1915: *Stag at Sharkey's* is no. 16, listed as *Club Night*. (This exhibition travels to Detroit and Los Angeles under a different title, see below.)

1915 *Exhibition of Paintings by George Bellows*, Detroit Museum of Art, 6 to 29 January: *Stag at Sharkey's* is no. 16, listed as *Club Night*.

Paintings by George Bellows N.A., Los Angeles Museum of History, Science, and Art, 7 to 28 February: *Stag at Sharkey's* is no. 16, listed as *Club Night*.

22 April, second daughter, Jean, is born.

Begins doing lithographs.

Paintings by Lester D. Boronda; Paintings by George Bellows, The Minneapolis Institute of Arts, 4 to 31 May: *Stag at Sharkey's* is no. 37, listed as *Club Night*.

Bellows family summers in Ogunquit, Maine, with Leon Kroll and the Henris.

Exhibition of Oil Paintings by George Bellows, Hackley Art Gallery, Muskegon, Michigan, 9 June to August: *Stag at Sharkey's* is included, listed as *Club Night*.

Exhibition of Paintings by George Bellows, New York City, Worcester Art Museum, Massachusetts, 5 to 26 September: *Stag at Sharkey's* is no. 13, listed as *Club Night*.

Special Exhibition of Paintings by Mr. George Bellows, Cincinnati Art Museum, October: *Stag at Sharkey's* is included, listed as *Club Night*.

Bellows earns $6,530.54 from his art this year, a substantial amount for a young artist of thirty-three.

1916 Bellows installs a lithography press in his studio. George C. Miller serves as his printer. Bellows executes thirty-five lithographs, including *Introducing the Champion*, No. 1 (cat. no. 33) and *Between Rounds*, No. 1 (cat. no. 32).

Collier's commissions Bellows to do three drawings of the heavyweight boxer Jess Willard in training for a forthcoming fight with Frank Moran. Bellows spends time in the gym with Willard, ultimately translating this experience into the lithograph, *Training Quarters* (cat. no. 30). *Study of Arms* (cat. no. 15) is a drawing for this print.

Sells *In Virginia* to Knoedler's for $2000.

Spends summer and part of the fall in different areas of Maine—Camden, Matinicus Island, and Criehaven.

1917 *Paintings, Lithographs, Drawings and Etchings by George Bellows*, Milch Galleries, New York, 13 to 24 March.

Exhibition at the MacDowell Club, New York, in which *Both Members of This Club* is included.

Wins the Temple Award from the Pennsylvania Academy for *Day in June*; wins the Isador Medal from the National Academy for *Doris in the Parlor*.

The Bellows family spends the summer in an artists' colony in Carmel, California, and then travels through the southwest until October.

"The Big Idea: George Bellows Talks about Patriotism for Beauty," in *Touchstone*, 1, July, 269-275.

Becomes interested in dynamic symmetry, a system developed by Jay Hambidge that uses geometric formulas to determine compositional organization.

Teaches at the Art Students League during November and December.

1918 *Exhibition of Paintings by George Bellows*, Gallery of Fine Arts and Art Association of Columbus, Ohio, 30 January to 13 February.

Paintings by George Bellows, Milch Galleries, New York, 13 to 24 March.

In the spring, Bellows executes a series of eighteen lithographs and four oils dealing with the atrocities committed during World War I.

The war prints are deposited at Keppel's Gallery where Charles Dana Gibson sees them, subsequently sending them on to the Committee on Public Information in Washington.

Sir Joseph Duveen, subsidized by Helen Frick, commissions Bellows to immortalize the war in two panels, each ten feet high: *Hail to Peace* and *The Dawn of Peace*.

Bellows family spends summer in Middletown, Rhode Island.

Exhibition of Lithographs by George Bellows, Frederick Keppel & Co., New York, 7 to 23 November.

1919 Bellows serves on a committee to select American paintings to be included in an exchange exhibition with the Luxembourg Gallery in Paris.

From April to June paints four portraits of Mrs. Chester Dale.

Summer is spent in Rhode Island.

Paintings by George Bellows, Albright Art Gallery, Buffalo, 11 September to 5 October; travels to The Art Institute of Chicago, 1 November to 16 December. This is Bellows' first major exhibition in the midwest. He is asked to teach painting at The Art Institute during November and December.

Oil Paintings by George Bellows, Memorial Art Gallery, Rochester, New York, 6 December to 5 January 1920.

1920 Exhibits with the New Society of American Artists.

Bellows family spends summer in the Shotwell House, Woodstock, New York.

Paints a portrait of *Elinor, Jean and Anna* (Aunt Fanny, Jean Bellows, and Bellows' mother).

Wins first prize at the National Arts Club for *Old Lady in Black*.

"Relation of Painting to Architecture—An Interview with George Bellows" is published in *American Architect*, 118, 20 December 1920, 847-851.

1921 In the first three months, Bellows completes sixty drawings. At the same time, he begins executing more lithographs, with Bolton Brown as his printer. He produces fifty-nine prints by March.

Participates in the *First Retrospective Exhibition of American Art*, Fine Arts Building, New York, sponsored by the Junior Art Patrons of America, 7 to 21 May: *Stag at Sharkey's* is no. 10.

Writes "What Dynamic Symmetry Means to Me" for the June issue of the *American Art Student*.

The Bellows family again spends the summer at the Shotwell House in Woodstock; Bellows purchases land adjacent to Eugene Speicher's property in Woodstock to build a summer house.

Bellows is commissioned by Herbert Bayard Swope of the *New York World* to cover a prize fight on 2 July at Boyle's Thirty Acres, Jersey City; the fight is between Jack Dempsey and Georges Carpentier (Dempsey wins). This commission leads to the drawings *Introducing Georges Carpentier* (cat. nos. 20, 21).

E. H. Ries publishes "The Relation of Art to Everyday Things; An Interview with George Bellows on How Art Affects the General Wayfarer," in *Arts and Decoration*, 15, July 1921, 158-159, 202.

Old Lady in Black wins the First Harris Prize in Chicago.

Bellows is commissioned by *Century Magazine* to do fifteen drawings and a portrait for a serial, "The Wind Bloweth," by Donn Byrne. Bellows is offered $100 for each drawing.

1922 Paints Chester Dale's portrait for $1500.

Carnegie International Exhibition awards Bellows first prize ($1500) for *Elinor, Jean and Anna*.

Club Night is sold to the Cleveland Museum of Art (for $1500) and subsequently renamed *Stag at Sharkey's*; *Stag at Sharkey's* is renamed *Club Night*.

Designs and builds a house in Woodstock from April to August. The Bellows family would spend summers there from then on.

Second Exhibition of Contemporary Painting, Cleveland Museum of Art, 8 June to 8 July: *Stag at Sharkey's* is included.

Hearst's *International Magazine* commissions Bellows to illustrate H. G. Wells' book, *Men Like Gods*, which it plans to serialize.

1923 Produces sixty-four lithographs, many of which illustrate "The Wind Bloweth" and *Men Like Gods*.

Concentrates on drawing until June.

Paints *Introducing John L. Sullivan* (cat. no. 4) in the summer.

Anna Bellows dies.

Paints *Emma in the Black Print*, which he sells to a Boston collector for $3000.

Elinor, Jean and Anna is sold to the Albright Art Gallery, Buffalo.

Paints the *Crucifixion* and *Emma and Her Children*.

The *New York Evening Journal* commissions Bellows to cover the fight between Dempsey and Firpo (Dempsey wins). Executes the drawing *Dempsey through the Ropes* (cat. no. 22).

Chicago awards the Logan Purchase Prize to *My Mother* and subsequently purchases the painting.

Lectures at the Masters School and the Art Students League.

1924 By March Bellows has executed thirty-three lithographs, including one of *Dempsey and Firpo* (cat. no. 45).

In the 3 May issue of *Collier's* a drawing by Bellows is used in the story "The Chins of the Fathers"; *Collier's* crops the drawing without permission from Bellows. In retaliation Bellows sues. This drawing serves as the basis for *Ringside Seats*.

Summer is spent in Woodstock, during which *Ringside Seats* (May, cat. no. 5) and *Dempsey and Firpo* (June, cat. no. 6) are painted.

First symptoms of chronic appendicitis occur.

Joint exhibition in Chicago includes forty-two

paintings by Bellows. *Special Exhibition of Paintings by George Bellows, Leon Kroll, Eugene F. Savage, Walter Ufer, Paul Bartlett, Edgar S. Cameron, H. Aimard Oberteuffer, and George Oberteuffer*, The Art Institute of Chicago, 23 December to 25 January 1925: *Dempsey and Firpo* is no. 6, *Ringside Seats* is no. 8, and *Introducing John L. Sullivan* is no. 5.

Last major oil is painted, *Jean, Anne, and Joseph*.

1925 Suffers a ruptured appendix on 2 January. Is rushed to the Postgraduate Hospital where he undergoes surgery. After complications, George Bellows dies of peritonitis on 8 January at the age of forty-two.

Bellows' funeral is held at the Church of the Ascension on Fifth Avenue at 10th Street.

Paintings by George Bellows, Durand-Ruel Gallery, New York, 2 to 14 February: *Dempsey and Firpo* is no. 2, *Ringside Seats* is no. 7.

Exhibition of Paintings by George Bellows, Worcester Art Museum, Massachusetts, 22 February to 8 March: *Dempsey and Firpo* is no. 2, *Ringside Seats* is no. 14.

Exhibition of Paintings by George Bellows, Charles Hopkinson, Eugene Speicher, Boston Art Club, 11 to 28 March: *Dempsey and Firpo* is no. 2 (listed as *Dempsey-Firpo*), *Ringside Seats* is no. 6.

In March, Emma Bellows organizes *Lithographs and Drawings by George Bellows*, Frederick Keppel & Co., New York, 24 March to 25 April: *Stag at Sharkey's* and *Dempsey through the Ropes* are included.

Exhibition of Paintings by George Bellows, Charles Hopkinson, Robert Henri, Rhode Island School of Design, Providence, 2 to 27 April: *Dempsey and Firpo* is no. 2, *Ringside Seats* is no. 6.

A large memorial exhibition, containing sixty-three oils, twenty-four drawings, and fifty-nine lithographs, is held at The Metropolitan Museum of Art, New York: "*Memorial Exhibition of the Works of George Bellows*," 12 October to 22 November: *Stag at Sharkey's* is no. 7 (listed as *Sharkey's*), *Both Members of This Club* is no. 10, *Introducing John L. Sullivan* is no. 49, *Ringside Seats* is no. 56, and *Dempsey and Firpo* is no. 57 (listed as *Dempsey-Firpo*).

Commemorative Exhibition by Members of the National Academy of Design (1825-1925), Corcoran Gallery of Art, Washington, D.C., 17 October to 15 November; traveled to Grand Central Galleries, New York, 1 December to 3 January 1926: *Club Night* is no. 200.

Memorial Exhibition of Paintings by George Wesley Bellows, Memorial Art Gallery, Rochester, New York, December: *Introducing John L. Sullivan* is no. 17, *Dempsey and Firpo* is no. 21.

1926 *Memorial Exhibition of the Work of George Bellows (1882-1925)*, The Buffalo Fine Arts Academy, Albright Art Gallery, 10 January to 10 February: *Introducing John L. Sullivan* is no. 19 (of paintings), *Dempsey and Firpo* is no. 23 (of paintings).

George W. Bellows Memorial Exhibition, Cleveland Museum of Art, 16 February to 22 March.

Memorial Exhibition of the Work of George Wesley Bellows, Fine Arts Gallery of San Diego, 10 November to 15 December: *Dempsey and Firpo* is no. 15.

Carlo Beuf publishes "The Art of George Bellows," in *Century*, 112, October 1926, 724-729.

1927 Emma Louise Bellows and Thomas Beer publish *George W. Bellows: His Lithographs* (New York), reproducing all 195 lithographs.

Memorial Exhibition of Paintings by George W. Bellows, The City Art Museum of St. Louis, March: *Dempsey and Firpo* is no. 15.

1929 Emma Story Bellows, *The Paintings of George Bellows* (New York).

Drawings by George Bellows, Frederick Keppel & Co., New York, 20 March to 20 April: *Counted Out* is possibly no. 9 (listed as *The Last Count*), *The Last Ounce* is no. 53 (listed as *The Crowd Surged to Its Feet as They Thundered across the Ring*), *Preliminaries to the Big Bout* is no. 31.

1931 George W. Eggers, *George Bellows: American Artists Series* (New York), reproduces *Dempsey and Firpo* (page 29) and *Stag at Sharkey's* (page 43).

Important Paintings by George Wesley Bellows, Columbus Gallery of Fine Arts, Ohio, January to February 1931: *Stag at Sharkey's* included.

1937 Charles Grant writes "Stag at Sharkey's," republished in part in *Beta Theta Pi Magazine*, May 1947; manuscript in National Gallery files.

1939 *George Bellows, 1882-1925: Loan Exhibition of Paintings*, The Century Association, New York, 15 January to 19 February: *Dempsey and Firpo* is no. 10.

1940 The Keppel gallery merges with Harlow, becoming Harlow Keppel & Co.; H. V. Allison of Keppel's starts his own gallery with his son, Gordon. As Allison was the Bellows expert, Emma Bellows takes not only the prints but also the paintings to H. V. Allison & Co.

Thirty-six Paintings by George Bellows, Columbus Gallery of Fine Arts, Ohio, 3 October to 6 November 1940: *Both Members of This Club* is included.

1942 Peyton Boswell, Jr., publishes *George Bellows* (New York).

1944 Chester Dale acquires *Both Members of This Club* then, later in the year, gives it to the National Gallery of Art.

1945 *Drawings and Lithographs: George Bellows*, Phillips Memorial Gallery, Washington, D.C., 14 January to 12 February: *Introducing the Champion* is no. 16, *The Last Ounce* is no. 18, *Preliminaries to the Big Bout* is no. 9, *Introducing Georges Carpentier* is no. 12.

1946 *George Bellows: Paintings, Drawings and Prints*, The Art Institute of Chicago, 31 January to 10 March: *Stag at Sharkey's* is no. 5, *Both Members of This Club* is no. 6, *Ringside Seats* is no. 56. Drawings included were *Dempsey through the Ropes*, no. 65, *Introducing Georges Carpentier*, no. 71, *Introducing the Champion*, no. 72, *The Last Ounce*, no. 77, and *Preliminaries to the Big Bout*, no. 84. Catalogue written by Frederick A. Sweet, Carl O. Schniewind, and Eugene Speicher.

1948 Frank Sieberling, Jr., writes "George Bellows, 1882-1925: His Life and Development as an Artist" (Ph.D. dissertation, University of Chicago).

1957 *George Bellows: A Retrospective Exhibition*, National Gallery of Art, Washington, D.C., 19 January to 24 February: *Club Night* is no. 5, *Stag at Sharkey's* is no. 13, *Both Members of This Club* is no. 14, *Ringside Seats* is no. 60, *Dempsey and Firpo* is no. 61. Drawings included: *Introducing Georges Carpentier*, no. 70; *Introducing Georges Carpentier*, no. 71; *A Knock Down*, no. 72; *The Knock Out*, no. 73; *Preliminaries to the Big Bout*, no. 79.

Paintings by George Bellows, Columbus Gallery of Fine Arts, Ohio, 21 March to 21 April: *Stag at Shar-*

key's is no. 11, Ringside Seats is no. 63, Dempsey and Firpo is no. 64.

George Bellows, Prints and Drawings, Smithsonian Institution traveling exhibition, 1957-1958: A Knock Down is no. 53, Preliminaries to the Big Bout is no. 57, and Introducing Georges Carpentier is no. 52.

1959 Death of Emma Bellows.

1963 Frances Roberto Nugent, George Bellows, American Painter (Chicago).

1965 Charles H. Morgan, George Bellows: Painter of America (New York).

1966 George Bellows: Paintings, Drawings, Lithographs, Gallery of Modern Art, New York, 15 March to 1 May: Club Night is no. 8 (of paintings), Introducing John L. Sullivan is no. 66 (of paintings), Ringside Seats is no. 71 (of paintings). Drawings included: A Knock Down, no. 1; Between Rounds, no. 3; Dempsey through the Ropes, no. 6; Introducing Georges Carpentier, no. 16; Preliminaries to the Big Bout, no. 22; Study for "Dempsey and Firpo": Figure of Dempsey, no. 29; Study for "Dempsey and Firpo": Head and Shoulders of Dempsey, no. 30; Study for Dempsey and Firpo": Arm of Firpo, no. 31; Study for "Dempsey and Firpo": Referee, no. 32; Study for "Dempsey and Firpo": Hands of Referee, no. 33; Study of Arms, as Study for "Training Quarters," no. 35; The Last Ounce, no. 38.

John Canaday, "George Bellows and the End of a World Picasso Never Knew," New York Times, 13 March 1966, sec. X, 27.

1968 Kenneth Morton Davis, "Bellows, Stylistic and Thematic Development" (Master's thesis, Ohio State University, Columbus).

1969 Mahonri Sharp Young, "George Bellows: Master of the Prize Fight," Apollo, 89, February, 132-141.

1971 George Bellows (1882-1925), Hirschl & Adler Galleries, New York, May: Ringside Seats is no. 16.

Donald Braider, George Bellows and the Ashcan School of Painting (Garden City, New York).

1972 George Wesley Bellows, Mead Art Museum, Amherst College, Massachusetts, 1 to 20 November: Dempsey and Firpo, Study of Arms, The Last Ounce, Study for

"Dempsey and Firpo": Referee's Hands, Study for "Dempsey and Firpo": Figure of Dempsey, Study for "Dempsey and Firpo": Head and Shoulders of Dempsey, Study for "Dempsey and Firpo": Referee, Study for "Dempsey and Firpo": Arm of Firpo.

1973 Charles H. Morgan, The Drawings of George Bellows (Alhambra, California).

Mahonri Sharp Young, The Paintings of George Bellows (New York).

1975 The Graphic Art of George Bellows: Lithographs and Related Drawings, Boston University Art Gallery, 7 February to 2 March: A Knock Down, Preliminaries to the Big Bout, Introducing Georges Carpentier.

1976 Suzanne Boorsch, "Lithographs of George Bellows," Art News, 75, March, 60-62.

1977 Lauris Mason, The Lithographs of George Bellows: A Catalogue Raisonné (Millwood, New York).

1979 George Bellows: Paintings, Drawings, and Prints, Columbus Museum of Art, Ohio, 1 April to 8 May: Stag at Sharkey's is no. 12 (shown in Columbus only), Dempsey and Firpo is no. 52; traveled to Virginia Museum of Fine Arts, Richmond, 29 June to 5 August; Des Moines Art Center, 17 September to 28 October; Worcester Art Museum, Massachusetts, 16 November to 28 December.

1981 Robert Henri — George Bellows, The Cummer Gallery of Art, Jacksonville, Florida, 22 January to 8 March.

Portraits of George Bellows, National Portrait Gallery, Smithsonian Institution, Washington, D.C., 4 November to 3 January 1982.

1982 Homage to George Bellows: An Exhibition of Lithographs with Selected Drawings and Paintings, The Metropolitan Museum of Art, New York, 4 May to 4 July.